THE COMPLETE GUIDE TO
CALLIGRAPHY

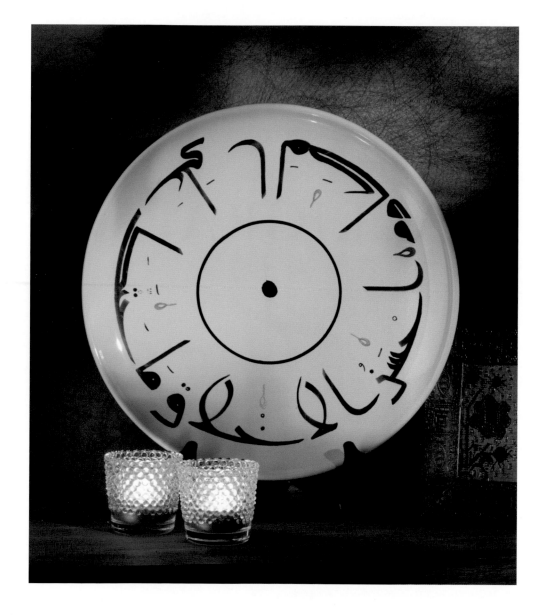

THE COMPLETE GUIDE TO
CALLIGRAPHY

Master Scripts of the West and East,
Step-by-Step with 45 Projects

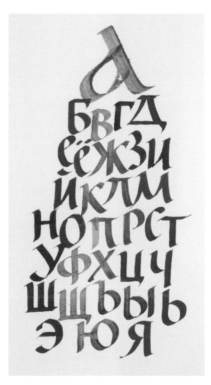

Professor Ralph Cleminson, General Editor

FIREFLY BOOKS

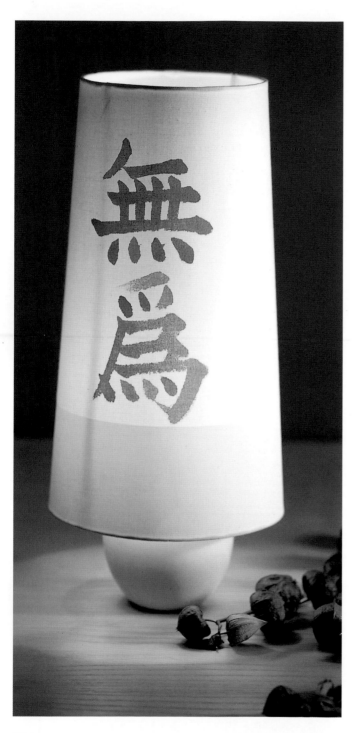

A FIREFLY BOOK

Published by Firefly Books Ltd. 2006

Copyright © 2006 Cico Books,
an imprint of Ryland, Peters & Small Ltd.

First printing

Publisher Cataloging-in-Publication Data (U.S.)

The complete guide to calligraphy : master scripts of the west and east, step-by-step with 45 projects / edited by Ralph Cleminson.
[224] p. : col. photos. ; cm.
Includes index.
Summary: Handbook to the ancient art of lettering in the key scripts of the world: Roman, Greek, Cyrillic, Hebrew, Arabic, Chinese and Japanese. Includes information on techniques, tools and problem-solving tips and projects.
ISBN-13: 978-1-55407-179-1 (pbk.)
ISBN-10: 1-55407-179-8 (pbk.)
1. Calligraphy —Technique. 2. Lettering — Technique I.
Cleminson, Ralph. II. Title.
745.61 dc22 NK3600.C66 2006

Library and Archives Canada Cataloguing in Publication

 The complete guide to calligraphy : master scripts of the West and East, step-by-step with 45 projects / edited by Ralph Cleminson
Includes index.
ISBN-13: 978-1-55407-179-1
ISBN-10: 1-55407-179-8
1. Calligraphy--Technique. I. Cleminson, R. M. II. Title.
NK3600.C65 2006 745.6'1 C2006-901531-7

Published in the United States by Firefly Books (U.S.) Inc.
P.O. Box 1338, Ellicott Station, Buffalo, New York 14205

Published in Canada by Firefly Books Ltd.
66 Leek Crescent, Richmond Hill, Ontario L4B 1H1

Contributing Authors
Latin Scripts: Fiona Graham-Flynn
Ancient Greek: Christine Mckinnon
Russian Cyrillic: Christopher Austin
Hebrew: Gordon Charatan
Arabic: Nassar Mansour
Chinese: Qu Lei Lei
Japanese: Yoko Takenami

Project Editor: Robin Gurdon
Editor: Richard Emerson
Designer: Ian Midson
Photographer: Geoff Dan
Stylist: Sammie Bell

Printed in China

Note
The Common Era dating convention is used throughout this book for all scripts, whether pre-Christian, European, or non-European. It defines dates with the terms B.C.E. *(Before Common Era) and* C.E. *(Common Era). The dates are comparable with the traditional, Christian system using the terms* B.C. *(Before Christ) and* A.D. *(Anno Domini—"in the year of our Lord").* `

CONTENTS

PREFACE 6
INTRODUCTION 7
SECTION 1: **Latin Scripts** **12–121**
MATERIALS 14
MASTERING FOUNDATION SKILLS 20

CHAPTER 1 CAROLINGIAN 28

CHAPTER 2 ROMAN CAPITALS 58

CHAPTER 3 UNCIAL & HALF-UNCIAL 72

CHAPTER 4 BLACK LETTER GOTHIC 88

CHAPTER 5 ITALIC 100

CHAPTER 6 COPPERPLATE 114

SECTION 2: **Non-Latin Scripts** **122–179**
CHAPTER 7 ANCIENT GREEK 124

CHAPTER 8 RUSSIAN CYRILLIC 140

CHAPTER 9 HEBREW 156

CHAPTER 10 ARABIC 164

SECTION 3: **Pictographic Scripts** **180–213**
CHAPTER 11 CHINESE 182

CHAPTER 12 JAPANESE 198

TEMPLATES 214
CALLIGRAPHY SOCIETIES, SUPPLIERS, AND WEBSITES 220
INDEX 222
NIB SIZE CHART AND GLOSSARY 224

PREFACE

Calligraphy is the art of handwriting. Like any work of art, a piece of calligraphy is hand-crafted, unique, and personal. Unlike printed text, no two pieces of handwriting are truly alike. In this computer-driven age, such originality is beyond price. When you copy an illuminated text in Celtic or Cyrillic script, for example, or Persian verse in Arabic, you are following the path of ancient scribes whose dream was to create a legacy for future generations to cherish. In *The Complete Guide to Calligraphy* you can learn how to write some of the world's major scripts, and find out about the history and culture of the people who developed them. You'll also discover how to use authentic writing materials to produce the calligraphy of each culture. These are as varied as the scripts themselves. There are numerous types of inks, pigments, paints, paper, papyrus, animal skins, and clay tablets, as well as all sorts of pens, quills, and brushes. At the back of the book you'll find a list of suppliers.

Calligraphy is not only fascinating to study, it is also great fun to do. This book features many beautiful craft projects to display different script styles to best effect. These include greetings cards, invitations, romantic love tokens, exciting gifts, and intriguing ideas, such as Celtic name plaques, a Japanese lunch mat, a lampshade, a fan, and a trinket box.

THE AUTHORS

The Complete Guide to Calligraphy has been compiled by leading contemporary calligraphers and artists. They are:

PROFESSOR RALPH CLEMINSON (Editor). Ralph Cleminson is Professor of Slavonic Studies at the University of Portsmouth in England and Visiting Professor at the Central European University in Budapest. He is a specialist in medieval manuscripts and early-printed books, with a particular interest in the development of writing systems.

FIONA GRAHAM-FLYNN (Latin scripts). Fiona was born in Scotland and has been a calligrapher and illuminator for 26 years. She has taught her skills since 1992 in adult learning and private classes. She uses seven calligraphic scripts, and specializes in the Celtic Uncial and Irish Half-uncial, pigment colors, and vellum. Fiona co-wrote the book *Celtic Ornament: Art of the Scribe* (1995), with Courtney Davis, and *Celtic Calligraphy* (2005), a book for children.

CHRISTINE MCKINNON (Ancient Greek). Christine produces the "Papyrus Productions" collection, inspired by Egyptian, Minoan, and Classical Greek art. She was Egyptology consultant for the "Library of Alexandria" set in Oliver Stone's film *Alexander*, as well as Greek script coach. She was also a consultant for *The Mummy*, *The Mummy Returns*, and *Cleopatra*. She has contributed a chapter on Greek calligraphy for an encyclopedia to be published in 2006 and is currently working on a number of commissions.

CHRISTOPHER AUSTIN (Russian Cyrillic). Christopher studied calligraphy and bookbinding at Roehampton University in London, England. Since 1997 he has run his own studio for both individual clients and corporate bodies, and teaches classes and workshops. He has been historical consultant for various TV and movie documentaries and is chairman of the South London Lettering Association.

GORDON CHARATAN (Hebrew). Gordon is an architect who has dedicated his spare time to the study of Hebrew calligraphy. He lives and works in London.

NASSAR MANSOUR (Arabic). One of the most proficient Arabic calligraphers today, Nassar was born in Jordan and took up calligraphy at an early age. Initially self-taught, he later trained in Istanbul under renowned calligraphy master Hassan Chalabi, gaining a certificate of competency (*Ijaza*) in 2003. Before moving to London, Nassar taught calligraphy in Amman, Jordan, and contributed in establishing the Institute of Islamic Arts there. He has also participated in various international events, including co-ordinating an exhibition of Arabic calligraphy (Making of the Master) at the British Museum, where his works are exhibited in the permanent collection. He teaches calligraphy at the Prince's School of Traditional Arts and is finalizing his PhD there.

QU LEI LEI (Chinese). Born in China in 1951, Qu Lei Lei is a founding member of the Stars Group, the first contemporary art movement to challenge China's anti-Western art establishment. His works comprise a blend of classical Chinese and Western art techniques. His work is deeply concerned with humanity and the human condition. One of China's leading artists, he has exhibited internationally at venues including the Venice Biennale, the Beijing Biennale, New York, Tokyo, Geneva, and Paris. He has recently staged a one-man exhibition at Ashmolean Museum, Oxford. As well as being a leading calligrapher renowned throughout the U.K., he paints in various styles.

YOKO TAKENAMI (Japanese). Born in Tokyo, Yoko started calligraphy at the age of seven. Always enthusiastic about art in general, she spent a year as an exchange student in the U.S., which opened her eyes to the joys of introducing Japanese culture to the world. Now based in London, she holds regular workshops, often returning to Japan for inspiration. She is the author of *The Simple Art of Japanese Calligraphy* (Cico Books).

CALLIGRAPHY NIBS

Many different types of nib, using many different sizing conventions, are available. Throughout *The Complete Guide to Calligraphy* William Mitchell roundhand nibs are pictured but Speedball nib sizes are referenced, except where indicated. A nib-size conversion table is provided on page 224.

INTRODUCTION: THE HISTORY OF SCRIPTS, LETTERING, AND WRITING

Throughout history, cultures have looked for ways to record their words for others to appreciate, using materials as diverse as stone, reeds, skins, and clay. But for these ancient scribes, communication of ideas alone was not enough—they also sought to make their work pleasing to the eye. And so was born the calligrapher's art.

It is not known when human beings first began to write. The earliest examples are of developed writing systems that must already have had a considerable history behind them. It appears that writing arose independently in different places—in China, in the Indus Valley, in the Eastern Mediterranean, in Central America, and quite possibly elsewhere—and spread over the ancient world, with different peoples either adopting existing scripts or devising their own in imitation of them.

It is most likely that the origin of writing lies in an attempt to draw a likeness of the objects and actions they were intended to portray. Think of the beautiful depictions of animals painted on cave walls by our Stone Age ancestors hundreds of thousands of years ago. Over the millennia there followed a gradual shift from an accurate

Above: *This image depicts a form of pictographic text, dating from* c. 4000 B.C.E., *that was a forerunner of modern Chinese.*

representation of the object to a purely symbolic form. As a result, the sign became dissociated from the image it depicted and began to develop a meaning of its own.

This early form of visual communication has not died out entirely and can still be seen in use today, especially in public buildings, where people of diverse nationalities and languages gather together. For example, a simple image of a man placed on a bathroom door is not a picture of anyone in particular, but an indication that behind the door is a lavatory to be used by members of the male sex. Similarly, a knife-and-fork symbol has become an almost universal icon for an eating establishment, regardless of the type of food that might be offered (which may be eaten with a spoon, with chopsticks, or with the fingers!).

This is not writing as such, however, as it conveys meaning only if we see it in its correct location or context. For example, the "man" sign painted on a blank wall would be meaningless. The development of a true writing system requires a further shift: a system of signs arranged in such a way that their specific meaning may be gleaned from the signs alone, regardless of their location or context.

The earliest writing systems were pictographic. That is, the symbol marked down was a simplified version of the object it represented. This developed into a logographic system, where characters or graphs represent units of concept or meaning, as in early Japanese and in Chinese writing today. The way a character is drawn has no connection with the way that the word it represents is pronounced. In Chinese, two words that happen to sound the same are likely to be represented by two completely different symbols.

However, in many cultures a further separation took place when signs ceased to have inherent meanings and came to represent sounds instead. The earliest examples of this were lists of characters representing syllables, known as "syllabaries," such as Linear B, an ancient form of writing used on the island of Crete in the Mediterranean, and on mainland Greece, and dating from c. 1400 to 1200 B.C.E. Syllabic scripts are the ancestors of the modern alphabet, in which each character represents an even smaller unit of sound.

The various writing systems have their own unique advantages. A logographic system is good for representing a language with invariant word forms, such as traditional

Chinese, but insufficient for Japanese, which supplements its logographic symbols with a syllabary.

A syllabary is good for languages with open syllables, but less well-suited to those that have consonant clusters or final consonants; and it is often awkward to represent any language with an alphabet that was designed for another, or for an older form of the same language, as the often eccentric spelling found in English testifies.

Not all the writing systems of the past have descendants that are still in use today. Some, however, have been extraordinarily prolific, notably Chinese, which spread throughout East and Southeast Asia (although it is no longer used for Vietnamese). Phoenician, which was derived from Egyptian hieroglyphs, is the ancestor of the modern European and Middle Eastern alphabets, and can be linked, via various extinct Central Asian scripts, to a vast array of Asian forms of writing, ranging from Mongolian in the north to the various Indic scripts in the south, including ancient Sanskrit and the modern written languages of the Indian subcontinent.

The development of writing has also been heavily influenced by the development of the writing materials used to produce it. It is possible to write on any flat surface. Stone, wood, plaster, clay, metal, papyrus, parchment, paper, wax, bark, palm leaves, and pottery have all been inscribed or incised by different cultures at various times.

The media in which—and on which—writing was performed have played a large part in determining the form of the script that developed. The widespread use of the brush in China and Japan has done much to influence the bold, sweeping strokes of the characters that make up their writing systems.

Cuneiform is a script designed to be impressed on clay, just as Ogham and Runic are meant to be incised on stone or wood. Europeans often refer to the script of the Orkhon inscriptions or to the Hungarian *rovásírás* (literally "cut writing") as "runes" simply because of the similarity of their shapes, even though, historically speaking, they have nothing to do with the Runic alphabet that developed in Northern Europe from the third century C.E.

These various media not only greatly affect the form of the writing that they carry, they also play an important part in determining how workable, portable, and durable a particular piece of writing will be. Many examples of the most ancient forms of writing that have survived to modern times were inscribed on stone—perhaps the most durable writing material of all. But stone-engraved writing tends to be of a public nature. It was generally intended for a wide audience and had to convey information of sufficient importance to have been worth all the time, effort, and cost of having someone carve it.

So stone carvings can tell us a great deal about, for example, what ancient towns and cities were called, their greatest generals, or their most influential statesmen—as well as the laws and proclamations they passed—but are less likely to contain more mundane information, such as business transactions, items of news, declarations of love, and similar personal correspondence of the time.

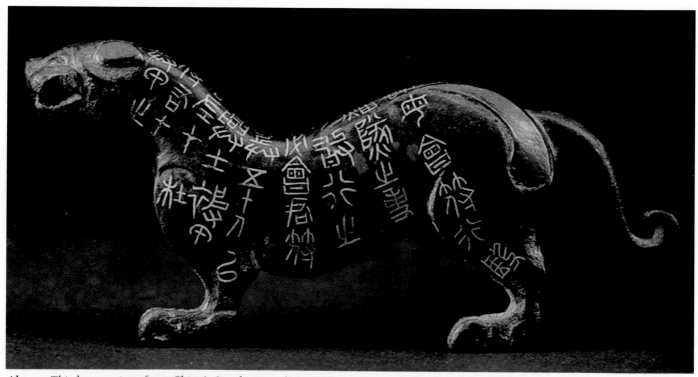

Above: *This bronze tiger from China's Qin dynasty (221–206 B.C.E.) is inlaid with gold and covered in calligraphy. The work is in two pieces—one kept by the Emperor, and the other by his leading general. When the two pieces were fitted together it proved the authenticity of the Emperor's orders.*

Above: *The use of a brush in Japanese calligraphy creates a more flowing style of writing that allows subtle changes of thickness and direction.*

Other pieces of ancient writing that have lasted till the present day have frequently done so simply because of chance events, such as the huge fire that destroyed the palace at Knossos, the principal city of the Minoan people of Crete, which was occupied until *c.* 1200 B.C.E. This fire was so intense it acted as a kiln, hardening the unfired clay tablets marked with Linear B inscriptions that were stored there, and turning them into durable pottery, thereby preserving them for modern times.

The hot, desert climate of Egypt also preserved much early writing of the Egyptians, not only the hieroglyphs painted on the walls of the pharaohs' tombs, but also vast quantities of papyrus, including much that is of critical importance for the textual history of the New Testament. Where a cheap and portable surface for writing is readily available, the opportunities for writing are much greater, as it can be used for many more purposes. Just as the Egyptians and their Mediterranean neighbors used papyrus, for the Chinese, the most important writing material was paper.

The visual impact of writing can vary considerably, with much greater care being given to text that was intended to be long-lasting, public, and of high status, than that which was ephemeral, personal, and purely practical in purpose. Indeed, the Egyptians categorized scripts in one of three ways: hieroglyphic, hieratic, or demotic, the first being used for the most solemn and ceremonial purposes and the last for the most pragmatic. However, the strong pictorial element in these hieroglyphs means that they are still as much drawing as calligraphy.

The alphabetic scripts of the ancient world also reveal a clear distinction between writing whose form is intended to impress, and writing that is used to convey a simple meaning. For example, in the ancient Roman world, there was a clear difference between scripts used for inscriptions carved on ancient monuments, and the graffiti scrawled on walls, such as those of Pompeii, which were rediscovered when the city was excavated in 1748. Until that time, Pompeii had lain buried and forgotten under volcanic dust, following the eruption of Mount Vesuvius in 79 C.E. that killed many of its citizens. The Roman poet Ovid (43 B.C.E. –17 C.E.), in the preface to his collection of poems *Tristia*, describes the luxury books of his day—contrasting them with the sort of book in which he expects his own work to circulate.

The emergence of calligraphy, with its emphasis on the decorative aspects of writing as much as communication, led to the development of writing as an art form. This is particularly true of China and Japan, where the form and variety of the characters provide particular scope for decorative impact, and where considerable importance has long been attached to standards of calligraphy.

Arabic script has considerable decorative potential as well. This was encouraged by the fact that in certain Middle Eastern cultures depicting the natural world in a realistic way was—and still is—frowned upon. So, while in the West we might use pictures of plants, animals, or landscapes to decorate homes and public buildings, people of the Arabic world often turned to calligraphy instead. In some cases the message being communicated by the calligraphy has been far less important than its decorative function, and calligraphers have produced work that is beautiful but practically indecipherable! There are examples of this in medieval Greek and Cyrillic as well.

Before the introduction of paper in the 13th century, the principal writing material in medieval Europe was parchment (sheep or goat skin), which was both expensive and limited in supply. In the East, where the Roman Empire lived on in Constantinople—the New Rome—the classical

Above: *Over many hundreds of years, the Phoenician script (top) gradually changed to a form of Greek that would be recognizable today (bottom). (Script recreated by author.)*

culture survived because of the demands of an educated professional class, separate from the clergy. But in the West, production of books and documents was largely determined by the needs of church, state, and legal administration, the latter also largely in the hands of churchmen (a "clerk" was originally a "clericus," a member of the clergy). Non-church literature, whether in Latin or in the language of the ordinary people, was confined to a few centers of ecclesiastical learning and courtly culture.

Writing was therefore practiced mostly in the major monasteries and the chanceries of princes. The scribe was, like other artists, regarded as an artisan, a specialist craftsman, working as part of a team. It was common for a book to be written by several scribes working to a common standard, and unusual for the same man to be responsible for both writing and decoration (known as "illumination").

The introduction of paper allowed a much wider production of all kinds of writing, including the most highly decorated and sophisticated books, while parchment was kept for special works, such as luxury volumes for the wealthy, or for important documents intended to be long-lasting. The laws, or Acts, of the Parliament of the United Kingdom are still printed on parchment today and the earliest of these have survived for hundreds of years.

As the use of paper became more widespread, this was accompanied by a steady increase in the number of people who could read and write, both professionally and incidentally to their daily business. It was, however, in Italy in the Renaissance, the period at the end of the Middle Ages, that "the scribe" truly became "the calligrapher."

Above: *Arabic script is often written for purely decorative effect, rather than to convey useful information.*

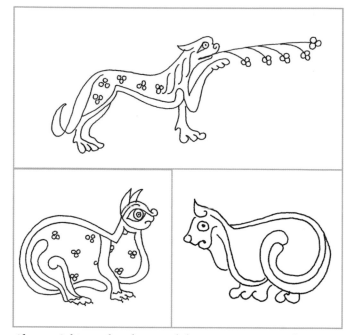

Above: *Celtic scribes decorated their manuscripts with comic or fantastic animal designs that often had symbolic meaning.*

The new movement in the arts extended to handwriting, with prominent individuals developing and popularizing a type of writing suitable for the new age. A landmark in this process was the publication in 1522 of the *Operina* of Ludovico degli Arrighi, the first printed handbook of calligraphy, and one of the most influential.

Meanwhile, another Chinese invention, movable type, was also having its impact on Europe. Printing in the Latin alphabet began in the 1450s, quickly followed by Greek, Hebrew, Cyrillic, Glagolitic, and Armenian. The first printed books were imitations of contemporary manuscripts, and could be illuminated by hand in the same way. The expansion in printing played an important part in the revival of classical literature, which also developed during the Renaissance.

The printers, in collaboration with contemporary calligraphers, began to revive classical forms of script for their typefaces. The printers' "Antiqua" is regarded as a "modern" typeface (as opposed to Black Letter Gothic, say), even though its origins are far older. This is because the typographers' immediate models were not Roman handwriting but Roman carved inscriptions, as these were the examples that had survived in greatest numbers. The most perfectly proportioned letters were considered to be those of Trajan's Column, in Rome, which celebrates the victory by Roman Emperor Trajan (53–117 C.E.) over Dacia (now Romania).

In modern Europe the book has essentially been the printed work, and although "writing masters" continued to flourish, their status declined from that of the Renaissance calligrapher, and their skills became largely confined to the personal and practical sphere. It is noticeable that the dominant form of handwriting in 18th- and 19th-century England was Copperplate (see pages 114–117), whose

name reveals its origins—a polished copper plate was engraved for use in printing—and demonstrates the pre-eminence of the press over the pen. With the invention of typewriters, a legible, standardized hand ceased to be necessary for the commercial clerk, and so the importance of handwriting diminished still further.

The Victorian rediscovery of—and interest in—medieval culture brought about a new appreciation of manuscript books, while the principles of the famous Arts and Crafts movement, which originated in England in the latter half of the 19th century, encouraged a revival of lost and dying craft skills that spread around the world as a reaction to the growing trend toward impersonal mass production. With the Kelmscott Press, founded by a leading member of the movement, the English artist, writer, and social reformer William Morris (1834–1896), there came a new focus on the book as a thing of visual beauty in itself. This trend, too, had an international influence.

The leading figures of the Arts and Crafts movement returned to medieval and Renaissance models—Morris used a "humanistic" or "Classical-style" hand for his private correspondence—and bequeathed to succeeding generations a renewed awareness of the importance of handwriting in the creation of letters. It is no accident that two of the most important figures in 20th-century typography were also artists: the sculptor and graphic artist Eric Gill and the virtuoso calligrapher Hermann Zapf. Their names are perhaps more familiar to the public as computer typefaces. In the present day the fact that most written texts are not handwritten has redirected our attention to the esthetic aspects of writing: to choose to write something by hand is to choose to create a particular visual impact, and more and more people are developing an interest in calligraphy and an appreciation of its potential.

Above: *In Europe during the Middle Ages, calligraphers could become very rich producing decorative books for the wealthy. This beautiful design is based on the French Duke de Berry's* Book of Hours—*and reproduced as a project in this book.*

At the same time, increased population movement and the ease of communications have made people increasingly aware of the calligraphy traditions of other parts of the world and awoken a desire in them to learn about and practice them. This book appears in fulfillment of that desire.

Above: *Traditional illumination skills have been used in many projects found throughout this book as a celebration of the art of the calligrapher. The examples shown here are: Celtic rubrication (left), Italic flourishes (center), and Cyrillic gold leaf (right).*

LATIN SCRIPTS

Unlike most arts and crafts, in calligraphy there's no long, tedious delay while you learn a series of complex skills. You can start right away—after all, you already know how to write! The art of calligraphy is all about honing the handwriting skills you already possess until you can produce truly stunning pieces of text. In this introductory section, we look at everything you need to know in order to do calligraphy, from the choices of paper, ink, and writing tools available—to how to hold the pen. The first script you will tackle is a form of Carolingian, known as "Foundation." It is chosen because of its elegance, simplicity, and natural, free-flowing style—ideal for beginners. Like all the styles covered in this section, Foundation is a Latin script. That means it is based on the Latin alphabet, which now forms the basis of texts in most European countries, and all the English-speaking nations around the world.

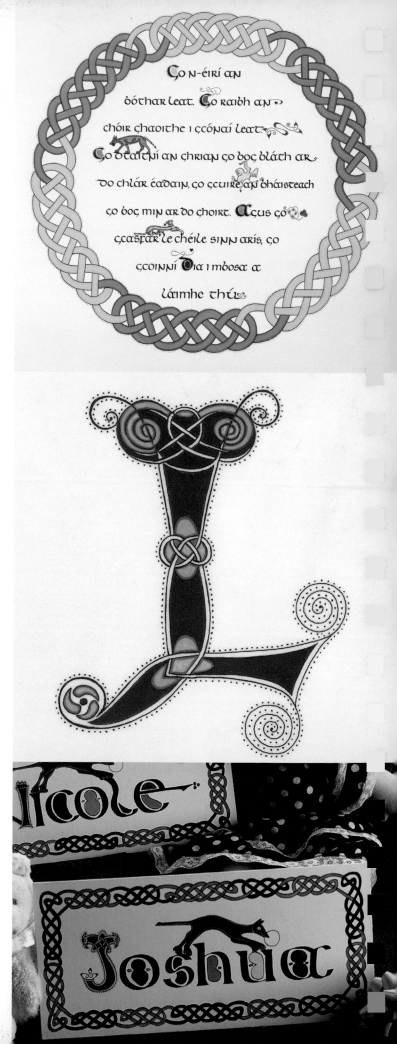

Ti amo.

I love you

Ich liebe dich

Je t'aime

Noel

FIDE ET AMORE
by faith and love

ET NUNC ET SEMPER
now and forever

Bonnes Vacances

Vacaciones

Holi

PENS AND NIBS

A wide variety of pens are used for calligraphy. The most ancient ones are bamboo and reed pens, which have changed little in the last 2,000 years. Later, dip-in pens appeared with interchangeable nibs ranging in size from the very thinnest, designed for Copperplate text, to chisel heads, for Black Gothic script. Modern additions are gel and fiber-tip pens. All are great for calligraphy.

Quill pens, cut from the flight feathers of a large bird, such as a swan or goose, have been used for centuries. They have a flexible nib, which gives them a natural feel and makes them wonderful to use.

Dip-in pens come in various shapes and sizes and are very versatile. They comprise a plastic or wooden pen holder, to which can be fitted a wide range of detachable steel nibs. Popular types include steel multi-line nibs, broad poster nibs, and Copperplate nibs. The choice of ink used with this type of pen is important to ensure they write evenly and smoothly without blobbing.

Nibs All nibs here are William Mitchell roundhand. They range from size "6," at 0.5 mm the smallest, to size "0," at 4 mm the largest. See the conversion table on page 224, which shows equivalents from other popular manufacturers. The small brass reservoirs are clipped to the underside of some types of nibs to hold the ink.

Felt-tip pens have fiber nibs and can be flat-edged for calligraphy. Some are double-ended, with different widths at either end. Fiber nibs are easy for beginners to use as you do not have to work with ink. But they lack the sharpness and precision of a steel-nibbed pen.

Ink Use bottled Fount India Ink. This should not be confused with "Indian Ink," which is not suitable for use with steel pens as it clogs the nib.

Other types of pens:
Bamboo and **reed pens** are cut and shaped at one end to form a point or a chisel nib. These have little flexibility when writing, but work well on various types of paper and fabric.

Fountain pens have a refillable reservoir and nibs of all shapes and sizes, including flat, chisel-edged ones ideal for calligraphy. **Cartridge pens** use handy ink cartridges, but the ink can be thin and watery.

TYPES OF PAPER AND OTHER WRITING MEDIA

Paper and other forms of writing surface come in every conceivable size, thickness, weight, texture, and color. Their history is as long and varied as the pens used to write on them. The most ancient medium is papyrus, which is hugely resilient but can be very difficult to use. Other types of material include vellum and parchment. These are made from animal skins and, for the novice calligrapher, can be just as tricky as papyrus.

Vegetable parchment paper is available in a variety of weights and colors. It can have a slightly uneven texture that can enhance a piece of calligraphy.

White cartridge paper is a good type to use when beginning calligraphy. You can buy it in what is called an "art block" of 10 or 20 sheets. Always buy paper of good quality and thickness. If the paper is poor quality and is too thin, it will ripple when ink is applied to the surface.

Handmade paper can be a little more expensive to buy than machine-made paper but it is ideal for special pieces of work. It comes in many sizes, colors, and textures and usually has a watermark.

Goatskin parchment paper is available in two weights—90 and 120 gsm. This type of material is known as "hot pressed," a process that gives it a smooth surface and takes ink very well, and so it is a good choice for calligraphy.

Parchment is made from sheepskin, which is a naturally smooth hide that is still used today for many important documents. Most suppliers do not carry real parchment, but rather parchment paper, which is a suitable substitute. Sheepskin parchment can, however, be special ordered at most retailers.

Papyrus is made from a reed plant that grows in Africa. Unlike paper, it is not smooth but has a cross pattern on the surface running lengthwise and widthwise, which gives it a coarse texture. The split reed stems are flattened and pressed one on top of each other, with the layers arranged at right angles. Reed or bamboo pens work well on papyrus.

Machine-made paper comes in a multitude of colors and textures and is available at most art stores.

Watercolor paper gives an elegant look to calligraphy and color work. It has a rough texture that gives an attractive background for a free-flowing script.

COLORS, INKS, AND PAINTS

Other media, including pencils and color, can add a depth of beauty to calligraphy work.
Pencil is especially useful when practicing. Colors add weight and strength to a piece
and can be applied with a pen nib or painted on using a chisel-headed brush.
Pigment, gouache, and watercolor all produce their own special effects.

Pencils come in a wide range of hardnesses. The softest are used in practice as they can be easily erased while the hardest are useful for transferring traced designs.

Small brushes are available in a variety of materials, ranging from synthetic hair to the finest Kolinski sable brushes. The best sizes to use are 000 to size 1. These have fine points, which makes them ideal for artwork such as Roman Capitals and illuminated (decorated) letters, and for painting fine lines and filling in hollow pencil-drawn letters.

Double pencils are the ideal way to begin practicing calligraphy. They replicate the movement of a nib to show a script's form.

Chisel-edged brushes work well for calligraphy on fabric, wood, and thick paper or card.

Poster color, also called tempra, can be used in a similar way to gouache, but does not produce such a professional finish.

Pigment powders give a professional finish. They are in strong, vibrant colors and, unlike modern paint and inks, will not eat into paper or vellum. This means they will last for hundreds of years.

Inks come in many shades, ranging from jet black to a translucent or pearly finish. Chinese Black ink is extremely dense and so is ideal for most forms of calligraphy work.

Gouache color paints come in all colors and even metallic shades, such as gold, silver, and bronze. They produce strong colors that are ideal for design and especially for illuminated letterwork.

MASTERING FOUNDATION SKILLS

Anatomy of a letter

All the strokes that make up the different parts of lowercase letters, and even some of the letters themselves, are given their own special names in calligraphy. Examples of the different types are shown on the right. They have all been written on lines using 7 pen-widths measurement.

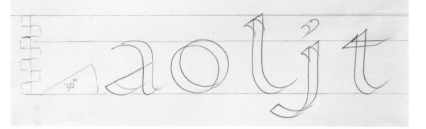

• The lowercase letter "a" has a **curved** stroke at the top and bottom and a **diagonal** stroke in the middle. The rounded part of the letter "o" is called the **bowl**.
• Tall, **upright** letters, such as "l" shown here, that go above the line are called **ascenders**. The letter "l" also has a short decorative stroke at the top, called a **serif**.
• Letters such as "j" and "p" that go below the line are called **descenders**.
• The letter "t" has a short horizontal line called a **crossbar**.

Anatomy of a numeral

The same terms are also applied to the strokes that make up numerals. Examples are shown on the right, again using a measurement of 7 pen-widths between the lines.

• Number 1 is an **upright** stroke with a **serif** at the top.
• Numbers 2, 3, 4, and 7 have **diagonal** lines.
• Numbers 6, 8, 9, and 0 have a **bowl**.
• Number 4 has a **crossbar**.
• Numbers 2, 3, 5, 6, and 9 have **curved** stokes.

As with lowercase letters, some numbers can be written above or below the line, depending on the type of script you are using. This can be a difficult technique to master.

Holding the pen

Try to relax your arm and shoulder when holding the pen. Right-handed writers should keep the pen in an upright position between the thumb and first finger, but with the first finger a little further down toward the nib. This will give you better control of the pen. The same applies to left-handed writers, except you may need to angle your paper to the right a little, instead of keeping it straight, to help you see the writing.

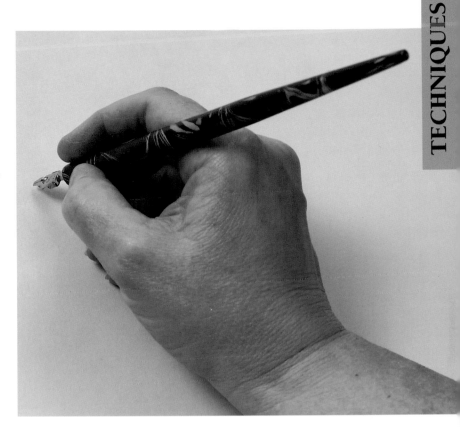

The writing position

It is important to have a writing slope. You cannot write with a calligraphy pen just working "flat" on a table, as you need to get the ink flowing at the right speed. Writing "flat" causes the ink to flow out of the pen too quickly. The angle of your drafting table can vary according to what you find a comfortable writing position.

A professional drafting table is a useful piece of equipment to own if you plan to spend time doing calligraphy. These can be bought from specialized art shops. Some are floor standing. Smaller ones sit on the table top. These drafting tables can be raised or lowered to different writing heights. They usually have a ruler attached at each side that can move up and down the board, which is very helpful when ruling up. However, they can be expensive.

An inexpensive option is simply to sit at a desk or table and place the bottom edge of a drawing board on your lap with the board itself against the edge of the table.

Another way to create a writing slope is to place some heavy books on the table and prop the board up against them. You can vary the height of the board according to the number and thickness of the books you use.

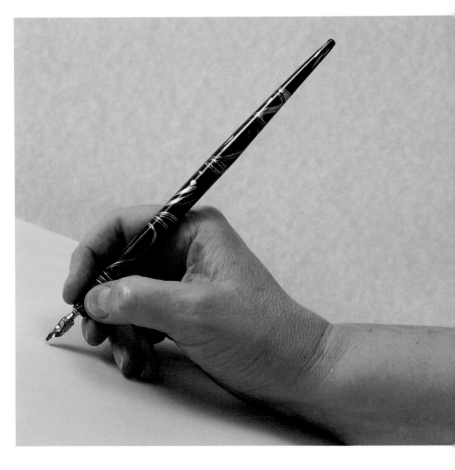

LOADING THE PEN NIB

Ink

When using ink from a bottle, dip the nib into the liquid until the ink has gone over the brass reservoir about two-thirds of the way down. This allows the ink to flow under the nib, to load it.

If you feel too much ink has been loaded you can take off the excess against the neck of the bottle.

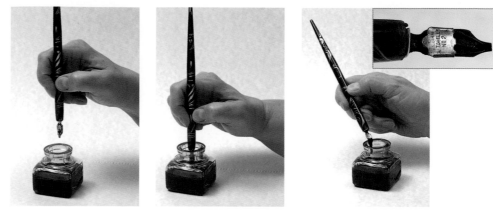

Gouache colors

Loading a pen with gouache uses a different technique. First, squeeze some gouache color from the tube onto a palette. Add a little water and a drop of gum Arabic and mix to a watery consistency. You will need to try some practice strokes of the pen to get the mixture right.

Dip a size 3 or 4 brush into the gouache to load it. Hold the pen in your left hand with the reservoir uppermost, so you can see it, and stroke over the reservoir with the brush to transfer the gouache onto the nib. Scrape off any excess gouache against the side of the palette.

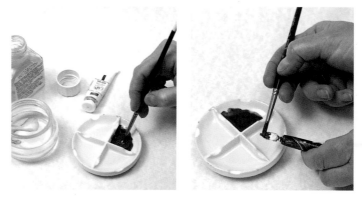

WRITING ANGLES AND PEN-WIDTHS

Writing angles

The angle at which you hold the pen nib against the paper depends on the script style you are writing.

For Foundation hand the angle of the nib to the top guideline for the writing is 30° (see below). This angle can make the letters fatter or thinner depending on the direction the pen is moving.

Uncial or Half-uncial script is written at as flat an angle as possible: ideally 20°. Many people find writing at such a flat angle difficult, however, and prefer to keep to 30°.

For Italic script you should use an angle of 45°. Gothic script is written at an angle of 30–35°. For Copperplate you should use an angle of 30°.

Placing the nib at an angle to the paper creates the thick and thin strokes that makes calligraphy script distinctive.

Pen-widths

The pen-widths used to determine the height of a letter also vary according to the nib being used and the script you are writing.

For Gothic writing, the pen-widths are 7 for capital letters and 5 for lowercase letters.

Italic writing has letters written at $7^1/_2$ pen-widths for capitals and 5 pen-widths for lowercase letters.

Uncials are written at between 4 and 5 pen-widths. These letters do not have capital letters as such, so the script is written between two lines only. This will be explained later on in the Uncial section (see pages 72–77).

The angle of the nib varies according to the type of script you are writing and ranges from 20° to 45°.

Practice strokes with double pencils

Once you have mastered the basic pencil technique, you can practice writing letters. Start by drawing a practice stave. Draw a line across the top of the paper. Measure down 10 in. (25.5 cm) and draw a line parallel to the first. Draw a line down the left side of your paper, measure 8 in. (20 cm) across and draw a second line parallel to this one.

Mark down your paper in pencil on the left side, as on page 25, and rule guidelines across the whole sheet.

Fasten your two pencils together using an elastic band. To make sure the points are level, hold the pencils upright and gently press the points down onto a flat surface.

Now you can practice the strokes shown in the examples below. As you practice keep the pencil points level and together, always maintaining the angle of 30°.

Practice writing just one letter for a few lines. Once you feel you are starting to master it, practice the next letter.

You will probably find that curves are a little more difficult to write than straight lines, but with patience and plenty of practice you will find they get much easier.

The more practice you put in at this stage, the easier you will find it when we come to write whole words and sentences in pencil, and later in ink.

Try writing these simple curved strokes using double pencils.

Practice strokes with a brush

As an alternative to using pens, you can use brushes to paint calligraphy script. You use different sizes of brush according to the style you are writing: either wide brushes to create large flowing letters or small brushes for painting fine lines and textures, and for other detailed work.

It is a good idea to have a selection of good-quality brushes in your work box. If you look after them they should last for years. Sizes 4, 3, 2, 1, 0, 00, and 000 are very useful for most tasks.

The wide chisel-edged brush is used for very large letters and for writing a free style such as Italic script. For example, a ¼ in. (6 mm) chisel-edged brush made of ox hair is ideal as it is very soft and flexible to use. It can be used for writing posters, perhaps using gouache color, or

writing decorative script on fabrics, using special fabric paints. Try some practice strokes using the examples below before attempting complete letters. You use exactly the same grip for holding a brush as you would for a pen.

Then there are the fine brushes for intricate work. Brushes made of synthetic materials, such as nylon, are inexpensive and are good for mixing gouache color and for applying color to the nib.

Kolinski sable hair brushes are the most expensive, but are of great quality. They are lovely to use for fine work on illumination or when you need a fine line, for example when painting Versal-style Roman letters. Try practicing the brushstrokes in the example below to help you learn how to control the brush for fine work.

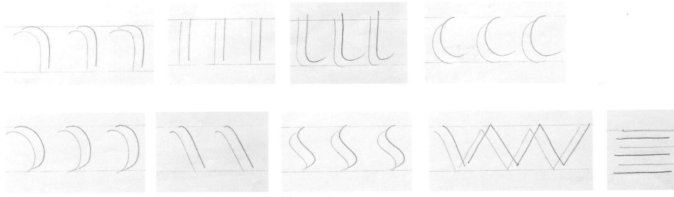

Start by practicing simple curves, taking care to show a clear distinction between the thick and thin sections of each stroke.

Now build up letters using these few strokes with variations.

Practice strokes with pen and ink

After you have mastered the basic pen technique, you can try letters. As before start by creating a practice stave. Draw horizontal lines 10 in. (25.5 cm) apart and vertical lines 8 in. (20 cm) apart. Measure all the way down the paper on the left-hand side and rule guidelines across. In the example below, the practice strokes are written with a Speedball size C2 nib (see page 224 for equivalents).

Practice these shapes, which make up the letterforms of the Foundation hand—also known as the Roundhand script—until you feel confident with the pen. The more you practice the more confidence you will gain at forming the shapes.

Make sure the pen is held at a 30° angle to the paper and that your writing sits neatly on and between the lines.

Try to keep the pen high in your hand—taking care not to let it slip down—and aim to maintain an even pressure on the paper. The curved strokes are the hardest to do. Try to make them nice and round.

These are the basic straight-line strokes that make up a simple capital letter "A."

Combine the straight lines with a combination of curves to make up the capital letter "B."

Letters like the capital "C," which are made up mainly of curves, need more practice to master.

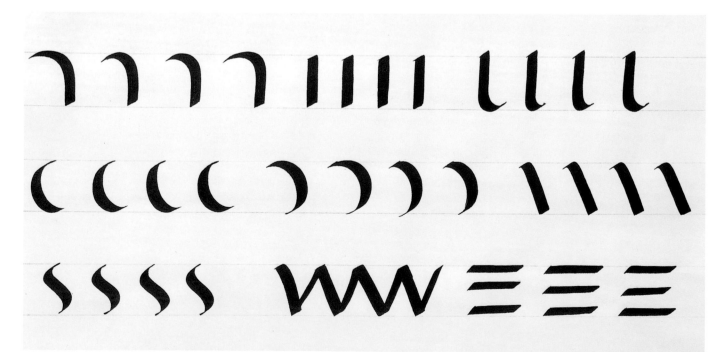

Keep the angle of the pen constant to achieve good Roundhand strokes with a thick nib.

CREATING A LETTER STAVE

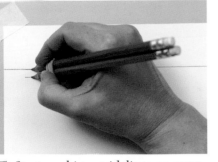

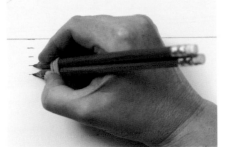

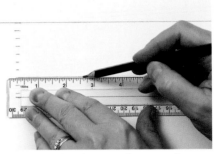

1 Start marking guidelines on your paper by ruling a line 1¹⁄₈ in. (3 cm) from the top of the paper. Now place the double pencils with the top point resting on this top line, ready to mark down the left side.

2 Now mark in pencil-widths down the paper. Here we are using 7 pencil-widths for capital (large or uppercase) letters and 4¹⁄₂ pencil-widths for lowercase (small) letters.

3 Rule a line across the page from the bottom pencil mark. This line is called the baseline.

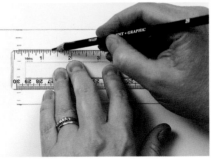

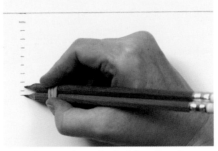

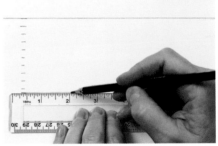

4 Count up 4¹⁄₂ pencil-widths from the baseline for the lowercase letters. Draw a line across from that mark. This is the x-line, the top line of the lowercase letters. The space between these lines is known as the x-height of a letter.

5 The top line (ruled first) is for capital letters and also for the lowercase ascender letters such as "d," "b," and "l." For the descender letters, such as "g" and "j," mark 3 pencil-widths below the baseline.

6 Now rule the bottom line. You should now have four ruled lines across your paper. When you become experienced at writing, this bottom line (for descenders) can be omitted.

top line

x-line

baseline

bottom line

7 Now use a protractor to draw an angle of 30° to your baseline. As you write, you should keep checking against this line to ensure your double pencils are at the right angle. After you have practiced you will be able to keep this angle automatically.

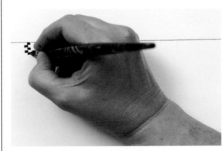

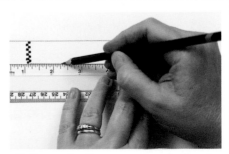

1 To rule up in ink, the pen is put at right angles to the paper and drawn sideways in steps, as shown.

2 Draw the lines across as before in pencil—not ink, so that they can be erased at the end of the project.

PREPARING TEXT FOR LAYOUT AND PLACING BORDERS

Layouts

When you start ruling up it is important to mark guidelines and measurements using a soft 2B pencil. Make sure you press lightly on to the paper, as you will want to rub out the lines after applying the ink—you do not want them to show on the finished work. There are many ways of laying out your writing on a page, including the six examples shown here.

The easiest way is to work to a left-hand margin. To do this, first rule a line down the left-hand side of your paper. This line marks your margin, which could be 1–2 in. (2.5–5 cm) from the edge of the paper, for example. Working down this margin line, mark three or, if needed, four guidelines for each line of writing. Rule these lines—your baseline, x-line, top line and, if needed, bottom line—across the page (see Creating a Letter Stave on page 25 for complete details on how to mark and rule guidelines).

Another interesting design is to stagger your work, which means one line starts at the left margin, the next line starts, for example, 2 in. (5 cm) in from the margin, then the next one at the margin again, and the following line indented as before, and so on down the page.

Using a simple left-hand margin leaves room for an eye-catching motif.

Staggered designs can be decorated with motifs and illuminated letters.

For a different look you can center your lines of writing. Start by writing out your lines on a rough piece of paper. Now, measure each line in turn and halve the measurements. Draw

Centered layouts work best for short, memorable pieces of verse, quotations, or sayings.

a center line down the middle of your final draft. Mark where each writing line will be placed and then work down the paper, transferring the measurements you made and putting a pencil mark to show where each line of writing will start and finish.

Once you have pencilled in the marks, it is a good idea to write out your lines again in pencil, just to see how they will look, before attempting the final draft. This can be a difficult procedure to get right, but it creates a very attractive design to work with.

Circular writing also looks good and makes a change from the standard straight layouts, although you should bear in mind that it can be difficult to read those words that appear upside down.

Spiral layouts are complex but also more interesting to look at. This layout works especially well with Uncial scripts.

You can also write freehand where no guidelines are used on the page. Patterns can be made by using the letters as designs. Some modern calligraphy is written this way, but it takes an experienced hand to write like this.

Spiral writing needs a lot of planning, but the result is well worth it.

Circular writing works best around a central motif to draw the eye.

Another technique is to cut out each line of text, arrange it on the page, and then stick it down, once you have it correct. This method is often known as "paste-up."

If you try this with rough paper to start with it will give you a good indication of where your writing will begin and end and allow you to make changes. You'll also be able to see what the finished work will look like.

Free-hand layouts allow calligraphers much more freedom of expression.

Placing borders

Adding a border to your writing will enhance the whole page, especially if you are using color. There are many types of borders, from simple corner motifs, to margin decorations, to borders that go all the way around the page.

To start, place tracing paper over your writing page and attach it to the corners using masking tape. Decide what type of border you think looks best for your piece of work, then measure the space where the border will start. Draw two lines on the tracing paper for the border to fit into, allowing you to sketch the pattern directly onto the tracing paper. Now draw your design. Remove the tracing, turn it over and rub lightly on the back with the side of a soft 2B pencil. Now turn the tracing over again, attach it once more and, using a hard H pencil, draw over your pattern to transfer carbon to the paper below. This is called "carbonizing." When you have finished, remove the tracing.

Now that you can see your design on the paper, you may need to draw over what you have traced to make it clearer. Use a light touch with a soft pencil. You can then ink it in, using a pen or a brush. You might like to add color to the design, or outline the pattern with a fine-line black pen.

With some designs you may need to draw the borders and other pieces of decoration first, and then write the text afterward.

More elaborate designs will need lots of planning. Write the text in pencil first and measure each line, so that you know how much space to allow.

COMMON MISTAKES, TIPS, AND PROBLEM SOLVING

Two examples of the word "pascal" have been written to show the difference between good and bad spacing.

The first figure shows:
• There is too much space between the "p" and the "a," and between the "a" and the "l."
• The letters "a" and "s," and "c" and "a" are too close.

• Most letters need to have even spacing—but there are exceptions to this rule. For example, when writing "t" and "r" or "a" together, you can write them with less space between.

The second figure below shows how the word should be written with even spacing.

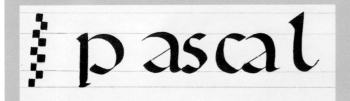

Uneven spacing between the letters.

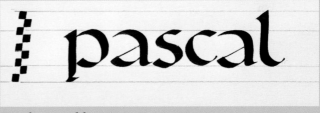

Evenly spaced lettering.

CHAPTER 1: CAROLINGIAN

This script is often called Roundhand because it is a round script with open spacing, which makes it easy to read. It is also known as Foundation hand because it is the script taught first to students. The double-pencil practice method shown here allows you to see how to construct the letters, and where you start and finish each letter.

DOUBLE-PENCIL MINUSCULE

Writing with two pencils allows you to create a much larger letter, and it is much easier to see which letters in the alphabet go above and below the ascender and descender stroke lines.

You will find using a pencil to start with a great help to your writing. Most importantly, using two pencils allows you to practice how to keep to the correct writing angle, which varies according to the script you are writing. Carolingian script is always at 30°. Here we are starting with the lowercase letters—known as "minuscule."

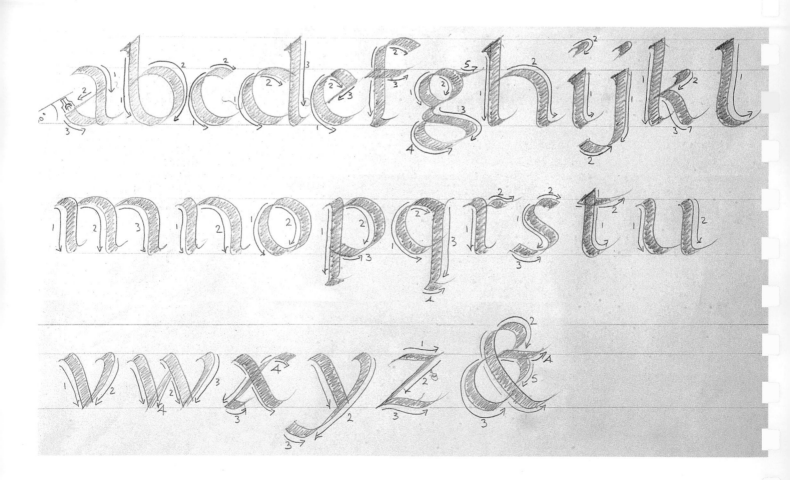

Follow the sequence of strokes indicated by the arrows to write each letter.

How to start using two pencils

You may ask why do we start learning calligraphy with double pencils? There are several good reasons for this. First, it helps the student see the formation of the letters— to look through them, if you like—and see how they are made. Double-pencil work also helps you to keep the angle of the writing correct and lets you see where you start and finish each letter. You can also see your mistakes more easily.

Writing with two pencils also allows you to draw a much larger letter. The largest letter that can be written with a steel nib is still much smaller than one you can achieve by using double pencils. This method also shows in easy steps which strokes go above the x-line (ascenders) and which go below the baseline (descenders).

You may find it easier to fasten the two pencils together using an elastic band.

The fact that you are not using a pen at the start and so do not have to concern yourself with using ink is a great help, as this allows you to concentrate on the letterforms. Ink can be hard to control with a steel nib when you begin calligraphy work.

Later you will discover that the skill of using the pen is in applying the right pressure. If you press too hard, the steel nib may open and allow too much ink to flow down the nib onto the paper. This can result in blobs on the letters, and the letters can become too fat. If you do not apply enough pressure then too little (or no) ink flows onto the paper, which can be a frustrating start.

Ruling up

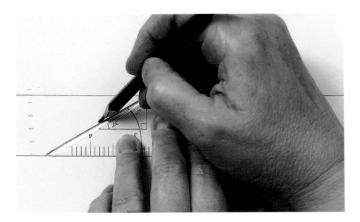

Make sure your writing position is correct. Keep your feet flat on the floor and your back straight.

After drawing a top line across the paper, hold your double pencils in an upright position on the left-hand side of the paper. Now touch the pencils onto the paper leaving a small pencil line. Mark down the side of the paper in this way to give 7 pencil-widths and draw a baseline. Now measure 4½ pencil-widths and draw another line along

your paper. This gives you your x-height for the main body of this lowercase script and for starting the letter "o."

Carolingian script is always written at 30°. Use a triangle (above) or a protractor to draw an angle of 30° on your baseline. Place both pencils at the top of the 30° line to find the correct writing angle. As you write remember to keep checking that the angle is correct. Now start writing the letter "o" (below).

Writing the letter "o"

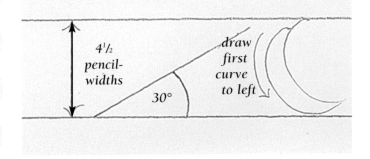

Keeping your pencils at the 30° angle, place the uppermost pencil on the x-line (the top line at left) and draw a curve to the left side and down to the baseline and stop.

Go back to the top of the stroke, where you started from before and, again keeping the 30° angle, draw a curve to the right side, down to meet the bottom of the "o."

To ensure that a script is even, you must keep all the thick downstrokes slanted consistently at the correct angle for that script. Try to give the letter a nice round shape. Repeat writing this letter to the end of the line. Practice this until you have written five lines of the letter "o."

Construction of the letter "w"

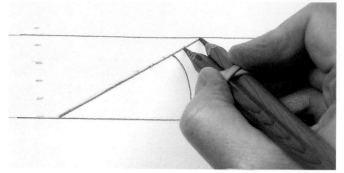

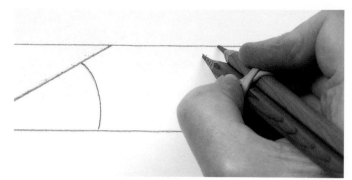

1 Create a stave (see page 25) for lowercase letters and use a triangle or protractor to draw in the 30° marker for the pencil angle.

2 Place the double pencils on the page at the angle shown in the stave and with the upper pencil touching the x-line.

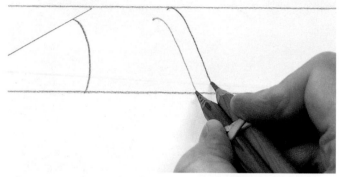

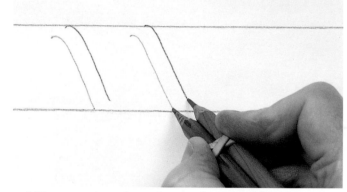

3 Keeping the angle of the pencils constant, sweep them slightly to the right and then bring them down until the lower pencil touches the baseline.

4 The second stroke replicates the first. Take care to leave the correct spacing so that the joining stroke is neither too steep, nor too flat.

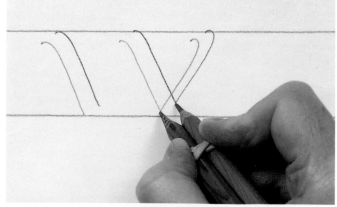

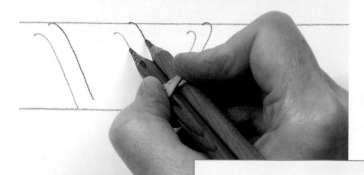

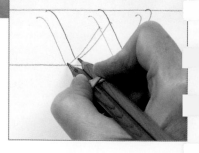

5 Make the outer stroke next. Start from the same position but curve the pencils sharply to bring them back to the base of the second stroke.

6 Make the final stroke at the same angle. Place the pencils on the existing lines and bring them down until they both sit on the lines from the first stroke.

Construction of the letter "g"

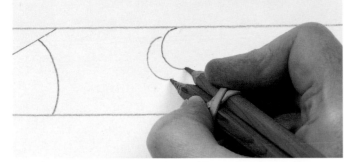 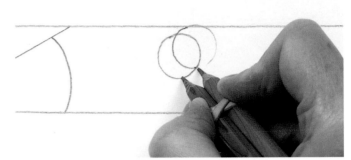

1 The "g" is a more complicated letter, made up of curves. Start with the top pencil on the x-line and sweep the pencils around, finishing in the middle of the stave.

2 Take the pencils back to the starting point and bring them around to the right to join up with the first stroke.

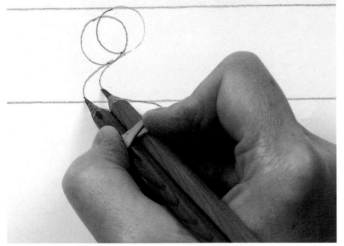 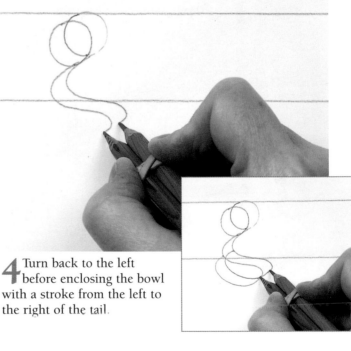

3 Begin the tail of the letter at the finishing point, and sweep the pencils left and then right along the baseline.

4 Turn back to the left before enclosing the bowl with a stroke from the left to the right of the tail.

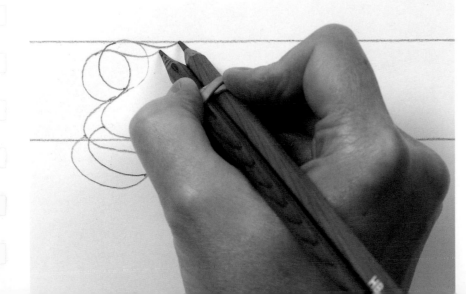

5 To make the final tail at the top of the letter, place the pencils back at the very beginning point and sweep them to the right along the x-line.

Construction of the letter "s"

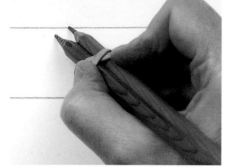

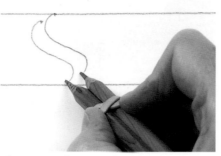

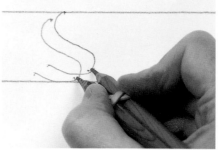

1 The "s" is made up of mirrored curves. Start the main body of the letter in the same place, with the upper pencil on the x-line.

2 Sweep the pencils down to the left, across to the right, and back to the left until the lower pencil sits on the baseline.

3 Make the bottom of the letter by bringing the pencils back to meet the end of the previous stroke.

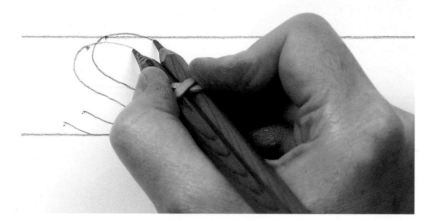

4 Finish the letter at the top by placing the pencils back at the start point and sweeping them to the right. You can enclose the ends with a tick from a single pencil.

Construction of the letter "j"

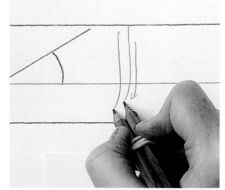

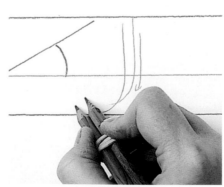

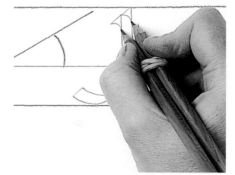

1 Check your writing position is correct. Keep the pencils at 30° and start at the x-line, as before. The "j" has three strokes. Write the first stroke by pulling down, stopping just above the bottom line.

2 Follow the directions of the arrows to complete the second stroke. Return to the top of the first stroke, again finding the 30° angle with pencils to the x-line, and draw to the right to join the first stroke.

3 Return to the top of the letter and find the angle. Now draw the serif, pulling slightly to the right, before joining the main body of the "j."

Construction of the letter "o"

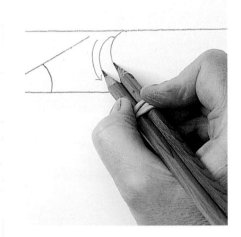

1 Keep pulling the pencils toward the baseline, and finish the curve by drawing the remainder down toward the right. Pull the pencils off as soon as you reach the baseline to complete the first stroke. The "o" has two strokes.

2 Return to the top of the stroke, and again find the 30° angle with pencils to the x-line. Now draw a curve downward to the right side, moving left, and coming off the paper as you cross the baseline. Practice the "o" five times.

COMMON MISTAKES, TIPS AND PROBLEM SOLVING

A common mistake when starting with this Foundation hand is in making the round letters too narrow. They need to be wide and rounded. The letters "b," "c," "d," "e," "g," "p," and "q" are all based on the letter "o."

• The letters "h," "m," "n," and "u" are also written with wide spaces between the strokes.

• Beginners also tend to not leave enough space between the downward strokes.

• Another common mistake when starting to form the letters is failing to keep the 30° angle. Keep checking the angle as you write. After writing a few letters, go back to the 30° angle diagram on your paper. Place the pencils on the angle line. Keeping the right angle of the pencil (and pen) is one of the hardest things to master.

• Changing the angle to form some of the strokes in the letters takes a bit of practice too. These changes occur in the letters "a," "f," "t," "v," "w," "x," "y," and "z." You will need to flatten the angle to draw them correctly. If you do not change the nib angle these strokes will look too fat and you will not have the right weight of letter.

• The curve of the "s" can also be difficult. Try writing lots of "s" practice strokes without the top and bottom curves. The practice stroke page really does help you with the formation of all the letters.

• Try to keep your concentration on the example of the lowercase letters when you are copying the alphabet. Study how the different strokes make up each letter. Look at the directional arrows, too, so that you know the order in which to draw the strokes.

• Keep even spacing between upright strokes like those in the "h," "m," "n," and "u." A common mistake is to allow too little—or too much—space between them.

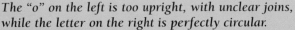

The "o" on the left is too upright, with unclear joins, while the letter on the right is perfectly circular.

The "d" on the left has been drawn with badly angled pencils, giving unclear crossovers and joins.

DOUBLE-PENCIL MAJUSCULE

The double-pencil method is a good way to practice the Carolingian majuscule, or capital, letters. These are slightly different to construct than the lowercase letters and a little more difficult to draw, but the same basic principles apply as before.

Carolingian majuscule letters are based on 7 pencil-widths between the ruling lines. As with the minuscule, or lowercase, letters it is easier to understand how the letters are constructed when using double pencils, which is an important advantage at this early stage.

The only letters formed with curved strokes are "B," "C," "D," "G," "O," and "Q." These are wide, round letters.

Remember to sweep the pen nib around with even pressure. All the rest of the letters are formed with straight-line strokes. The letter "M" is the most difficult letter to construct, as it is made up of five different strokes.

You still need to keep the 30° angle when writing the capital letters. This gives you the right weight of the letter stroke.

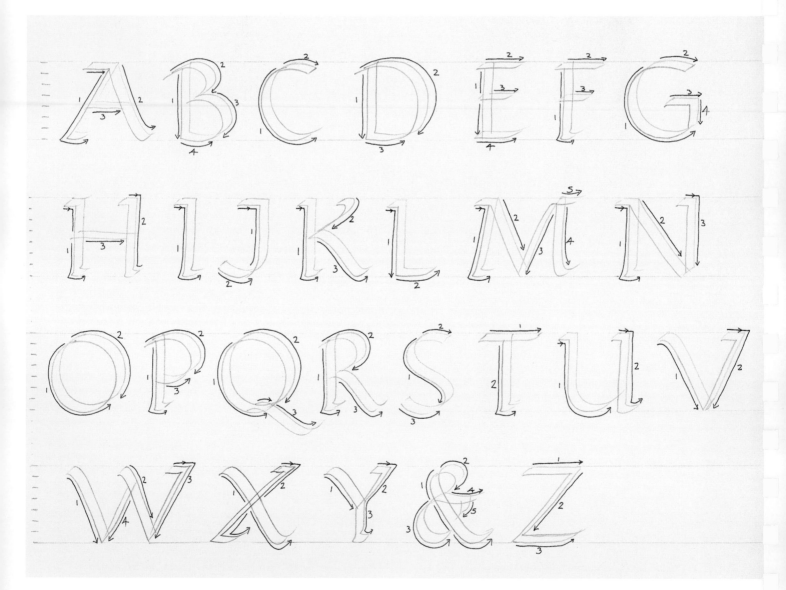

Use the stroke sequence arrows to complete the alphabet.

Construction of the letter "A"

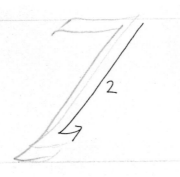

1 Begin the capital with the serif running along the top line. It acts as a marker for the rest of the letter.

2 Keeping the pencils at a steady angle, come down to the left and give a flick to the right for the foot.

3 From the same point, come down to the right. Keeping the pencils at the same angle ensures this stroke is thicker. End with a flick up.

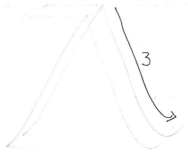

4 Finish by adding the crossbar, moving the pencils from the outer edge of the left-hand stroke to the far right of the right-hand stroke.

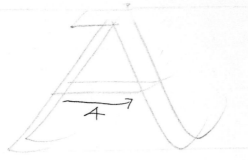

Construction of the letter "M"

1 Repeat the first stroke of the "A" at a slightly less steep angle.

2 Follow by bringing the pencils down from the very top line, but leaving the base open to be joined.

3 Allow the third stroke to have slightly more movement and flow than the first.

4 The right-hand stroke is more vertical than the second and ends in a slight flick to the right.

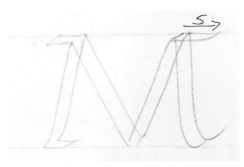

5 Finish with a straight serif along the top line.

Difficult majuscules

The majuscule letter is more difficult to draw than the minuscule, both because of its size and because it is made up of lots of straight lines. It can be difficult to keep the pen controlled and ensure that the form of the letter does not become uneven. The examples given on these pages show the most problematic majuscule letters to draw.

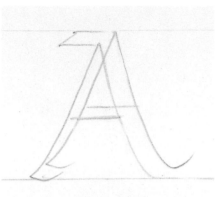

The "A" has two diagonal strokes that need to be spaced correctly: not too narrow, but not too wide either.

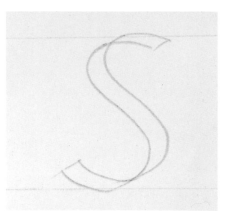

Practice the body of the "S" several times before trying to complete the letter. The second and third strokes can be over the topline and below the baseline.

"E" and "F" are both made up completely of straight lines.

Flatten the angles of the horizontal strokes, reducing their weight, so that they do not look too heavy.

"W" is made up of four strokes. The two diagonals to the left are narrower than the others. The angle is slightly flattened.

"M" is the most difficult letter to write as it is made up of five strokes and the stroke angle changes several times in the course of construction, with the first and fourth strokes ending with an outward move.

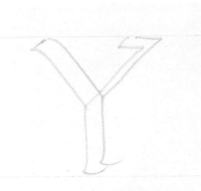

"X," "Y," and "Z" are all constructed in the same way from a mixture of straight strokes. The diagonal stroke to the left of the "X" has a flattened

angle, as does the second diagonal stroke of the letter "Y." With the "Z," all the angles must be written with a

flattened angled pen, otherwise it will look too heavy on the top and bottom strokes.

COMMON MISTAKES, TIPS, AND PROBLEM SOLVING

• The majuscule Carolingian alphabet is more tricky than the lowercase version as the letters contain more strokes, requiring a steady hand and unhurried movement. Keeping the pen controlled is the absolute key.
• If you do not write with confidence, the letters tend to wobble as you write the downstrokes, and the bowls of the letters become uneven, requiring various angles to ensure they meet at the correct point, rather than keeping the lines straight.

• Problems can also occur when writing the round letters. The most common mistake when starting out is not making the bowls of the letters rounded enough. In the letter "B," for example, the bowls of the letter (the second and third strokes) need to be very rounded, but most beginners compromise on these strokes by making them too narrow, giving the letter a rectangular appearance that doesn't fit the bold roundedness required of the hand.

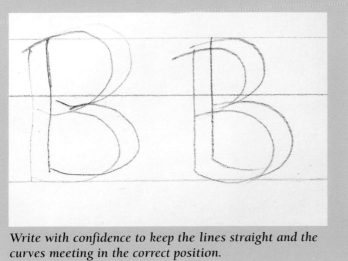

Write with confidence to keep the lines straight and the curves meeting in the correct position.

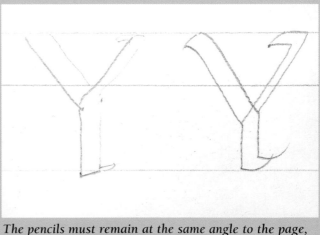

The pencils must remain at the same angle to the page, whatever the direction of the stroke, to retain evenness.

DOUBLE-PENCIL NUMERALS

Writing numerals is no different from writing letters in roundhand. Use the full height of the stave, noting which numerals dip a little below the baseline. Ensure the lines that make up straight strokes are parallel, and draw curved strokes with a fully rounded sweep.

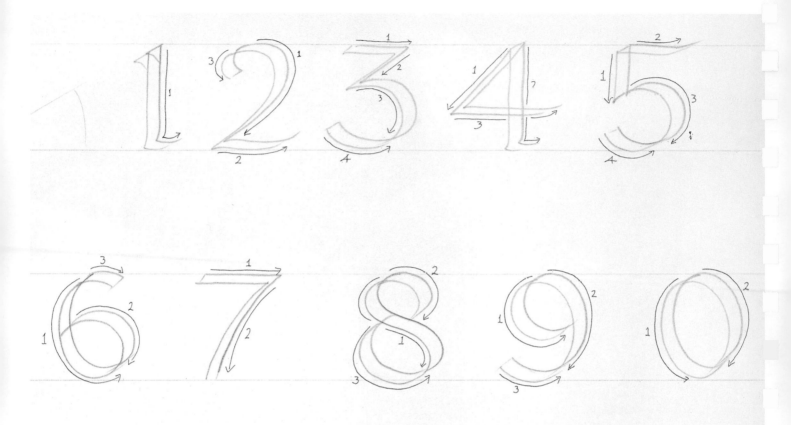

Use the stroke sequence arrows to complete the set.

Writing a year date

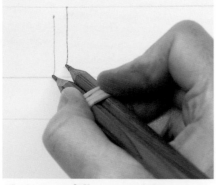

1 Create a full stave and draw in the angle, if required. Start the "1" with a crisp vertical stroke.

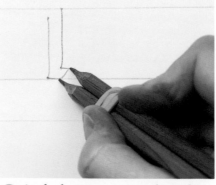

2 At the bottom, turn to the right to give the numeral its foot, and enclose the stroke with a tick.

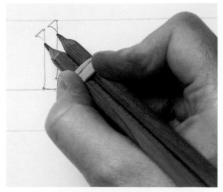

3 Place the pencils back at the starting position and draw two little triangles to form the serif.

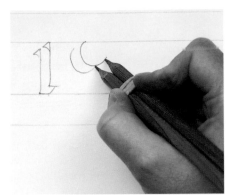

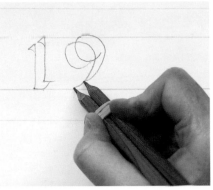

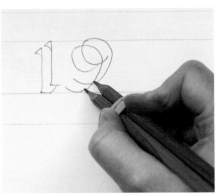

4 The "9" starts at the top line, with a tight, counterclockwise curve.

5 Return to the start to make the main body of the numeral.

6 Finish by bringing the tail of the "9" back to the bottom of the numeral.

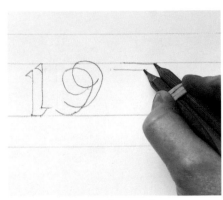

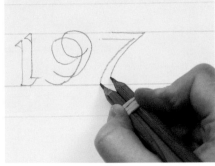

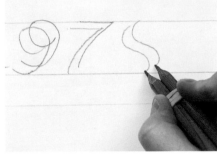

7 The "7" is made up of two strokes, the first running directly along the top line.

8 Bring the tail down in a long sweep that opens out toward the base of the "7."

9 Start the "8" like an exaggerated "S"—with the top and bottom openings near the vertical.

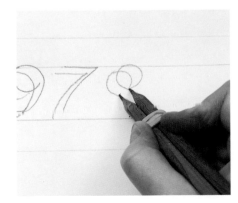

10 Enclose the top bowl as before, bringing the pencils down to the first stroke.

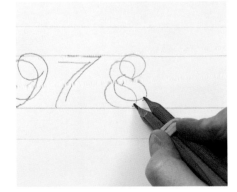

11 Finish by enclosing the bottom bowl, moving to the right from the first stroke to the bottom of the numeral.

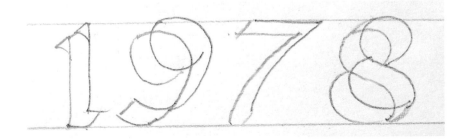

12 Finish the year date by enclosing the open ends with ticks from single pencils.

USING THE PEN: MINUSCULE

Once you feel you have gotten as far as you can using the double-pencil method, it is time to start to write the Carolingian script using pen and ink. It may take a little practice just to discover the right amount of pressure to use but you will soon get a feel for it.

Start with a Speedball size C1 nib (see page 224 for equivalents from other manufacturers). This is the largest and easiest to practice with. Using a pen can be difficult to master at first after writing with double pencils, as the letters are smaller and the ink is more difficult to control.

Place the reservoir just below the tip of the nib, up to ⅛ in. (3 mm) is fine. If it is too close to the end of the nib it may touch the paper when you start to write. If it is too far back then too much ink will flow down the nib and the letters will be too thick. Try the practice strokes first to learn how the letters are formed. When writing lowercase, try to keep the letters flowing with an even pressure. The letters should have a good rounded appearance.

Keep the nib at a 30° angle all the time. As you are moving the pen over the page to form the letters, the angle must remain constant. Keep checking throughout the writing of the alphabet. Make space between the upright strokes and keep them wide and even.

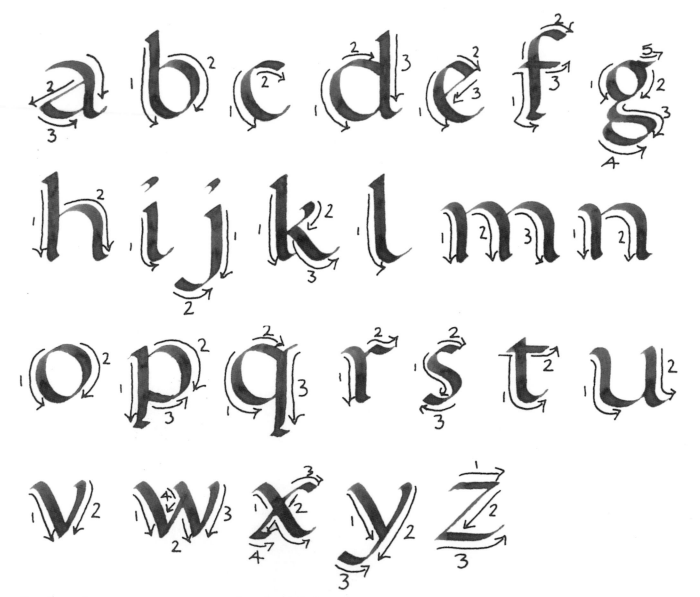

Use the stroke sequence arrows to complete the alphabet.

How to draw ascenders

1 For the letter "b," put the nib under the top line. Draw the pen down the paper in a straight line. Before the bottom, curve to the right in a wide stroke and stop.

2 Put the nib onto the stroke a little from the top. Draw the pen up and over into a curved stroke. Go down to meet the first bottom curve. This makes the bowl part of the letter.

3 To make the serif, put the nib on the top of the letter at a 30° angle. Go slightly to the left and then down to the right to meet the straight part again with a little movement.

1 For the letter "f," put the nib on the top line at a 30° angle. Draw down the paper to the baseline. Now go slightly to the left and then to the right, drawing the pen across on the line.

2 Put the nib back onto the top of the letter and, with a sweeping curve stroke, draw the nib to the right in an arc.

3 To make the long crossbar of the letter, put the nib to its left, just below the x-line. With a slightly flatter pen angle, draw the nib across, keeping it level to the right and stop just below the curved line of the "f" above.

How to draw descenders

1 For the letter "j," start at the x-line. Keeping the pen at a 30° angle, draw the pen down the paper. Keep an even pressure. Before the bottom line, curve a little to the left and stop.

2 Put the pen to the left and draw the nib to the right in a curve, to meet the first stroke.

3 Place the nib on the x-line and make the serif by going to the left slightly and then to the right in a diagonal stroke to meet the straight downward line.

4 To make the dot, place the nib on the paper above the top of the letter. Curve the nib to the right in an arc and then make a small curve to the left.

How to draw complicated letters

1 For the letter "q," put the pen on the x-line at a 30° angle and draw the nib around to the left in a curving stroke that touches the baseline and then sweeps up.

2 Go back to the starting point. In a curved stroke to the right, move the nib in a slight arc and stop.

3 Place the nib on the end of the previous stroke and draw the nib straight down to below the baseline to form a descender.

4 Put the nib on the end of this downward stroke and draw the nib across to the right to form the final serif line.

1 For the letter "g," put the pen on the x-line and draw the nib to the left to form a small curve two-thirds of the x-height, and then stop.

2 Move back to the top and curve the nib right and down to meet the bottom of the first stroke. This forms the small bowl in the shape of an "o."

3 Place the nib on the bottom left curved line. In an "s" curve below the baseline, draw the nib across to the right and then left and stop.

4 Now place the nib onto this "s" curve and sweep the nib to the right in a curved stroke to meet the third stroke. This forms a rectangular shape.

5 The last stroke is the small sideways serif stroke at the top. Place the nib at a 30° angle and draw the nib to the right a little just below the x-line. Stop.

1 For the letter "w," place the nib on the x-line. Keeping the pen at a 30° angle, sweep down diagonally to the right-hand side with a slight curve and stop at the baseline.

2 Repeat the first stroke, but spaced to the right a little.

3 The third stroke joins the second stroke. Angle the pen slightly flatter, put it on the x-line and move diagonally down to the left to meet the base of the second stroke.

4 To finish, place the nib a little way down on the middle stroke (drawn in step 2). Angle the nib flat again and draw down to meet the first stroke on the left at the bottom.

1 For the letter "m," put the nib on the x-line. Keeping the nib at a 30° angle, arc up a little, then curve down. Before reaching the baseline, go slightly to the right. Stop.

2 Put the nib on the stem of the first stroke. Curve to the right and down to the baseline, as in step 1. Finish with a slight curve to the right. Ensure there is a wide space between downstrokes.

3 For the third stroke, put the nib on the second stroke and curve right. Now go down to the base. Finish off with a slight curve to the right. Ensure there is equal space between all three downstrokes.

1 For the "s," put the nib on the x-line. Sweep down to the left, curve to the right, curve to the left again, and end at the base.

2 Now go to the top of the first stroke and curve to the right in an arc and stop.

3 Take the last stroke down to just above the baseline. Sweep to the right in a curve to meet the first stroke.

1 For the letter "x," put the pen on the x-line. With even pressure, draw a diagonal line to the right down to the baseline.

2 Put the pen on the x-line to the right of the first stroke. Turn the nib to the right to make a flatter angle. Draw down to left. Stop just above the line.

3 Place the nib on the baseline and draw it a short way to the right to make the serif,

4 To finish the letter, place the nib back on the x-line and curve the pen to the right in an arc stroke.

1 For the letter "z," start by putting the nib just below the x-line. Use a flatter angle otherwise it will look too heavy. Draw the nib to the right along the line keeping the pen straight.

2 Take the nib back to the x-line at the right side. Turn the nib slightly to the right and flatten the angle again. Draw a diagonal line to the left. Stop at the line.

3 From where the last line finished, place the nib on the paper and draw it across to the right, along the baseline. Stop.

PEN MAJUSCULE

Creating the Carolingian majuscule (or capital) letters requires even more practice. As with the double-pencil method (see pages 34–37), check that the angle of the pen remains at a constant 30°. Always write with confidence and remember that some of the letter strokes are written at strange angles. Keeping these angles correct ensures that the letters always have the right thickness and so will always have sufficient "weight" on the page.

When writing capital letters, make the curved letters rounded and open, especially "B," "C," "D," and "G." There are quite a few angle changes in letters of the majuscule alphabet, particularly the "V," "W," "X," "Y," and "Z." You use the same basic techniques you practiced when writing lowercase letters with a pen (see pages 40–43).

Try some practice strokes using your largest nib (refer to page 224 for nib sizing). Look at the arrow sequences shown on the letters below to help you follow the right direction of the pen when forming the letters. Always pull the pen—if you find yourself pushing you will probably smudge the ink and can even break your nib.

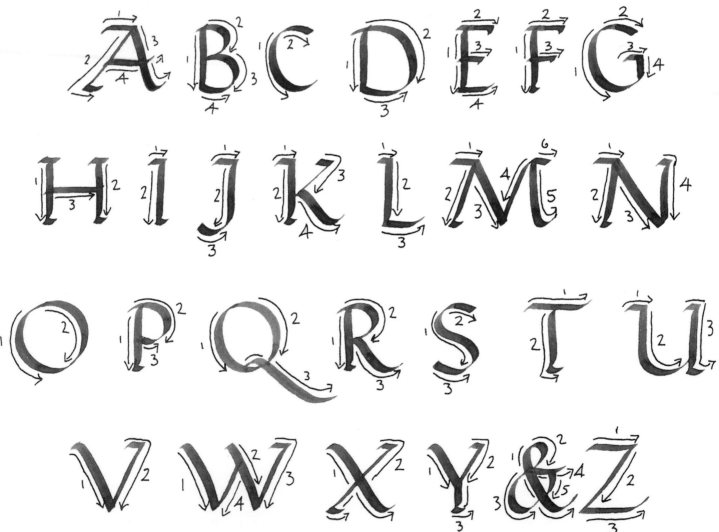

Use the stroke sequence arrows to complete the alphabet.

PEN NUMERALS

When writing numerals in pen you should follow exactly the same techniques as for the capital alphabet. Use the full letter stave (7 pen-widths), keeping your pen at the same 30° angle throughout, and follow the stroke sequences shown below to build up each number. Numerals are generally plainer than the letters, with fewer serifs. But all follow the same general rules, with the bowls full and generous, and the straight lines solid and well-defined. Numerals are not often used, but they can appear in unexpected places!

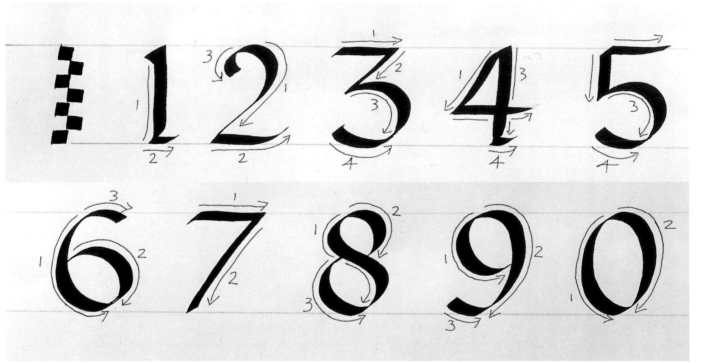

Use the stroke sequence arrows to complete the numerals.

Writing the number "3"

1 Place the pen at a 30° angle along the top line and pull to the right.

2 Keep the same angle to draw a sharply defined diagonal stroke down to the left.

3 Ensure the numeral's bowl is full and well-bodied, breaking out to the right of the top stroke.

4 Finish by completing the bowl, highlighting the end with a small tick.

Problem combinations

Certain combinations of letters, known as ligatures, have to be written with particular care to avoid some of the strokes clashing in a messy way.

The most common examples of these are "tt," "ft," "ff," and "fl." Other problem combinations include capitals and ascenders, such as "Th" and facing letters like "ra."

Common writing errors are shown at the bottom of the page. To make it easier on yourself, try to concentrate on the example of the lowercase letters when you are copying the alphabet. Study how the strokes make up each letter and look at the directional arrows too.

Maintain even spacing between upright strokes such as those of the "m," "n," "h," and "u." A common mistake is to allow too little or too much space between letters.

Bring the second "t" to the left and use a single crossbar.

An "f" and a "t" also share a crossbar.

Join the top of the "l" to the end of the "f."

A second "l" should be taller than its predecessor.

A second "f" should also be taller, and also a little narrower.

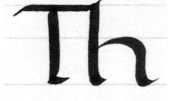

Start the arc of the "a" from the end of the "r."

The "h" will also break into the crossbar of the capital "T."

All the punctuation marks, including question marks and colons, sit more closely to the preceding letter than would another letter.

COMMON MISTAKES, TIPS, AND PROBLEM SOLVING

The example word "montreal" (below) has been written to show examples of common errors made by beginners in calligraphy. Compare this version with the correct one (below right). As well as problems with the individual letters, overall spacing is inconsistent.
• The "m" is not written with even spacing between the upright strokes.
• The "o" is too thin and needs to be more rounded.

• There is too much space between the upright strokes of the "n" and its feet do not sit parallel on the baseline.
• The bottom curves of the "t" and "r" are too extended.
• The two curved strokes of the "e" are not rounded enough.
• The "a" is not wide enough at the top and bottom.
• The "l" is too short at the bottom—it should curve around further.

Every letter shows a problem.

Every letter is written correctly.

How to create a simple illuminated letter "L"

1 To construct guidelines, draw a box shape 2 in. (5 cm) square using a soft 2B pencil. Draw the letter to be painted inside this box using a very light touch.

2 Now paint a thin outline. Using a size 000 sable brush, take some color and very carefully paint around the whole letter with a single outline just inside the pencil line.

3 Finally, take a size 1 sable brush and fill in the rest of the letter. Float the color up to your painted thin outline. Try not to go over the line.

4 Now you can add the attractive foliage decoration. When the paint is completely dry, use a soft 2B pencil to draw your leaf and vine design over the letter. Now use a black fine-line pen to go over your pencil lines. Paint the leaves by filling inside the black outline. You can make the leaves all black or add another color to the leaves if you wish. When the black is dry, rub out your pencil lines, if they show.

ILLUMINATION TIPS

Drawing decorated letters is known as illumination and is an ancient craft practiced by medieval scribes. The technique is shown in the steps above.

Drawing over the painted letter with a black fine-line pen is a simple way to create decoration.

It is always a good idea to draw the design in pencil first as a guide and then go over it in black ink. Always wait for the color to dry completely, otherwise the ink from your pen will bleed into the color.

Start with a soft 2B pencil and adopt a light touch as you do not want to see the pencil line beneath the color.

In step 2 above, use long, thin, flowing strokes in a smooth movement to give a crisp color outline.

When filling in with color in step 3, try to float the color over the infill of the letter. Load the brush with plenty of paint and fill in the letter as quickly as possible. This gives good opacity. Try not to let your brush get too dry as this leaves brushstrokes—a common mistake.

Mixing the Gouache
Take a tube of gouache color and put a small amount in a palette. Using a size 3 brush, mix in a drop of gum Arabic and a little water until it is the consistency of light cream.

BIRTHDAY CARDS

It can be difficult to find a message for special occasions that will be truly appreciated, especially in today's "throwaway" world. Carolingian script was developed to add "weight" to words, not just to communicate. Creating a birthday card for a friend keeps this tradition alive.

1 To make the rough practice draft, rule guidelines on half the practice cartridge paper. Use 7 pen-widths for the top line, and 4½ pen-widths for the x-line.

2 Practice the phrase in ink until you are satisfied with it. For the six strokes of the majuscule "M," see the capital stroke alphabet on page 44. For the lowercase letters, see the stroke alphabet on page 40.

3 Use the spacing instructions on page 27 for the remainder of the phrase. Measure the finished words to make sure they fit onto half the front of the envelope.

Materials

Practice cartridge paper
Sheet of tracing paper
Sheet of 8½ x 11 in. parchment paper
Card stock and matching envelope
2 Speedball size C3 nibs
2 penholders
2 reservoirs
Soft 2B pencil
Gold marker pen
Chinese Black ink or Fount India ink
Ruler and triangle
Eraser
Black fine-line pen

For color work
Red gouache color
Gum Arabic
Size 4 paintbrush
Palette and jar of water

4 To create the envelope, rule lines over half of the area of the parchment paper envelope. As before, rule up with 7 pen-widths for the top line, and 4½ pen-widths for the x-line.

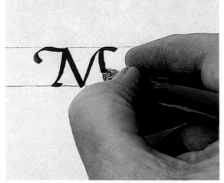

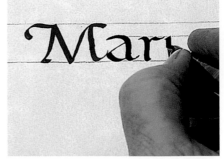

5 Use the brush to mix the red gouache on the palette with a few drops of water and one drop of gum until the paint has the consistency of single cream. Load the pen (see page 22) and create the "M" as in step 2.

6 Now use the second nib to create the lowercase letters in ink. Wait three hours for the ink and gouache to dry before erasing any pencil lines and adding the corner decorations, using black ink and a gold marker pen.

PERSONAL LETTERHEAD

Carolingian script has an elegant flowing style that lends itself beautifully to creating a personal letterhead. Before you start think about how you would like your name to appear and the data you wish to include so you can plan the best design.

1 First, rule lines on a sheet of cartridge paper to practice on. Measure 1 in. (2.5 cm) from the top and draw a pencil line across. Dip the nib in the ink, hold it sideways and mark 7 pen-widths down the left side for the capitals (4¹⁄₂ pen-widths up for lowercase). Practice the name, using the larger 30 double-point nib. This is the first line.

2 For the address, draw two pencil guidelines ¹⁄₄ in. (6 mm) apart. Go down the paper measuring the pen width of each nib you are going to use. Practice writing out the address you are using, both in capitals and lowercase letters.

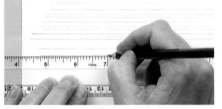

3 On a sheet of good-quality paper measure 1 in. (2.5 cm) down from the top. Draw a line across. Place a ruler across the width of the paper to find the center. Pencil a mark at the top and bottom of the paper. Draw down to mark the center line.

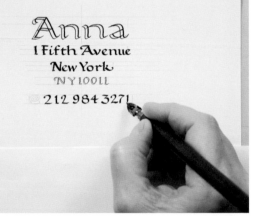

4 Draw your guidelines (7 and 4¹⁄₂ pen-widths). Allow ³⁄₁₆ in. (5 mm) between the lines, and ⁵⁄₁₆ in. (8 mm) between the zip code line and the telephone number line. From your practice writing measure the width of the lines. Place the ruler along each line to find the center and mark this on the layout. Do this for all the lines. Now write the name and address as you have practiced.

5 The last line is for your telephone number. Change the pen nib to the size C5 steel one. Now write the line as you have practiced. Allow all the ink to dry completely before erasing your pencil lines.

Materials

Practice cartridge paper
Good-quality letter paper
Soft 2B pencil
Eraser
Ruler
Penholder
Speedball size C5 nib
Reservoir
2 double-point nibs: sizes 30 & 40
Black fine-line pen
Metallic silver or gold pen
Size 4 paintbrush
Gum Arabic
2 fine paintbrushes: sizes 000 & 1

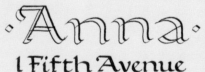

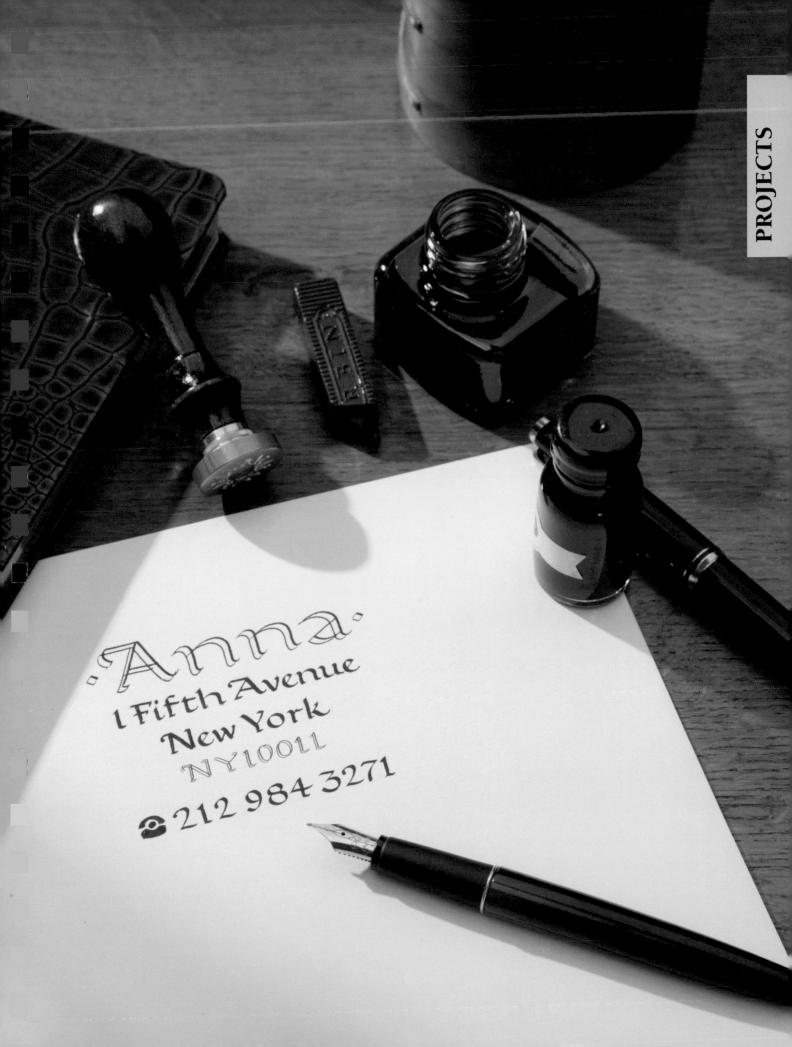

VACATION WRAPPING PAPER

This cheerful vacation wrapping paper will enhance any gift and demonstrates how versatile Carolingian script can be. In this project, bright gouache colors are used as a change from more formal black ink, and the phrases are written at different angles—in keeping with your carefree holiday spirit!

1 Take a sheet of practice cartridge paper and measure out the stave with a ruler. You should allow ⅝ in. (16 mm) for lowercase letters and 1 in. (2.5 cm) for capitals. Draw 3 pencil lines across the paper. Leave a 1½-in. (3.8-cm) space and then mark down the left side of the paper in pencil and rule up the whole sheet.

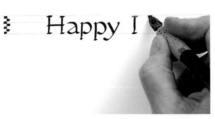

2 Start by practicing writing the English phrase using ink. Dip the pen into the ink bottle halfway up the nib. Take off the excess ink by stroking the nib on the edge of the bottle. Keep the pen at a 30° angle and write with an even pressure. Practice this several times.

3 Repeat the process, practicing writing the phrases in the other languages.

6 Practice marking guidelines on the paper using the same measurements as before, but this time vary the angle of the lines—some can even be upside down. You do not have to measure the width of the lines unless you want to be very precise as it does not matter if your writing goes off the edge of the paper. Write each language phrase in a different color, using the same method as before.

4 To mix the colors use a palette, five jars of water (one for each color), and add a little gouache color. Add a drop of gum Arabic to each color using the end of the brush and mix together with a little water until it is the consistency of light cream.

5 Load a nib with color and practice each phrase, again using one color for each language. Wash your nib after each color or the different paints will blend. Load another color on the nib and repeat the process until you have written all the phrases in different colors.

7 Now mark out lines on the final sheet of paper as before and write the phrases in different colors as you've practiced. If the gouache starts to dry out, add a little water to keep it workable. When completely dry, erase the pencil lines.

Materials

Soft 2B pencil
Eraser
12-in. (30-cm) ruler
Several sheets of practice
 cartridge paper
1 sheet of 11 x 17 in. cartridge
 paper
1 sheet of 11 x 17 in. cream or
 light-colored paper
Black ink and penholder
Speedball size C2 nib and
 reservoir
Gum Arabic
5 jars of water
1 palette or saucer
5 size 4 paintbrushes
6 gouache colors:
 – scarlet red
 – ultramarine
 – emerald green
 – corn yellow
 – purple
 – white

LANGUAGE OF LOVE SCROLL

This love scroll is a perfect gift for that special someone in your life—and shows you care. It also allows you to practice craft skills. Three ribbons complete the scroll—one to hang it, one threaded through as decoration, and one to keep it rolled up before you present it. You can copy the heart here, or draw your own, if you prefer.

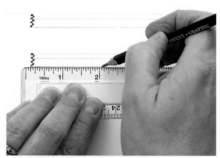

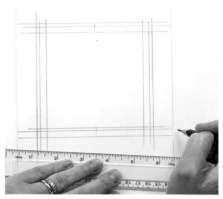

1 Mark the paper with practice lines: 7 pen-widths for capitals; 4½ for lowercase. Mix a little gouache with 1 drop of gum and some water, and, using a size 4 brush, apply it to the size C5 nib.

2 Practice the phrases. On scroll paper, draw a box 6 in. (15 cm) by 12 in. (30 cm). This is the outer edge. Inside this draw a second box 1 in. (2.5 cm) in the sides and 3½ in. (9 cm) in from top and bottom lines.

3 Measure ⅜ in. (10 mm) all the way around inside the center box to give you 7 pen-widths for the top line. From this inside pencil line measure outward ¼ in. (6 mm) for the x-line (4½ pen-widths).

4 Trace the heart using an HB pencil. Turn the tracing over and rub with a soft 2B pencil on its side. Turn the tracing over again, place in the center of the scroll and use an HB pencil to transfer the design to the scroll.

5 Measure all of the phrases you have written on the practice sheet. Now find the center point on the line of each phrase. You will shortly transfer these measurements to the scroll.

6 Measure the innermost box, halve it to find the center and mark with a soft 2B pencil. Working either side of the center point, transfer the measurements taken from your practice writing and put pencil marks at the start and end of the guideline. Do this on all four sides.

7 Mix your gouache again, adding a drop of water to the mix. Use a size 4 brush and apply the red gouache color to the C5 nib. Now write the first phrase at the top. Wait until the gouache has thoroughly dried before turning the paper around and writing the next line.

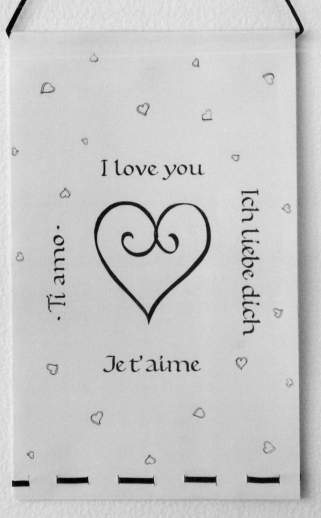

I love you

·Ti amo·

Ich liebe dich

Je t'aime

Materials

Tracing paper
Pencils: soft (2B), medium (HB), & hard (H)
Eraser
Ruler
Good-quality letter paper
Cartridge paper (for practice)
Red gouache color
Gum Arabic
Palette
Jar of water
Penholder
Speedball size C5 nib
Reservoir
Size 40 double-point nib
Size 4 paintbrush for mixing
Size 00 sable brush
1 yard (1 m) red satin ribbon
PVA glue
Sharp craft knife

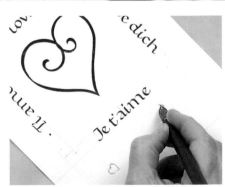

8 Using the red gouache, fill your size 00 brush and paint the red heart using smooth strokes. When it has dried completely, use the double-point nib size 40 to draw the little hearts. Fill the nib using the size 4 brush (no reservoir is used with this nib). You can draw the hearts in different sizes and directions, but keep within the outermost pencil lines.

9 Cut out the scroll along the outer pencil lines. Measure down 1 in. (2.5 cm) and fold over. Tuck a ribbon under, glue and knot. Measure up 1 in. (2.5 cm) from the bottom and fold. Cut slits in the fold at equal distances, open out, and thread a ribbon through. Now erase the pencil lines. Finally, roll the scroll and tie a ribbon round the middle.

PARTY INVITATION

Get ready for the party season by making these brightly colored, handmade invitation cards to send to all your guests. This fun technique merges different gouache colors for a "neon" effect to the writing and decoration. For this project we have used plain white card, but you can use different-colored cards to add a touch of variety.

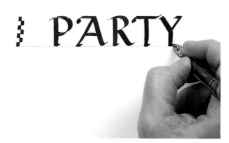

1 On a sheet of practice paper draw a stave (top, x-line and baseline) 2 in. (5 cm) from the top. Keeping the pen at a 30° angle, write the word "PARTY." Practice this a few times until you are happy with it. Wash the nib well after writing.

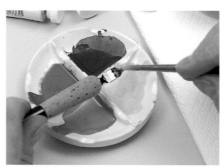

2 Use the brushes to apply gouache to the nib. You will be letting one color merge with another, without washing the nib. Use a different brush when adding colors to the nib, and also separate jars of water for each brush, to keep the colors pure.

3 Now write "PARTY." To start write the "P" in red. Continue in red for the first part of the "A," but before completing it load the nib with yellow. Now start the "R" in yellow then add green. Carry on like this, finishing the "Y" in blue.

4 Fold the card in half widthwise and cut along the fold. Take one of the pieces and draw a wavy line decoration down the right edge. It is a good idea to practice on cartridge paper first. Use a brush to load the nib with blue gouache to start. As you draw your line, switch colors—just as you did before—this time changing to green and then yellow, and finishing with red.

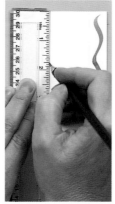

5 Now fold the card lengthwise ³⁄₈ in. (10 mm) off-center to leave a narrow strip down the right side so that the wavy line you've drawn is visible when the card is folded shut. On the front of the card, find the middle point and draw a line straight down.

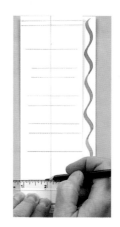

6 Now draw straight lines for the letters. Measure 1¹⁄₂ in. (3.8 cm) down and draw a short line, repeating all the way down your card, using a measurement of ³⁄₄ in. (20 mm) for each letter and a ³⁄₈ in. (10 mm) space between letters.

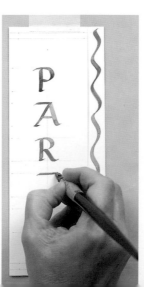

7 Start with the red gouache, just as you did before, and load your nib using the brush. Write the letters, changing the colors just as you have practiced. When the gouache is completely dry, erase your pencil lines.

8 Finally, use a size C5 nib to write "FIESTA" across the top and bottom of the card.

Materials

White 8¹/₂ x 11 in. card
Practice cartridge paper
Soft 2B pencil
Pen holder
2 Speedball nibs: sizes C2 & C5
 and reservoirs
Black calligraphy ink
Ruler
Eraser
4 gouache colors: red, blue,
 yellow, & green
Gum Arabic
4 jars of water
4 size 3 or 4 paintbrushes
Palette

CHAPTER 2: ROMAN CAPITALS

From the first century B.C.E. to the present day, Roman Capitals have been used in many forms. The form is derived from the Greek alphabet (via Etruscan) and achieved its status through the work of Roman master stonemasons, who carved it on great stone columns.

Also known as Roman majuscule letters, Roman Capitals were in use throughout the Roman Empire, carved on many of the buildings of this period. The best known example of this script is on the carved stone column of Trajan, which is covered in wondrous figures and Roman Capitals carved in deep relief by master stonecutters.

Roman Capitals passed out of use at the beginning of the medieval period, and did not reappear until the end of the 15th century, when they were revived by the Humanists.

As the name suggests, this script uses only capital letters, comprising straight, precise angles and sweeping curves.

The vertical lines narrow slightly in the center and curve outward at the top and bottom. They have great definition between the thin and thick lines. Spacing and the proportion of the letter are also important.

Roman Capitals are sometimes called Versals, the name originating from the use of the script in the manuscripts of Biblical verses. Each verse began with a large "illuminated" (decorated) letter, called a Versal. Some manuscripts used Roman Capitals in skeletal form, leaving the letters hollow by drawing them with a quill pen. Modern techniques use this method too, but with a steel-point or oblique steel nib.

CAPITAL ALPHABET

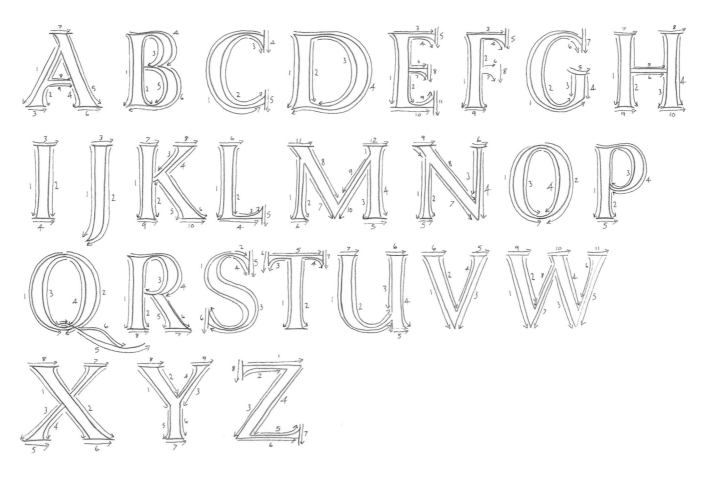

Use the stroke sequence arrows to complete the alphabet.

How to draw the letter "A"

1 Draw the farthest edge first, including a small sweep at the bottom for the serif.

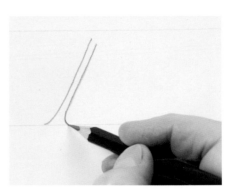

2 The inner side of the stroke is parallel until it nears the bottom, when it curves inward. Do not worry about leaving a gap for the crossbar at this stage.

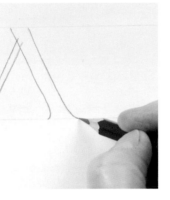

3 The right-hand stroke is wider than the left. Start each side at the top line and open out the serif at the bottom.

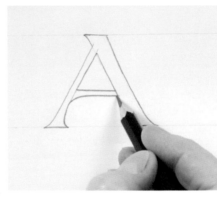

4 Enclose the feet and the top of the letter before adding the crossbar a little under halfway up the letter.

How to draw the letter "R"

1 Start with the letter's vertical section. To ensure that the sides are not exactly straight, give each edge a gentle concave curve.

2 Draw the outer bowl first in a single movement before inserting a tighter curve inside.

3 Add the foot, finishing to the right of the bowl. Let the foot widen at the base and add an extra curve to the right-hand side.

4 Finish the letter by enclosing the feet with horizontal lines along the baseline.

How to draw and paint the letter "V"

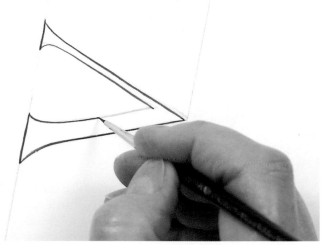

1 First take a piece of good-quality white cartridge paper. With a 2B pencil, draw a top line and baseline 2 in. (5 cm) apart. The letter "V" is made up of six strokes. Take care to keep the pencil lines light. Start at the top left and draw a curve to form the serif, then draw a line diagonally to the right and stop at the baseline.

Go back to the top left. Start at the top line again and curve the other side of the serif and then draw a line parallel to the first one, as shown. Stop before the baseline. Now go up to the right side and, using the same technique, draw a line diagonally down to the left to meet the first line you drew, forming the "V."

Now up to the top right and draw another line, not so far apart, to meet the second line you drew. Finally, draw the two horizontal lines at the top to complete the letter.

2 Mix some purple gouache with a little zinc white in a palette. With a size 4 brush, add water and a drop of gum Arabic and mix to the consistency of light cream. For outlining, the gouache needs to be a little more watery. Put a little of the mixture to one side and add a little more water. Use a size 0 brush and paint over your pencil line with a thin brush line. Keep an even flow with the brush.

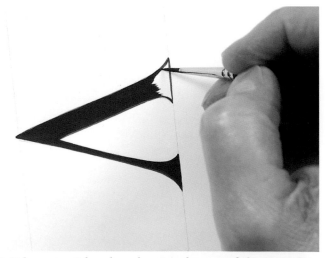

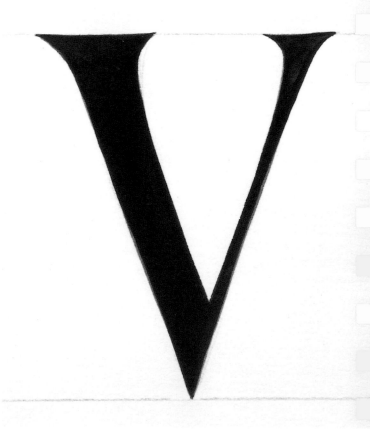

3 Take a size 1 brush and, using the rest of the gouache mix, start to fill in the body of the letter. Start at the top and follow through as quickly as possible until you have painted the whole letter.

Sign writing

Often a Roman Capital alphabet is used for modern sign boards because the letters are easily read from a distance, while still looking classical and timeless. For sign writing, a special enamel paint is used that gives a good opacity. Special long, flat, chisel-shaped brushes are needed for this type of lettering.

Incising

Incising letters means cutting in stone or wood using chisels (see pages 68–69). Roman Capitals are commonly used today as they were in the first century C.E. They can be cut into the stone with special steel chisels and a small-headed hammer. Slate, marble, and stone are fine surfaces for stone carving. Granite can be used but is a very hard stone to carve. You can cut into wooden surfaces in the same way, using wood chisels and a wooden mallet. Lime wood is especially good for wood carving.

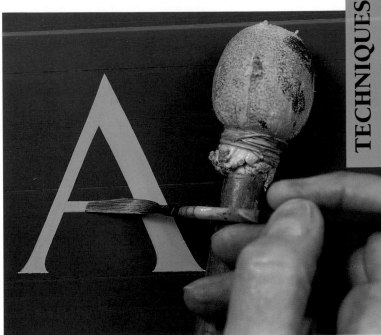

COMMON MISTAKES, TIPS, AND PROBLEM SOLVING

There should be definition between the thick and thin lines. A common mistake is to make the straight lines too thick and the curved lines too thin. A tip when drawing out the letters in pencil is to use a soft pencil and apply even pressure and a light touch. Then, if you make a mistake, it is easier to rub out the lines and re-draw them. If you press too hard with the pencil the score marks they leave will still show on the paper.

Keep the letters in proportion, with small serifs, taking care not to exaggerate lines.

Serifs should not be too wide, but balanced with the straight lines.

The straight lines should show clear definition between thick and thin strokes.

Be confident when writing and don't allow wobbly lines.

Take care to keep the letter within the stave.

COMING-OF-AGE CARD WITH LATIN MOTTO

In ancient times, Roman Capitals were carved onto milestones marking the distance to the next town. So what better script to use for a card marking important milestones such as coming of age! The border is a typical Roman wave design used on mosaic floors in the first century C.E.

1 Start by practicing the Latin quotation in Roman Capitals on a spare sheet of white cartridge paper. Draw guidelines ⁵⁄₈ in. (16 mm) wide with a gap between of ³⁄₈ in. (10 mm). Measure down ⁷⁄₈ in. (22 mm) and draw another set of lines ¹⁄₈ in. (3 mm) wide. As you write keep even spacing between letters and ensure there is a contrast between the thick and thin lines.

2 Take a sheet of tracing paper and fold it in half. Trace the border design and add a vertical line down the center.

4 Attach the corners with masking tape and trace the letters, using the center line to ensure it is centered for each line of lettering.

7 Using the size 4 brush, mix light blue gouache paint with water and a drop of gum Arabic until it is the consistency of watercolor paint. Now take a size 1 brush and paint the wave design. Once you have painted all the waves, mix the ultramarine blue and fill in the space around the waves, as shown above.

3 Turn the tracing paper over when you have drawn the design and rub a soft 2B pencil over it to carbonize.

5 Turn the tracing paper over and carbonize the back of the lettering.

8 Use the light blue gouache and a size 1 brush to paint the text. When complete use the C6 nib and the darker ultramarine blue to write the English translation in simple capital letter script. When the paint is dry, gently rub out the pencil lines. To finish outline the wave border with a fine-line black pen.

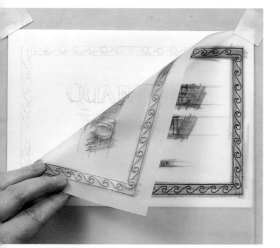

6 Now place the design onto your card. Stick it down and go over the border and lettering with a hard H pencil to transfer the design and script. Do not press too hard. Make sure you also draw the pencil lines for the writing.

QUAERERE
VERUM

SEEK WHAT IS TRUE

Materials

Tracing paper
Practice cartridge paper
Cream card
2 pencils: soft (2B) & hard (H)
Eraser
Ruler
Masking tape
2 gouache colors: light blue &
 ultramarine blue
Palette
Jar of water
Penholder
Speedball size C6 nib
Ink reservoir
2 paintbrushes: sizes 00 & 1
Fine-line black pen

PETRARCH PLAQUE

In Roman times, the homes of the wealthy often had mosaic floors made up of small, square blocks known as *tesserae*—often featuring a rope border. This plaque is based on a typical Roman mosaic and features a verse by the Italian poet Petrarch, taken from his poem *Canzoniere*.

Quelle pietose rime in ch'io m'accorsi

Di vostro ingegno et del cortese affecto,

Ebben tanto vigor nel mio conspetto

Che ratto a questa penna la man porsi

1 Draw a group of three-line staves on a practice sheet and practice writing out the words using a size C3 nib, drawing the first letter of each line from the Roman Capital alphabet. The bottom line of writing is small Roman Capitals with a fine-point nib. Measure your lines of writing so that you can position them on the final sheet.

2 Use a long ruler to draw out the area for the border on an 11 x 17 in. piece of tracing paper. Now position the tracing paper over the rope design so that it fits within the border and trace.

3 Rule lines on the 11 x 17 in. buff-colored paper, including a center line. Draw the Roman Capital in pencil at the beginning of each line, then use a fine-point nib to cover it in dark brown ink before writing the rest of the lettering in lowercase Carolingian script in dark brown waterproof ink.

4 When it is dry, fill in the letter using gold ink. You have to keep stirring the ink before you use it or it will separate.

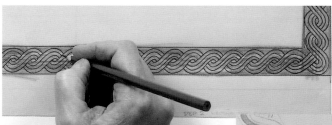

5 Turn over your rope border tracing and rub it with a soft (2B) pencil to carbonize. Turn it over again and use a hard pencil with a sharp point to draw over the tracing. Now fill between the lines with each color ink (shown right and far right) —first light orange, then gold (keep stirring), and finally dark brown. Take the ink straight from the bottle, using a size 1 brush and paint each band carefully. Make sure each color is dry before starting the next or the colors may bleed into each other.

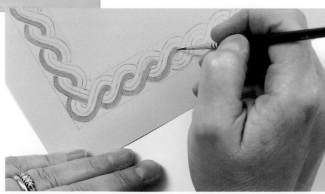

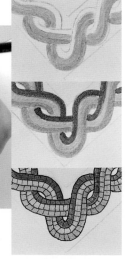

6 Finish by outlining the rope bands with a fine-line black pen and add little lines across each band (shown right) to simulate the tessera squares of Roman mosaic.

Quelle pietose rime in ch'io m'accorsi
Di vostro ingegno et del cortese affecto,
Ebben tanto vigor nel mio conspetto
Che ratto a questa penna la man porsi.

PETRARCH CANZONIER 120. 1-4

Materials

Cream or white practice paper
2 pencils: soft (2B) & hard (H)
Penholder
Speedball size C3 nib
Fine-point nib
Reservoir
Fine-line black pen
Long ruler
3 waterproof inks: dark orange,
 gold, & dark brown
Size 1 paintbrush
Sheet of 11 x 17 in. light
 buff-colored paper
11 x 17 in. tracing paper
Eraser
Masking tape

Translation

These kind verses in which you show me
your wit and your courteous affection,
show such concern, to my mind,
that I am forced to reach for my pen.

LATIN LOVE SCROLL

This Latin inscription makes an enchanting love token to give to a close friend or partner.
The paint is mixed to a watercolor consistency to give a light, airy effect and
the Roman Capitals are written in outline to allow the design only
to show through for a delicate touch to the scroll.

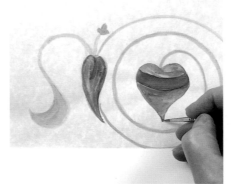

1 Use the template to enlarge the heart design to fit onto an 8½ x 11 in. sheet of paper. Trace this onto tracing paper before turning it over and carbonizing the design with a soft 2B pencil. Place the sheet on top of the parchment card, stick it down, and transfer the design to the card with a hard H pencil.

2 Mix the gouache colors with water and gum Arabic in a sectional palette until they are the consistency of watercolor paint—they need to look light and translucent on the card. Paint the design with each color in turn, starting with the yellow, then the green, and finishing with the red.

3 On the practice card measure ¾ in. (20 mm) for the Roman Capitals and ¼ in. (6 mm) for the English translation. Leave a space of ⅝ in. (16 mm) between the writing. Practice the Latin lettering in pencil, then go over the letters with either a pointed nib or a fine-line black pen. Now practice the lowercase writing.

4 Find the center of the parchment card and draw a vertical line with a soft 2B pencil. Measure the length of your practice writing and put pencil marks at the beginning and end of each line, centered around the vertical line. Draw the Roman Capitals softly in pencil. Now you can use a fine-line pen or a pointed nib and pen them in black over the pencil lines. The letters are left open so you can still see the design.

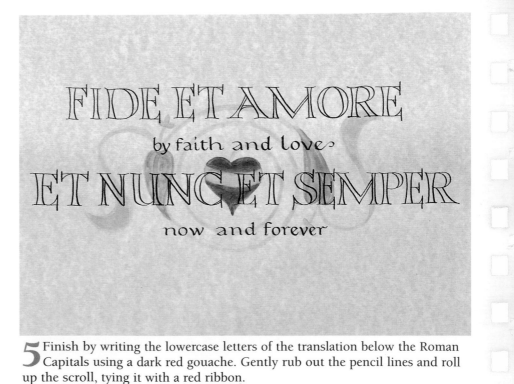

5 Finish by writing the lowercase letters of the translation below the Roman Capitals using a dark red gouache. Gently rub out the pencil lines and roll up the scroll, tying it with a red ribbon.

FIDE ET AMORE
by faith and love
ET NUNC ET SEMPER
now and forever

Materials

2 pencils: soft (2B) & hard (H)	3 gouache colors: yellow, green, & dark red
Eraser	Gum Arabic
Ruler	Palette
Masking tape	Jar of water
Penholder	8½ x 11 in. sheet of parchment-colored card
Speedball size C6 nib	
Reservoir	Tracing paper
Fine-line pen or fine-point nib	White card or cartridge paper
2 paintbrushes: sizes 1 & 4	

RELIEF CARVING ON WOOD

The angular Roman Capital script lends itself to relief carving on wood. Use a craft knife to score the outline and then a chisel to carve. By cutting wood away at an angle you can create a pleasing effect around each letter. You can take out all the wood around the letters if you wish, but this takes a little longer.

1 Take your piece of wood and lightly sand it with fine sandpaper. Wipe off the dust.

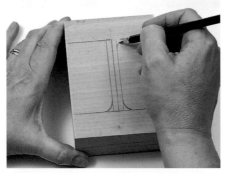

2 Now use your ruler and pencil to draw lines top and bottom on the wood. Draw your letter or number.

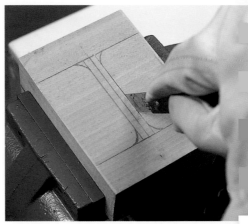

3 Protect your hands with gloves and use a vice to hold the wood in place, otherwise the knife or chisel may slip and cause injury. Start by using the straight chisel or craft knife, keeping it in an upright position, to go down the straight sides and top of the letter pressing into the wood to score a line.

4 The serif can be cut into the wood with a rounded beveled chisel. If you have only straight knives or chisels use the thinnest and go around the curve using small cuts.

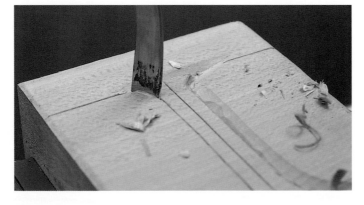

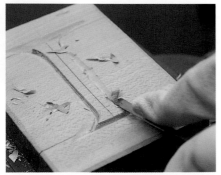

5 Remove the wood from the sides of the letter using a straight chisel at a flat angle. This makes the letter "pop" out of the wood. Do not rush—once wood has been cut mistakes are not easily corrected.

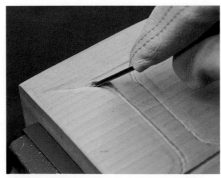

6 Use a fine chisel to finish. When you have chiseled all the wood from around the letter, the carving is finished. You can take the edge off the block of wood with a small plane, if you have one.

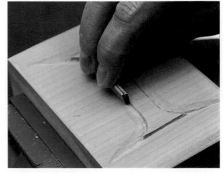

7 Give the letter a quick sanding using the fine-grain sandpaper and it is finished.

Materials

Block of lime wood
Fine-grain sandpaper
Medium HB pencil
Eraser
Ruler
Sharp craft knife
Carving chisels:
 straight, beveled,
 & V-shaped
Vice
Wood plane
Gloves

STENCILED T-SHIRT

Roman Capitals are not just used for mosaic patterns and carving wood—their clear lines are ideal for stenciled designs on T-shirts and sweat shirts, too. In this project a large, bold "X" is used for maximum effect, but you could also stencil your initials or the name of your favorite celebrity or sports team, using the alphabet on page 58.

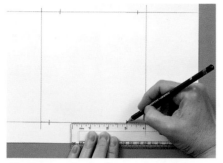

1 Take a sheet of stencil card. Draw the top and baselines and then vertical lines to make a box. Add marks to show the width of the diagonals—1 in. (2.5 cm) for the wide diagonal, 1½ in. (3.8 cm) for the narrow. By making the numeral as large as this it is easier to cut out.

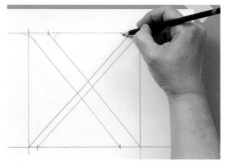

2 Draw your letter "X" with a medium pencil, joining the marks previously made. Add in the serifs by hand—these do not have to fit inside the box.

3 Transfer the letter onto a sheet of tracing paper before carbonizing the reverse and transferring it onto a sheet of waxed stencil card.

4 Place the stencil card on a cutting mat held in place with masking tape. With even pressure, cut out the stencil, keeping the blade at an angle to the card. Always cut well away from your hands.

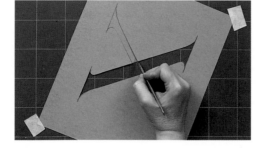

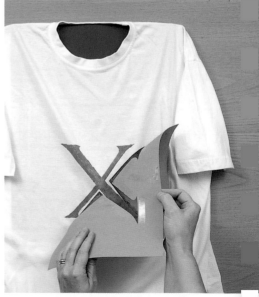

5 Lay a clean, uncreased T-shirt on a flat surface with a sheet of thick card inside. Use double-sided tape stuck on the underside of the stencil card to hold it in position. (Place the tape near the points of the letter to ensure they do not lift during stenciling.)

Use a short bristle stencil brush to work the paint into the fabric, going over the edge of the stencil card to get a good line at the edge. Go all over the fabric that you are filling in. Keep loading the brush, as the fabric quickly soaks up a lot of paint.

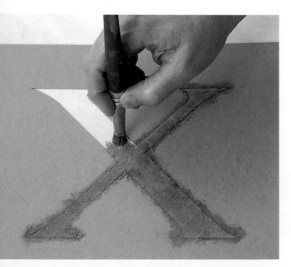

6 Wait for the paint to dry before carefully removing the stencil. After a few hours, iron the T-shirt. Always put a clean piece of fabric between the iron and the T-shirt. This will "fix" the paint so it can be laundered without the paint being washed out.

Materials

White cotton T-shirt
Stencil card
Craft knife
Cutting board
Steel ruler
Medium HB pencil
Fabric paint
Saucer
Stencil brush
Double-sided tape
Sheet of card

CHAPTER 3: UNCIAL & HALF-UNCIAL

Uncial scripts developed along with the growing use of animal skins for manuscripts. Unlike Roman Capitals, Uncial scripts are written with the pen in one position and so used by scribes of the British Isles to copy works of the early Christian church.

During the first millennium C.E. the monasteries of the British Isles were places of great learning, especially in Celtic countries such as Ireland and Scotland, and on tiny Lindisfarne Island (also called Holy Island), off the coast of Northumbria, in north-east England.

From the first to the fourth centuries C.E., books developed into a form we would recognize today, gradually replacing scrolls as the principal way of presenting text. With the book came new scripts, now known as the "Uncial family," which included Half-uncial and Insular.

The most famous books of the period included *The Book of Kells*, written on the small island of Iona off the west coast of Scotland, *The Book of Durrow*, written in Ireland, and *The Lindisfarne Gospels*, written on Holy Island.

Books were written in a special room called a Scriptorium and took many years to complete. Some were produced by a single scribe using a quill pen held at a flat angle to the paper, giving these scripts their characteristic appearance. The quill was cut from the flight feathers of a large bird, such as a swan, goose, or crow.

The Uncial family of scripts are rounded in formation. There are both "majuscule" (capitals) and "minuscule" (lowercase) variants, and manuscripts were produced in one or the other form. Initial letters would be "illuminated," that is written much larger than the text and embellished, perhaps with elaborate interlacing Celtic knots, or animal forms known as zoomorphics.

The Celtic scribes of the seventh and eighth centuries, in particular, were masters of art, design, and calligraphy. Sometimes they produced pages featuring Celtic designs only—and no text at all. These are known as carpet pages and were masterpieces of the scribe's art.

CAPITAL ALPHABET

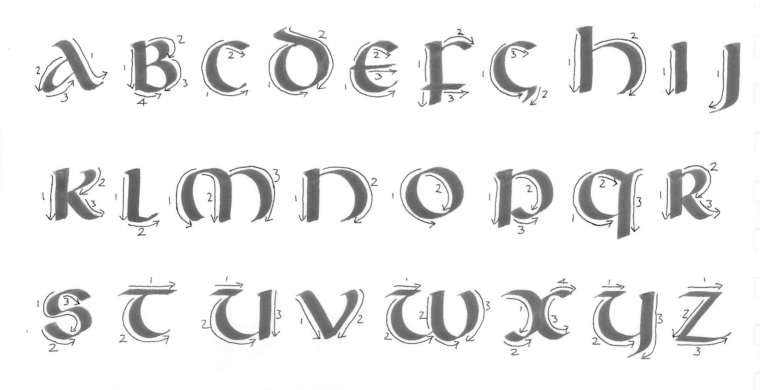

Use the stroke sequence arrows to complete the alphabet.

Creating the letter stave

1 Start by drawing a pencil line across the paper for the x-line. Then mark 4 pen-widths down the left side, holding your nib at a right angle to the paper, followed by half a pen-width, to give the correct spacing.

2 From the bottom pen mark draw another line across the page. This is the baseline; the space in between is the x-height of the letters. You can write Celtic scripts between 4 and 5 pen-widths—as you prefer. Now repeat the process to fill the whole page with staves.

How to draw the letter "h"

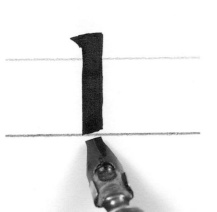

1 Hold the nib at a flat angle to the guideline to give the letters their rounded appearance and draw the pen down. Add a short stroke at the top, as shown here, for the serif.

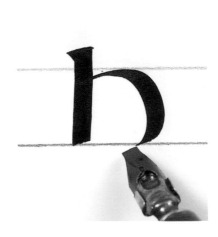

2 Keep the same angle to achieve the crescent shape of the letter's bowl.

How to draw the letter "f"

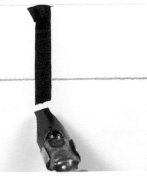

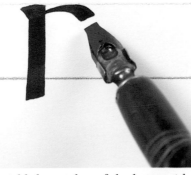

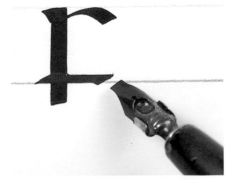

1 For "f," repeat the first stroke of the "h" but take it past the baseline to create a descender.

2 Add the top bar of the letter with a shortened curve that rises to touch the top line of the stave.

3 Draw the center crossbar along the baseline and give it a little flick downward to finish.

THE HALF-UNCIAL SCRIPT

In the Irish Half-uncial alphabet, the letters "B," "D," "H," "K," and "L" rise above the top line, and "F," "G," "J," "N," "P," "Q," and "Y" fall below. Some Half-uncial letters, such as "B" and "L," have ascenders resembling fishtails. The script is rounded and the letters are quite thick. This script is easy to read and pleasing to the eye.

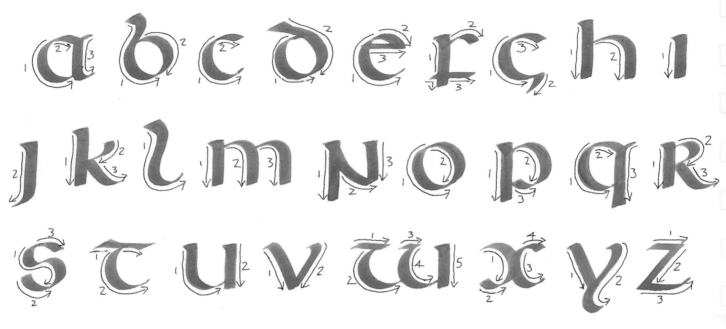

Writing the letter "d"

1 With the pen at a flattened angle, as in the Uncial script, make a reverse crescent.

2 Exaggerate the top of the tail and bring it around to meet the bottom of the crescent.

Writing the letter "n"

1 The left-hand side of the "n" drops below the baseline as a descender.

2 Turn the diagonal stroke into an upward sweep.

3 Bring the right-hand side of the letter down. Finish above the line to show the pen angle.

Writing the letter "b"

1 Draw the body of the letter in a single stroke, keeping clear definition in the left-hand sweep.

2 Enclose the bowl, starting close enough to the x-line to reach it while still on the upward movement.

3 Add weight to the "fishtail" by giving definition to the letter's ascender.

Pen numerals

Writing Half-uncial numerals in pen involves exactly the same techniques as writing the alphabet itself. Keep the pen at the same flattened angle throughout and follow the stroke sequences shown to build up each number.

As with other Roman scripts, Half-uncial numbers are slightly less ornate than the letters. Nevertheless, they still retain the same pleasing sweeping and rounded form of the letters.

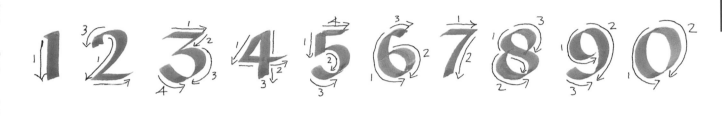

COMMON MISTAKES, TIPS, AND PROBLEM SOLVING

The following are some of the commonest mistakes when constructing the Uncial and Half-uncial scripts:
• Not marking the height of the guidelines accurately. Take your time and try to keep the square-cut nib on the paper when marking the side of your paper in ink.
• Filling the nib too full with ink when loading. This causes the letters to be thick and blobby. Once you have dipped the nib into the ink, take off the excess ink by stroking it on the side of the bottle neck.

• Not holding the nib flat to the paper at all times. This is a very common mistake. You need to keep the nib at 45° or so. But to form the letter well, practice your writing while holding the nib flat to the baseline and let the letters flow.
• Wrong stroke sequence. Follow the alphabet arrow sequence shown. This will help with the stroke directions and how to build the letter correctly, especially with the letters "M," "S," "W," and "X."

Make the curves of the letters rounded, and never let them be too narrow.

Never raise an ascender more than 1–1½ pen-widths above the x-line.

Avoid dropping too far below the baseline. The nib should be 1–1½ pen-widths below a line.

To form the letter well, practice holding the nib flat to the baseline and do this every time.

Never overload the nib with ink, which makes the letters thick and blobby.

Keep the nib flat as this gives a much nicer shape.

Keep the letters in proportion and avoid making them squashed or overextended.

Illuminated letters

The Celtic scribe used illuminated letters at the beginning of a sentence, or beginning a Gospel page, or to show the importance of a name. Illumination means to "light up" and this is sometimes achieved with color, Celtic designs, or with simple decoration.

The simplest illuminations were written in black ink bigger than the normal line of writing. The scribes also added color to the inside of the letter using a simple dot design. By adding simple black or red dots around the outside of a letter, a process known as "rubrication," the scribes made the initial stand out. Some letters had a simple knotwork design added to the inside or the top of a letter,

making the letter appear larger. Another form of illumination was to use spirals, key patterns, and animal designs. Some of the animals were recognizable, while others were intended as comical hybrids or were taken from mythology.

Animal heads were often drawn at the beginning of the interlacing knotwork, sometimes depicted with their mouths open and their teeth or tongue holding on to the interlacing Celtic band. The animal's feet or a tail would then be drawn at the end of the knot.

Some letters filled the whole page with color and were so intertwined with Celtic art that it is sometimes difficult to see exactly where the letter begins and ends.

1 Trace or draw the letters onto tracing paper. Turn the tracing paper over and rub over a soft 2B pencil to carbonize it.

2 Turn the tracing over again and go over the letters using an H pencil to transfer the design to the sheet of parchment paper.

3 Paint the letter and decoration with bright gouache colors using a fine brush. Ensure you allow each color to dry completely before adding the next one. Outline the design using a fine-point black pen.

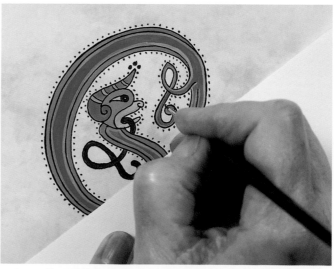

4 Finally, add the rubrication (red dots) around the letters. This technique is used for all illuminated letters and motifs. Why not design your own letters? Look at the motifs opposite for inspiration.

Flourishes can be geometric or zoomorphic. They can be part of the letters or additional decorations.

You can use these designs and zoomorphic motifs as decorations for your own illuminated letters, or some of the other designs on pages 214–218.

CELTIC NAME PLAQUE

This name plaque in Half-uncial script is a stylish addition to any child's bedroom and is suitable for all ages. The rich illumination features authentic designs from the best Celtic tradition. The templates on pages 214–218 offer a choice of flower, bird, and animal designs, along with a series of classic knot repeats.

1 For the girl's plaque, choose a border from the templates. Use the 2B pencil to trace it onto the tracing paper. Add repeats to fit. Turn over the tracing paper and rub the back with the 2B pencil to carbonize it.

2 Lay the tracing over your sheet of practice paper and stick it down flat using masking tape on all four corners. Use the harder H pencil to trace over the Celtic border around the paper.

3 Rule guidelines across the center of the letter paper with a soft 2B pencil: use 5 pen-widths above and below. See page 74 for the alphabet and practice the calligraphy of the name in H pencil.

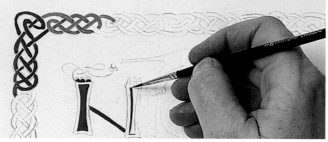

4 Mix the gouache in both red and green. Load the size 1 brush with red gouache and practice the border; rinse, and repeat in green until you are happy with both. Load the size 0 brush with red, and practice the initial.

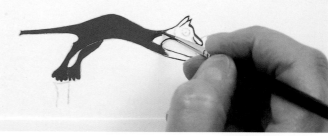

5 Trace the fox and place it above the calligraphy with its feet on the top writing line. Mix some orange gouache with gum Arabic and water, and use a size 1 brush to paint in the color.

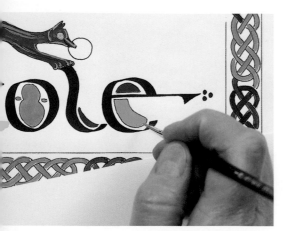

6 Fill in the geometric shapes with blocks of gouache color.

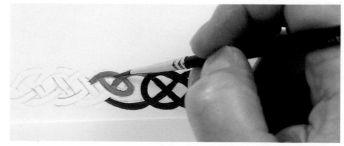

7 Transfer the design to the final sheet and color the border. When dry, use a black fine-point pen to draw around the color work. Put black dots around your initial letter and erase the pencil lines. Finally stick the corners of the project firmly to the mountboard or thick card with masking tape.

Materials

Cartridge paper	Eraser
5 gouache colors: blue, yellow, red, orange, & green	Palette or saucer
	Jar of water
Gum Arabic	Tracing paper
Speedball size C1 nib	Ruler
Penholder	Fine-line black pen
Size 4 paintbrush for mixing	Masking tape
2 paintbrushes for painting: sizes 1 & 0	Ivory mountboard or thick cream card cut to 9 x 4 in. (23 x 10 cm)
2 pencils: soft (2B) & hard (H)	to give firm backing

ILLUMINATED LETTER ON VELLUM

This project features authentic materials that Celtic scribes used to create elegant Bibles and other works. Vellum, which was used in Europe before paper, is calfskin that has been specially treated. The pigment colors came from plants and minerals and were mixed with egg, which acted as a binding agent.

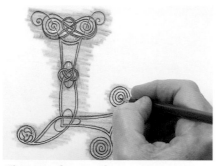

1 Trace the template on page 217. Turn the tracing over and use a soft 2B pencil to carbonize the reverse of the design. Place it onto the cream card and use the hard pencil to transfer the tracing to the card.

2 Mix red and green gouache colors together in your palette, adding a drop of gum Arabic and water, and then paint the colors as shown. This color rough shows how the colors will look on the final form.

3 Draw in the lines surrounding the colored sections with the black pen.

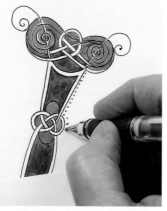

4 Add red dots around the letter using with a fine-line red pen.

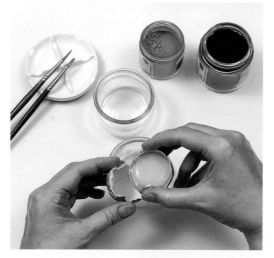

5 With two glass containers on hand, crack open an egg. Separate the white from the yolk, keeping the yolk in one half of the eggshell. Now take the yolk in the palm of your hand and wash it very carefully under the tap, without breaking the yolk sac. Take hold of the yolk sac at the top, hold it over the other glass container and break the sac at the bottom to let the yolk drain into the container. Try not to let any of the egg sac fall into the container.

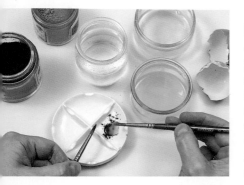

6 Use egg yolk for warm colors and the white for cool colors. Put about a quarter of a teaspoon of red powder in the palette. Now add a few drops of the egg yolk and some mineral water. Mix with the size 3 brush to a creamy consistency.

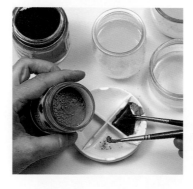

7 Now use another brush to do the same with the green pigment, mixing it with a few drops of the egg white. Try the color on a piece of spare paper first before painting the vellum. If it looks a bit watery, mix more pigment until it looks opaque.

8 If using real vellum take any grease off with powdered pounce. Put a little on the surface and use fine sandpaper to rub over the whole surface in a circular motion.

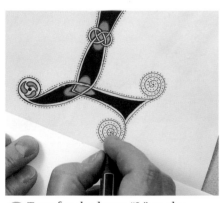

9 Transfer the letter "L" to the middle of the vellum as before, making sure that your hands are grease-free. Start by painting the red color with a size 0 brush. Paint the outer line of the letter first and then, using the size 1 brush, fill in the color. Do the same with the green. When it is dry, mix a little white with some of the green pigment to paint the lighter parts. When the paint is dry go around the letter with a black fine-line pen. Finally, add the black dots around the spiral.

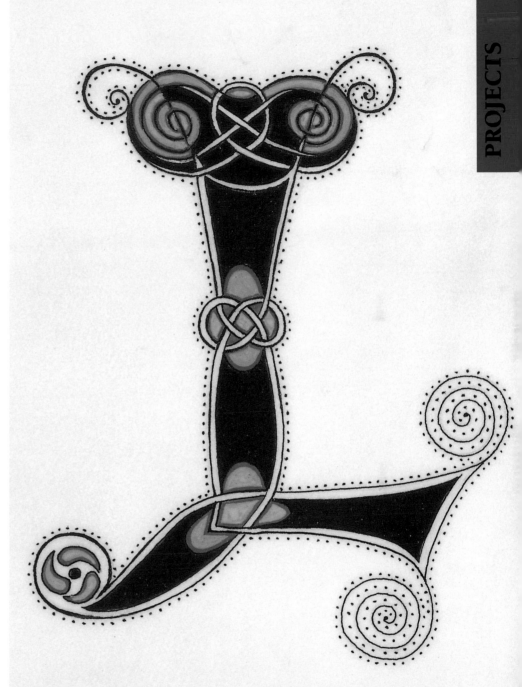

Materials

Cream card	Masking tape	Egg
Tracing paper	2 gouache colors: red & green	2 glass containers
Vellum or vellum paper 6 x 8 in. (15 x 20 cm)	Gum Arabic	Powder pigment colors: red, green, & white
2 pencils: soft (2B) & hard (H)	2 paintbrushes for painting: sizes 00 and 1	Distilled or mineral water
Fine-line black pen	2 size 3 paintbrushes for mixing	Fine pounce powder
Fine-line red pen	2 jars of water	Very fine sandpaper
Eraser	Palette for mixing	

GAELIC PRAYER

It was traditional in Irish homes to hang up a Gaelic prayer so as to keep the family
who lived there from harm. The prayer was surrounded by an elegant border
and decorated with animals that had spiritual and symbolic significance.
You can copy the examples shown here or choose your own.

1 Using a soft 2B pencil, prepare a sheet of letter paper with a stave combining two nib widths: 4¹/₂ nib-widths with a size C3 nib and 4¹/₂ nib-widths with a size C5 nib. This will give you three horizontal lines for each line of writing.

2 Write out the text using the size C3 nib for the initial letter of each sentence and the smaller size C5 nib for the rest of the text. Continue this throughout the text.

3 Trace part of the border from the photo opposite. Using a large compass draw two concentric circles: the diameter of the outer circle is 11¹/₄ in. (28.5 cm). Carbonize the reverse of the tracing paper and repeatedly transfer the design to make the circle pattern.

4 Cut out each line from the practice sheet using scissors. Find the center of the practice paper and draw a line down the middle of your paper. Place each line you have cut out on the paper and stick them down with glue or tape allowing even spaces between the lines of calligraphy to give you the layout for the final writing. If any line is longer than the available space cut the line at an appropriate place and take it over to the beginning of the next line.

Materials

Large sheet of tracing paper
11 x 17 in. cartridge paper
Large sheet of cream card
2 pencils: soft (2B) & hard (H)
Eraser
Long ruler
Large compass
Scissors
Paper glue or masking tape
Various gouache colors
Gum Arabic
Palette
Jar of water
2 paintbrushes: sizes 00 & 1
Fine-line black pen
Penholder
2 Speedball nibs: sizes C3 & C5
2 ink reservoirs
Black ink

5 Trace the entire border onto a large sheet of tracing paper and carbonize the back. Trace it first onto a sheet of practice paper and then onto 11 x 17 in. cartridge paper.

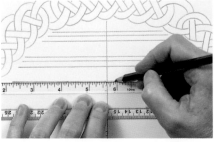

6 Now rule up the cream card. Measure each line in turn and transfer the measurement to the card. Put a pencil mark at the start and end of each line.

Go n-éirí an

bóthar leat. Go raibh an

chóir ghaoithe i gcónaí leat.

Go dtaitní an ghrian go boc bláth ar

do chlár éadain, go gcuire an bháisteach

go boc min ar do choirt. Agus go

gcasfar le chéile sinn arís, go

gcoinní Dia i mbosa a

láimhe thú

chóir ghaoithe i gcónaí leat.

Go dtaitní an ghrian go boc bláth

do chlár éadain

go boc min ar do choirt. Agus go

gcasfar le chéile sinn arís, go

gcoinní Dia

7 To write on the cream card, take the larger (size C3) nib for the first letter of the sentence. You will be starting this letter at the top line. Then take the size C5 nib and write the remainder of the line. Follow this method throughout the text. You can add decoration to the larger letters and zoomorphic decorations to the text.

8 Use the size 00 brush and gouache to paint the outline of the knot border. Fill in the rest of the color with a size 1 brush. When dry, add the darker color as an outline on the knot work. When this is dry, outline the border with a black fine-line pen. Add red or black dots to the inside and outside of the knotwork. Erase the pencil marks.

WOODEN BOX

A wooden box decorated with Celtic motifs and initials can make an original gift for others or a useful container for trinkets to keep yourself. Adding a coat of varnish before you decorate the box, and covering with a second coat at the end, ensures your work is protected from bumps and scratches.

1 Carefully sand the box smooth with fine sandpaper. Wipe off the dust with a damp cloth. When dry, varnish the box and leave it to dry overnight. Turn the box upside down onto a sheet of tracing paper and draw around the lid to mark the boundaries for your design. Write your initials in the center. Copy the Celtic corner motif from the Template section (page 217) and draw it into each corner of the traced area. Then carbonize the back of the tracing paper with a soft 2B pencil.

2 Use a hard pencil to trace the design onto the lid of the box. Go over your pencil lines carefully with the black pen until you have covered the design.

3 Add the dots with the tip of the same pen to finish the pattern.

Materials

Wooden box
Fine sandpaper
$^{1}/_{2}$ in. (13 mm) soft brush
Satin varnish
Black fine-line pen
2 pencils: soft (2B) & hard (H)
Eraser
Ruler
Tracing paper

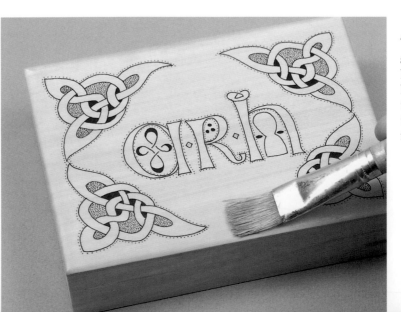

4 When the ink is dry, rub out any pencil marks left visible on the lid. Finally, varnish the box as before to seal the design in place.

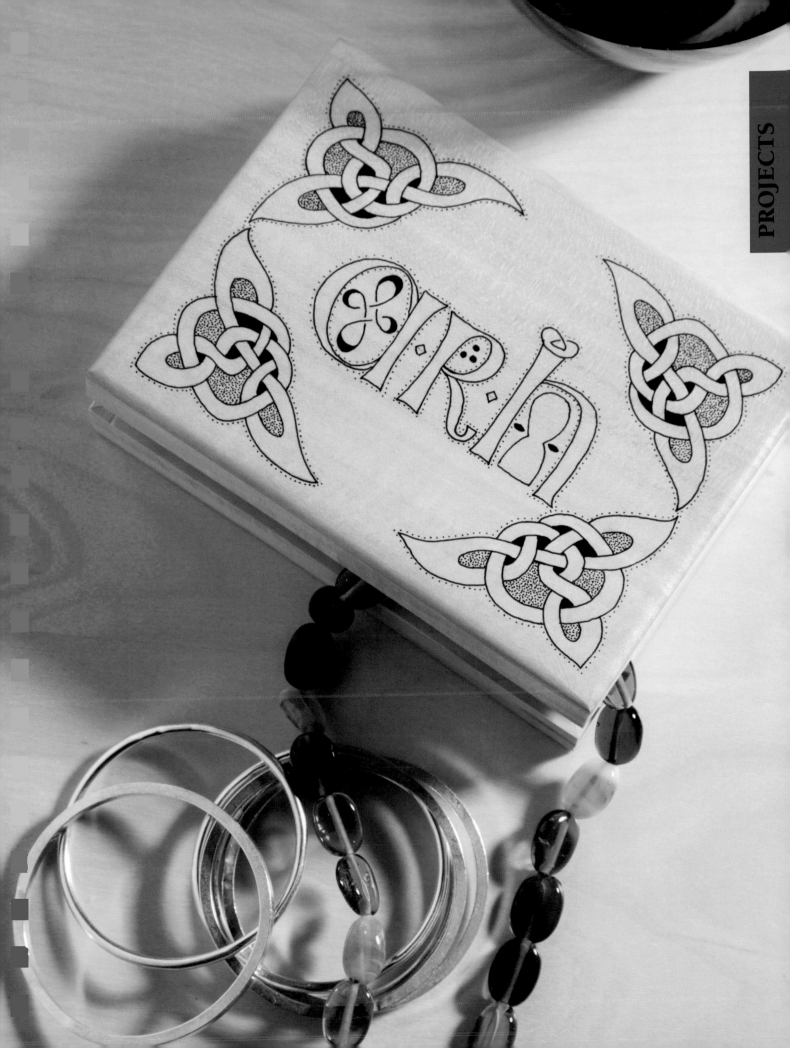

CELTIC ANIMAL ON STONE

Decorating a smooth stone you have found on a beach to make a doorstop or a paperweight
allows you to add ancient pattern to an object that has existed for many thousands
of years. Ancient people may have handled the stone and you can remember
them by painting on it a beautiful design that they would have recognized.

1 Photocopy and enlarge the template of the Celtic animal, then transfer it to the tracing paper with a black pen before carbonizing the back of the sheet.

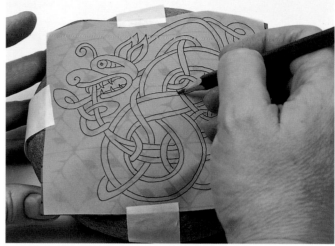

2 Varnish the smooth side of the stone. Put carbon paper under the tracing and stick them both to the stone with masking tape. Trace the design onto the stone.

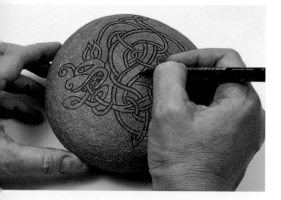

3 Go over the design with a black permanent marker to heighten the lines, allowing you to see the design clearly and so make painting easier.

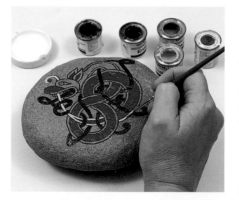

4 Use enamel paint to color the design. Mix it well, as it can thicken at the bottom of the pot. Use a size 1 brush, adding each color in turn, starting with the red, then blue, and then yellow.

5 Continue adding colors, finishing with the green.

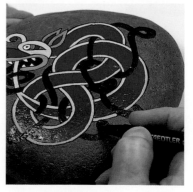

6 When the paint has dried go around the design using the black permanent marker to restore the design where the paint has covered your markings.

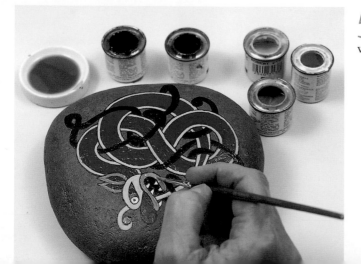

Materials

Black fine-line pen
Tracing paper
2 pencils: soft (2B)
 & hard (H)
Large, smooth stone
Varnish
Carbon paper
Masking tape
Permanent black fine-line
 markers
5 enamel paints:
 yellow, dark red, blue,
 light green, & white
Size 1 paintbrush

CHAPTER 4: BLACK LETTER GOTHIC

This script is derived from Carolingian minuscule, but from the 12th to 15th centuries it became compressed and angular in the hands of the scribes of northern Europe. An upright hand, it is characterized by closely packed strokes like fence posts.

Dense and black on the page, Black Letter Gothic script heralded a new era in writing, very different from the soft forms previously used. It was sometimes quite hard to read as one letter might even be touching the next.

From the 13th to the 15th centuries, medieval monks right across Europe from the city of Oxford, England, to Paris, France, and Bologna, in Italy, continued to craft books in this hand. The workshops at this time were divided into various groups. Some monks prepared the vellum, while others ruled up the pages.

Skilled scribes wrote the text while the illuminators painted the decorated capital letters. Gold was used in many of these fine books. A mixture known as gesso was made from powdered pumice, lime plaster, and water, and mixed with a fine clay called bole to give it color. This was painted onto the page to make a cushion and the gold leaf applied on top. The technique is known as raised gilding.

At this time many people commissioned such books to be produced specially for them. They would choose the style of book they wanted and told the scribe how long they would be prepared to wait. Those who paid extra got their books first. As a result some craftsmen became rich and famous. The Limbourg brothers, who were illuminators, were highly paid for their art and well-regarded in society.

BLACK GOTHIC MAJUSCULE

Use the stroke sequence arrows to complete the alphabet.

Writing the letter "E"

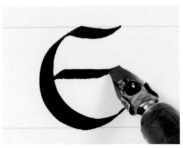

1 Draw a two-line stave, with 7 pen-widths between the top line and baseline. Place the nib on the top line. Curve it around to the left and back to the right as you reach the baseline.

2 Go back to the start point and draw the nib to the right curving the stroke down and back up to the top line.

3 Halfway down the first stroke, draw a horizontal line across the letter.

4 Return to the top pencil line and draw the nib down in a straight stroke to just below the cross-bar to form a space between the curved first stoke and this straight stroke.

5 In this space draw a small serif-shaped stroke, placing the nib a little way down the straight line and moving to the left. The last stroke is a thin diagonal line made from the right-hand end of the top line. Draw the nib diagonally down and stop at the horizontal line.

Writing the letter "M"

1 Curve a stroke to the left and then down below the baseline, curving to the left at the end. Place the nib to the left and curve to the right to meet the first stroke.

2 From the top of the first stroke, draw the nib around to the right in a curve and straight down to the bottom. Draw a foot on the bottom of the stroke.

3 Put the nib three-quarters of the way up the last stroke and draw a more rounded curve to the right. Continue the foot of the last stroke a little further than the last foot.

4 Put the nib on the top pencil line to the right of the first stroke. Draw the nib halfway down the letter and curve to the left at the bottom.

5 The last three strokes are made up of little serif-like strokes. Place the nib slightly left of the first downward stroke, just below where it curves from the top. Draw the shape three times, one below the other.

BLACK GOTHIC MINUSCULE

The bold angular strokes of the Black Gothic minuscule, or lowercase, alphabet are best for design impact, rather than readability. Unlike most other Roman scripts, there are no contrasting thick and thin uprights and—with a few exceptions—the arches are made up of elongated diamond shapes, rather than curves. The techniques needed to produce this script can be difficult to master, but the end result makes all the practice worthwhile.

The Black Letter Gothic minuscule alphabet is written very straight and angular and is somewhat dense in appearance. In this exercise you are going to practice writing the letters "a" and "g." The "a" is made up of three main strokes and the more complex "g" comprises four main strokes.

To start, place a large nib into the holder and then attach your reservoir. Start by ruling up 7 pen-widths to the left of your paper and then draw top and baselines with a soft (2B) pencil. Add an extra line to the stave at 5 pen-widths above the baseline. This gives you the x-height for the minuscule letters.

As you write always check that the nib is at a 45° angle to the paper. If necessary use a triangle or protractor to draw a line at 45° so that you can keep checking.

Start with the pen nib on the x-line. The downstrokes may look straight at first glance but all involve slight curves, which take practice to perfect.

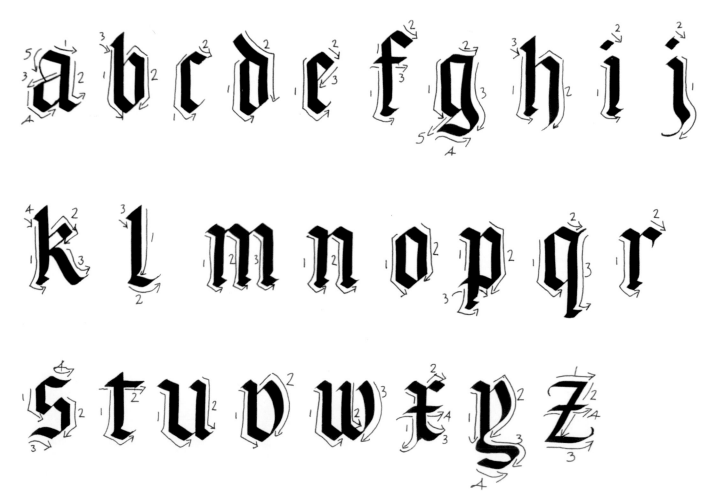

Use the stroke sequence arrows to complete the alphabet.

Writing the letter "a"

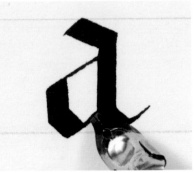

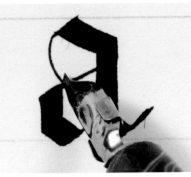

1 Put the nib on the x-line. Draw the first stroke diagonally to the right and then, without lifting the pen, go straight down the paper. Just before the baseline, go to the right diagonal and stop at the baseline. Move up to the right slightly and stop.

2 Put the pen halfway up this stroke. Draw a line diagonally to the left and, without lifting the nib, continue down to just above the baseline again and, without lifting the nib, go to the right to meet the first stroke.

3 Start the last stroke where you started the letter, turning the nib on its right side and drawing a thin, curved line down to meet the middle line, and stop.

Writing the letter "g"

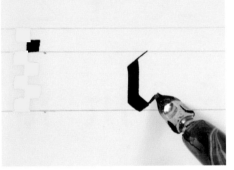

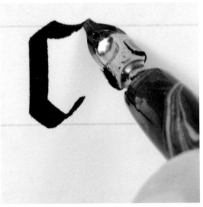

1 Place the nib at a 45° angle on the x-line. Draw the pen to the left a short way, then straight down until just before the baseline, now diagonally to the right down to the baseline. From here, draw a line diagonally up to the right.

2 From the top draw the nib diagonally to the right in a curved motion.

3 To form the descender, bring the nib downward, moving slightly left, then straight down. Just before the baseline curve a little to the right and then left below the baseline.

4 Return to the end of the first stroke. Put the nib at a 45° angle on the paper and draw the pen down diagonally to the left.

5 From this point to the left, write a curved stroke to meet the end of the third stroke. This completes the letter.

ROTUNDA

The Rotunda hand is derived directly from Black Letter Gothic. It is also written at a 45° angle, but is slightly more curved and open in its appearance, compared with the straight, angled pen strokes used in Black Letter Gothic.

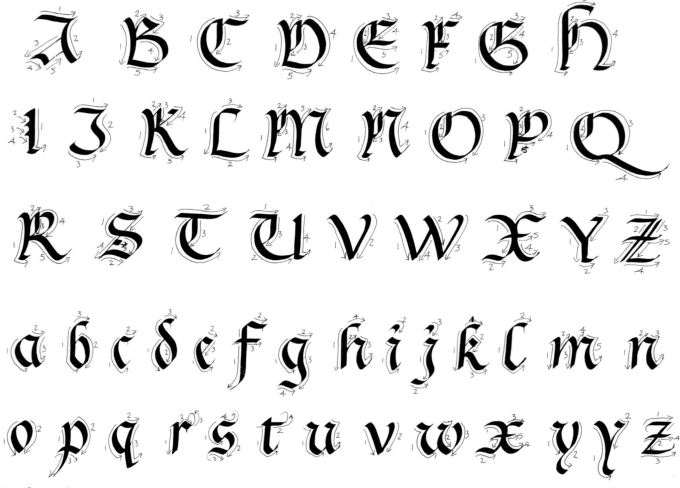

Use the stroke sequence arrows to complete the alphabet.

Numerals

Numerals follow the same basic rules as the letters. Black Letter Gothic numerals include serif-shaped motifs, while the Rotunda script is rounder and more open (hence its name).

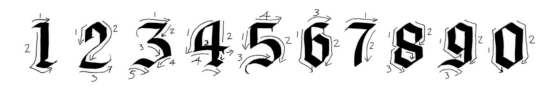

Black Letter Gothic numerals

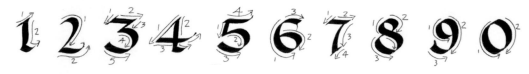

Rotunda numerals

Drawing and painting an illuminated letter

Traditionally, illuminated letters were painted in bright red and ultramarine blue, and greens were used for leaf and vine designs. These colors always look vivid, and add brightness to the main text written in black. Decide in advance where you are going to apply colors.

If you are going to use gold leaf, apply it before painting otherwise the gold will stick to the paint.

To mix gouache colors, put a little paint on a palette and mix with some water. Now add a drop of gum Arabic and mix until it is the consistency of light cream. For outline work, put a little mixed gouache into a separate palette and mix more water with it to give a thinner consistency. Paint the outline edge of the letter carefully, using a size 00 brush. Keep a nice flow going with the brush.

1 First draw a box shape using a soft 2B pencil and fill the space inside the box with the letter you have chosen.

2 Draw a decorative design of leaves and geometric shapes around the letter.

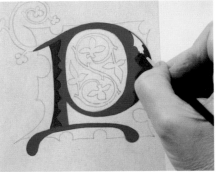

3 Use a size 1 brush to fill in color as smoothly and as quickly as possible to give an even, opaque surface. Allow the paint to dry.

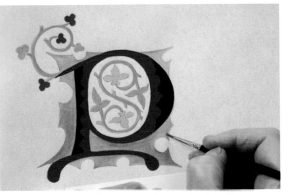

4 Mix a little white gouache with the deep colors and paint over the first color. This adds definition to the design. White can be used to highlight certain areas. Mix this as before, and pick out the design drawn on the thicker parts of the letter.

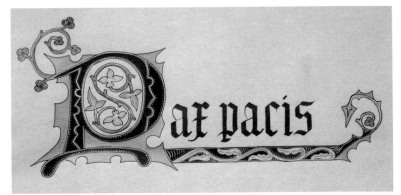

5 Now paint any decoration on the outside of the letter, such as leaves and vines, in green. When the painting is complete and thoroughly dry, go over the outline in deep red with a size 00 brush. Finally, rub out any pencil lines that show on the paper.

COMMON MISTAKES, TIPS, AND PROBLEM SOLVING

Common mistakes with the Gothic script include:
• Too much space between lowercase letters. They should be quite close and evenly spaced.
• Bad technique. With lowercase "a," "j," "x," and "y" it is hard to turn the nib onto its right side to make very thin strokes but with practice it can be mastered.
• Too much ink. Avoid blobbing.

• Wrong pen angle. Keep the nib at 45° for drawing clearly differentiated thick and thin lines.
• Rotunda capitals drawn too wide. They must look in keeping with lowercase letters.
• Serif shape drawn too large on the capitals. Try to keep them in proportion with the rest of the letter—especially when using more than one.

ILLUMINATED PAGE

This beautiful project is inspired by the French Duke de Berry's *Book of Hours*—an illuminated calendar. This example uses gold gouache color to dramatic effect. Steps 1 to 4 show the first rough version, for practice. The final work starts with step 5. The finished example (right) is embellished with raised and flat 24-karat gilding to give the flavor of the original.

1 Use a compass to draw 11 circles out from the center point at the following diameters:

½ in. (13 mm)	3 in. (7.5 cm)
1½ in. (3.8 cm)	3¼ in.(8.2 cm)
1⅝ in. (4.2 cm)	3⅜ in. (8.6 cm)
2 in. (5 cm)	3⅝ in. (9.3 cm)
2⅛ in. (5.4 cm)	3¾ in. (9.5 cm).
2¼ in. (5.7 cm)	

2 Draw the sun in the center and the segments for the moon phases. To draw the number segments around the outside edge, place a ruler across the circle and put a mark on each side. Allow a little more space for double figures. Now trace the zodiac symbols on page 218.

3 Pencil in the numbers of the days with a size C5 nib. Finally draw the "N" of "Noël" and write the three other letters with a size C2 nib.

Materials

Large cartridge paper
Large turquoise canson paper
Penholder
2 Speedball nibs: sizes C2 & C5
2 ink reservoirs
Black calligraphy ink
5 gouache colors:
 blue, green, gold, red, & white
Gum Arabic
2 paintbrushes: sizes 00 & 1
2 size 4 paintbrushes for mixing
Palette
Jar of water
Fine-line black pen
Large compass
Ruler
Soft 2B pencil
Eraser

4 Add the gold to the sun and the phases of the moon and stars. Mix the gouache and add this to the capital "N" of "Noël."

5 On the final sheet of paper draw the circles and mark out the segments for the moon as before. Now paint them in. Also at this stage, draw the "N" of "Noël" and write the three other letters.

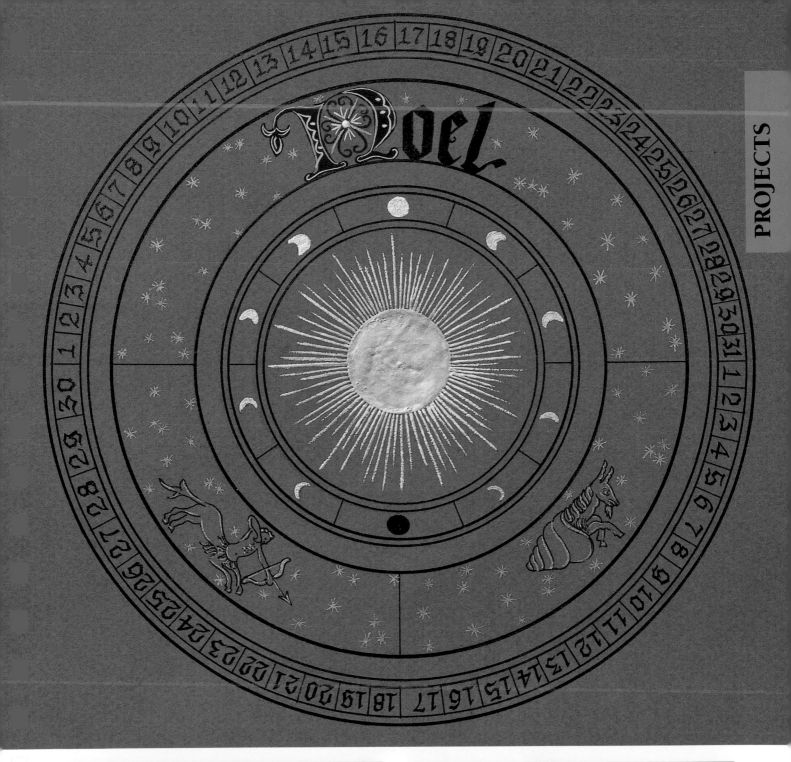

6 Put in the gold stars, spacing them evenly. Now draw in the zodiac signs.

7 All that is left is to paint in the letter "N" of "Noël," and the design is finished.

"L" FOR SPECIAL LETTER BOX

It is always handy to have a box in which to keep special letters. To remind you what you have in there, you can embellish it with an ornate Black Letter Gothic "L." Before you start study the finished letter (right) to get an idea of the strokes to use and then practice using the double-pencil method.

1 Use double pencils to practice the letter freehand a few times. When you are ready to start, draw two lines 5 in. (12.5 cm) long and 5 in. (12.5 cm) apart on cartridge paper to mark the base and top lines.

2 Using the size C2 nib and black ink, write the base of the letter in two strokes about 1 in. (2.5 cm) above the baseline. First, move across to the right and slightly down, then return to the start point and make a spiral to the left.

3 To form the body of the letter draw a narrow diagonal line down to the left 2 in. (5 cm) above the base. This marks the top of four downstrokes. Put the pen on the left side of this line to draw the first downstroke. Make diamond patterns using four short diagonal strokes to the left on the second downstroke, and five short strokes on the fourth downstroke.

4 To the right of the last downstroke, allowing a small gap, draw curved lines to the right. Above the body of the letter, draw a diagonal line to the right. Draw two spirals at either end and add a smaller stroke underneath. Above the last stroke draw the pen down again diagonally to the right. Draw three of these straight lines, adding in the spirals and the other zigzag decoration.

5 Now go below the first four downstrokes that you have made and draw the pen to the right. Add the diamond pattern in the middle, as before, and then curve around into a spiral. Now draw a second line below the last one and add a larger zigzag motif. Add more zigzags to the left of the body, ending in a spiral.

6 Start with a narrow line straight down. This goes along to the right of the body. Now add the zigzag pattern down. Draw another spiral to the right and pull the nib down and to the left. The last part to add here is the tip on the far bottom right. Draw a curved stroke to the right ending with a spiral, and a little one inside going the other way.

Materials

White card
Practice cartridge paper
Box 6 x 8 in. (15 x 20 cm)
Black calligraphy ink
Penholder and ink reservoir
Speedball size C2 nib
2 soft (2B) pencils
Eraser
Ruler
PVA glue
Scissors
Fine-line black pen

7 Use the fine-line black pen to draw triangle shapes inside the letter. Use the same pen to add a fleur-de-lis design at the top left and the leaf shape in the bottom right.

8 Fill in the triangles with the same pen, then take the finished letter and cut around it to fit the lid of your box. Add glue to the card and stick it in place.

CHAPTER 5: ITALIC

Italic script is popular for its flourished, free-flowing, yet compressed letters. There are several types, including the formal upright and the cursive hand—both are beautiful to look at and easy to read.

Italic script was established in Renaissance Italy during the 16th and 17th centuries. Scribes of that time had great pen control and could draw ink sketches of figures, animals, intertwining patterns, and very complex capital letters—just with a nib and ink. At this time specialized books were produced to show off the many new and elaborate styles of writing, including the *Petie Schole* (1587) by Francis Clement and *The Pen's Perfection* (1672) by Edward Cocker.

The formal Italic hand is characterized by long ascender and descender strokes, which curve above the top line and below the baseline, and the flourished free-flowing and yet rather compressed letters, which are written very straight. The lowercase letters are based on the oval letter "o."

Italic cursive scripts have a slightly different look compared with the formal hand. Some lowercase letters can be joined, as in handwriting, with each letter flowing into the next. They also have elaborate swashes and flourishes. These are made up of loops penned above the top line and below the baseline to enhance the letter, and are regarded as a sign of the real mastery of penmanship.

Italic scripts in general have narrow letters that lean to the right slightly at an angle of 5° and 12° to the vertical. They are written with the pen nib at a constant 45° angle.

To draw the stave, draw a line and then mark down 8 pen-widths and draw another line—this is for the baseline. Measure back up 5 pen-widths and draw a line to give you the x-height. You now have three lines to work from.

ITALIC MAJUSCULE

Use the stroke sequence arrows to complete the alphabet.

Writing the letter "A"

1 Start with the decorative bar at the top of the letter. Maintain the pen angle to define the end points.

2 Add the tail to the bar, starting at the sharp point before pulling the pen around to the right.

3 The left-hand stroke of the letter falls by half its height again below the baseline.

4 Smooth out the end of this stroke with another tail.

5 The right-hand side of the letter is almost vertical by comparison, with a right-angled tail along the line.

6 Finish with a horizontal crossbar, again highlighted by sharply defined ends.

Writing the letter "P"

1 Write the stroke with a movement to the left so that the tail finishes underneath the start point.

2 Touch the top line of the stave and end the stroke away from the vertical.

3 Join the two together with a short stroke, whose point matches that of the previous stroke.

4 Add a simple flourish to the top of the letter.

Writing the letter "W"

1 Give a little flick to start, letting the nib touch the top line.

2 Repeat the stroke exactly.

3 Keeping the gap open, write the longer end stroke, pulling the pen down to a point.

4 Add a simple flourish that ends above the top line

5 Copy the angle of the last stroke to join up the two sections of the letter.

ITALIC MINUSCULE

When writing the Italic script, keep the letters even. Do not make the bowl too round or wide. When writing the letters "a," "d," "g," and "q" make the curve on the bottom of the first stroke oval in shape and not too rounded, with the nib going up quite a way at the end of the stroke.

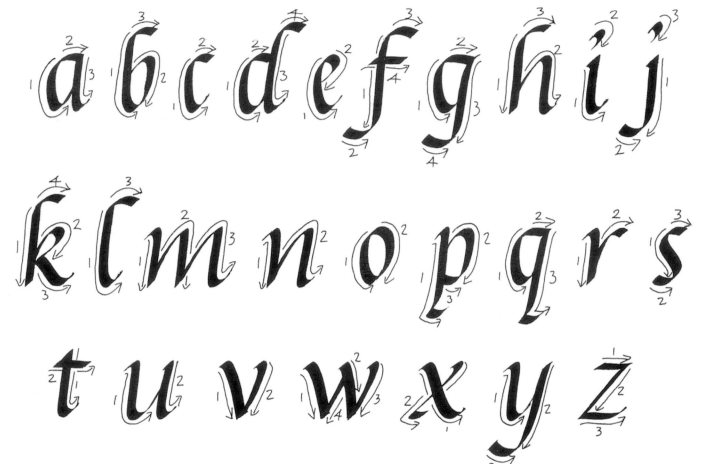

Use the stroke sequence arrows to complete the alphabet.

Writing the letter "d"

 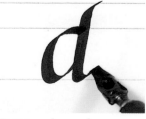 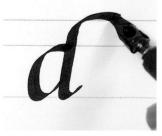

1 Move down from the x-height, but turn sharply at the bottom and come halfway back up.

2 Add a rounded tick to the top, ending it in line with the end of the previous stroke.

3 Bring down the vertical in one stroke, mirroring the turn at the bottom in the tail.

4 Finish with a flourish along the top line.

Writing the letter "g"

 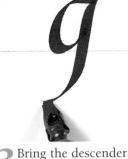 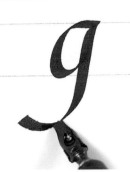

1 The first stroke replicates the first stroke of the "d."

2 Add a horizontal stroke along the x-line, finishing to the right of the previous stroke.

3 Bring the descender below the line in a simple sweep, defining the join at the top of the letter.

4 Add a tail to the descender, starting to the left of the body of the letter.

Writing the letter "e"

1 Use the full height of the x-line to make a well-defined curve.

2 Enclose the bowl of the letter with the nib at its narrowest at the join.

Linking letters

When some Italic letters are written next to each other they may be linked instead of being written separately. Alternatively, the lowercase letters can just touch each other. Letter combinations like this are known as ligatures. For example, the "c" and "l" (below) are not joined, but they flow together when they are written close to each other. The capital "T" followed by the letter "h" is another nice combination.

When the crossbar stroke of the "T" is taken across the straight stroke of the "h" they meet and form a loop. Double letters such as "f," "l," and "t" are written slightly closer to each other. With the "f" and "t" the crossbar goes through both letters in one stroke.

When writing the lowercase "s" and "t" (below) next to each other, you can connect them by letting the top arc stroke of the "s" go across to make the crossbar of the "t."

NUMERALS

Numerals should be rounded but with well-defined areas of thick and thin nibwork. Only "0" and "1" stay within the x-height. The numbers "2," "6," and "8" reach the top (capital) line while "3," "4," "5," "7," and "9" drop below the baseline.

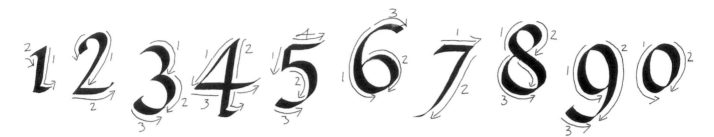

Use the stroke sequence arrows to complete the numerals.

Writing the number "2"

1 Start at the capital height with a sharp turn before descending to the left.

2 Give the horizontal base an upward turn at the end.

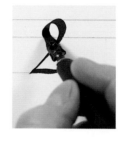

3 Define the top of the letter with a tick that reaches the x-height.

Writing the number "8"

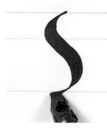

1 The main body of the "8" resembles a more vertical, bottom-heavy "S."

2 Enclose the top bowl with a short stroke down to the x-height.

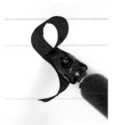

3 From opposite the end of the previous stroke draw a fuller, rounder stroke to enclose the bottom bowl.

Writing italic letters in color

Often when writing a piece of black text you would use a larger letter or word in color at the beginning of a line. These letters are also written in the Italic script.

The paint usually used is gouache color. It is mixed with gum Arabic and water to a slightly thinner consistency so that the paint flows easily from the nib and can be written smoothly on the paper, although you can also use calligraphy inks. There are lots of colors available today including metallics—although these do tend to be rather watery.

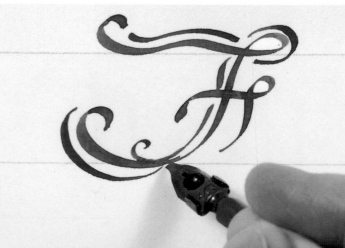

Flourishes and swashes

The Italic script uses flourishes and swashes to decorate the letters. Some of the early writing masters were so proficient with the pen that figures and swirling designs were used in the decoration.

The flourishes are made by free-flowing, sweeping movements of the pen nib to create beautiful letters that are almost an art form in themselves. Some decorative strokes are used above the top line in the ascenders and others in the descenders below the baseline. These swashes can fill in empty spaces as much as a few inches below or above the stave. In the middle or at the end of a line, they are joined to the top and bottom strokes of the letter.

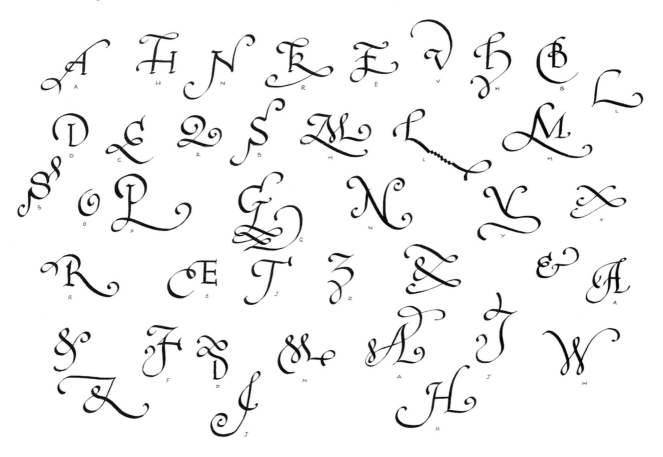

COMMON MISTAKES, TIPS, AND PROBLEM SOLVING

• Don't slant the letters too far to the right. Keep them upright when practicing, before leaning them very slightly to the right at a 5–12° angle.
• Some capital letters—for example "A," "E," "W," and "Z"—also change the stroke direction to form the letter. Try writing the difficult letters many times.

Always try to form the letters based on the condensed, oval-shaped letter "o," never too rounded.

The left-hand letter is too slanted and looks as if it is toppling over. When learning, practice upright letters.

Retain strong distinctions between the thick and thin elements of the letters.

SHAKESPEARE SONNET

The Italic script was well-established by William Shakespeare's time, in the 16th century, so it was the most popular style to adopt when writing love poetry. The elegant flowing strokes set off one of the Bard's sonnets perfectly and, once framed, it makes an elegant addition to any room.

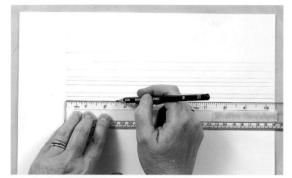

1 Practice on the large sheet of cartridge paper. Pencil in the lines for the poetry, checking where you want to leave extra space for initial capital letters while ensuring lines are evenly spaced and a margin is left on the left-hand side.

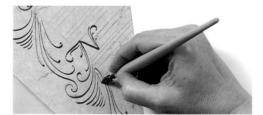

2 Start by practicing with a size C4 or C5 nib on the smaller of the lines at the top. Pencil in the letters you will write with the C3 nib—the capital "M" and the letters that make up the first word. This will give you a starting point.

3 Pencil in the lines on the sheet of parchment paper and draw in guides for writing in the capital letters and swashes.

Materials

Black ink
Penholder
2 Speedball nibs: sizes C3 & C6
2 Speedball size C4 or C5 nibs
4 ink reservoirs
Large sheet of cartridge paper
Large sheet of parchment paper
Soft 2B pencil
Long ruler
Eraser
Scarlet red gouache color
Palette
Size 4 paintbrush
Jar of water

4 On a second sheet of cartridge paper rule lines ¾ in. (20 mm) apart. Apply red gouache to a size C3 nib and glide the nib over the surface, using sweeping strokes. Use the alphabet to help you form the letters (see page 100).

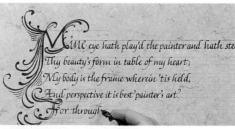

5 Go back to the ruled parchment paper and start to draw the capital letters and swashes over your pencil lines. These are free movements and can be as simple or flourished as you like. Also write the rest of the first word on the stave.

6 Now write in the rest of the sonnet in black Italic script, using the first size C4 or C5 nib. You will notice the first word is written in red following the capital "F" and "N": use the second size C4 or C5 nib for applying the other color. Write all the lettering until you come to the bottom. Use the size C6 nib for the author's name at the bottom of the page. When the ink is dry, rub out the pencil lines.

Mine eye hath play'd the painter and hath steel'd,
Thy beauty's form in table of my heart;
My body is the frame wherein 'tis held,
And perspective it is best painter's art.
For through the painter must you see his skill,
To find where your true image pictur'd lies,
Which in my bosom's shop is hanging still,
That hath his windows glazed with thine eyes.
Now see what good turns eyes for eyes have done:
Mine eyes have drawn thy shape, and thine for me
Are windows to my breast, where-through the sun
Delights to peep, to gaze therein on thee;
Yet eyes this cunning want to grace their art,
They draw but what they see, know not the heart.

Sonnet XXIV William Shakespeare.

"EX-LIBRIS" BOOK-PLATE

The most important works in your library (including this one!) deserve their very own "ex-libris" decorated book-plate or label, bearing your name, pasted into the front. The delicate Italic script and decorative flourishes add an elegance to grace any book. Remember to take equal care when writing your own name.

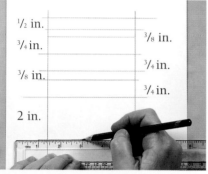

1 Draw a 4 x 6 in. (10 x 15 cm) box on a sheet of cartridge paper. From the top of the box, draw seven lines the following distances apart:

½ in. (13 mm)	⅜ in. (10 mm)
⅜ in. (10 mm)	¾ in. (20 mm)
¾ in. (20 mm)	2 in. (5 cm)
¾ in. (20 mm)	

Now measure ½ in. (13 mm) in from the edge of the card on both sides of the box. Draw lines down.

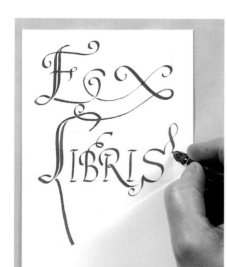

4 Create the writing staves on the card for the final piece. Mix the gouache with a drop of gum Arabic and some water to a smooth consistency. Apply this to your nib with a size 4 brush. Start writing at the same point on the letter "E."

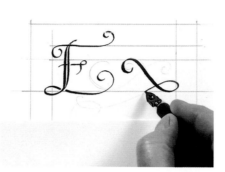

2 First, pencil in the words "Ex Libris," as a guide. Follow this by going over the letters in black ink with a size C5 nib. Start at the top of the double downstrokes of the letter "E." Continue until you have written all the letters.

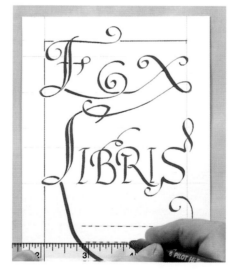

5 Mark lines around the card, ½ in. (13 mm) from the edge, taking care not to touch the violet lines. Now rule two lines for your name.

7 Using the glue, stick the card down in the center of the backing paper. When it is dry you can fix the plate into the front of a favorite book.

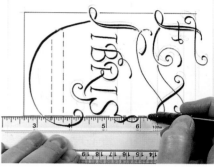

3 Use the fine-point pen and a ruler to draw in the two dotted lines for your name. Also draw lines in black around the rectangular box.

6 Cut the marbled backing paper 4 in. (10 cm) larger than the card, trimming the edges with fancy-edged scissors if you have them.

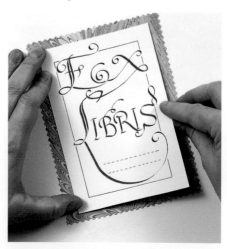

Materials

Fine-point black pen
Black ink
Violet gouache color
Gum Arabic
Jar of water
Palette
Size 4 paintbrush
Penholder
Speedball size C5 nib
Ink reservoir
Ruler
Soft 2B pencil
Eraser
White cartridge paper
Cream card
Marbled or colored backing
 paper
PVA glue
Fancy-edged scissors

LATIN LOVE CARD

This token of love is written freehand—without guidelines—so you can really accentuate the Italic flourishes. Some of the flourishes end with bright red hearts as a sign of your true devotion. To give the card an authentically "antique" look, the card edges are roughly torn to simulate aging.

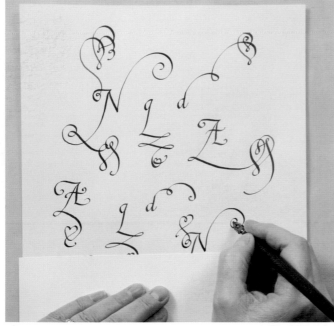

1 Take a piece of cream card and practice writing letters and flourishes freehand without guidelines. Mix up gouache with a little gum Arabic and some water, then fill the size C6 nib using the size 4 brush. As you write keep the letters flowing and include a flourished heart.

2 Take a sheet of card and fold it in half. Cut off any excess to make a card roughly 3 x 7 in. (7.5 x 18 cm). Open out the card and "age" it by roughly tearing each edge along a ruler.

3 On a practice sheet, measure 1½ in. (3.8 cm), 2 in. (5 cm), and 2½ in. (6.3 cm) down from the top fold and draw the three guidelines.

Materials

3 sheets of cream card
Penholder
Speedball size C6 nib
Ink reservoir
Soft 2B pencil
Ruler
Eraser
Size 4 paintbrush
Crimson red gouache color
Gum Arabic
Jar of water
Palette

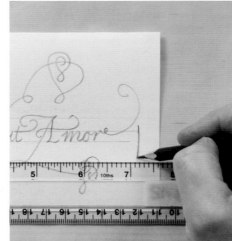

4 Use the soft 2B pencil to roughly pencil in the phrase you are going to write. Measure the length of the writing and transfer the marks to the start and end of the lines on the card.

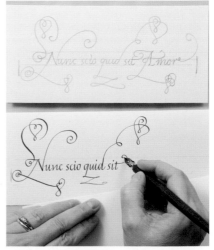

5 Load the brush with crimson gouache and apply to the pen nib. Write the card, keeping the letters and flourishes flowing. When dry, rub out the pencil lines.

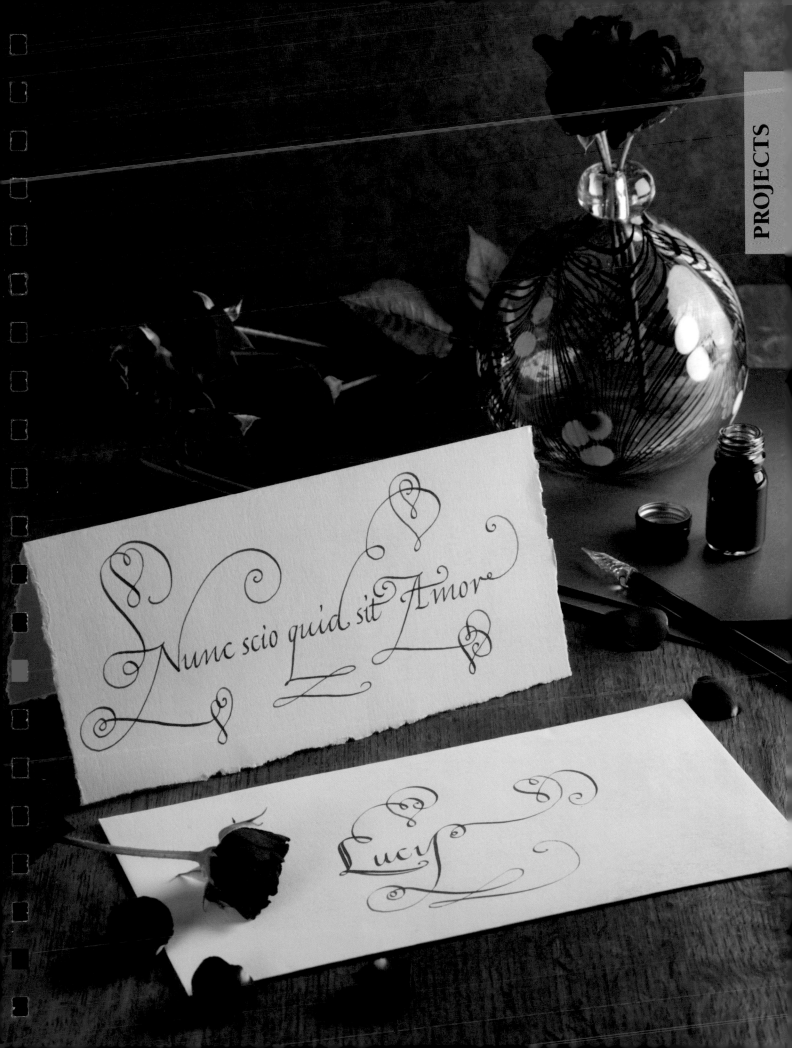

A CELEBRATION MENU IN FRENCH

Italic script is used in the best French-cuisine restaurants to add a touch of "class" to the menu. Next time you are holding a celebration meal or a dinner party for friends, why not send your guests an elegant menu in advance so they know what they'll be eating? They can keep it as a reminder of the evening, too.

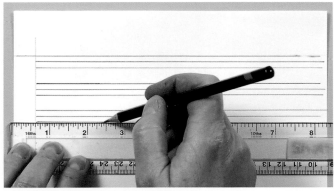

1 Draw a top line 1¼ in. (3.2 cm) from the top of the paper. Now measure in ⅜ in. (10 mm) for the left margin. Measure down ⁵⁄₁₆ in. (8 mm) and draw a baseline, then measure up ³⁄₁₆ in. (5 mm) and draw the x-line. Repeat until you have nine staves, leaving a space of ⅜ in. (10 mm) between lines.

2 Practice writing the menu with a size C5 nib, starting from the top stave.

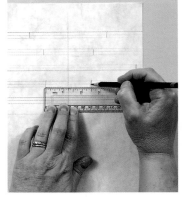

3 Measure the length of each line of writing. Put pencil marks at the beginning and end of each line, and note down the measurement.

4 Find the center of the sheet of parchment paper, and draw a line down. Create the lines as before, but this time ignore the margin and leave a ⅝ in. (16 mm) gap between each line of the menu. Center each line of the practice writing, marking the beginning and end of each line you will write.

5 Copy out the menu from your practice sheet, taking care to use the same amount of space for each line to keep the menu centered.

6 Add a flourish motif at the bottom of the menu to complete it. Rub out the pencil lines when the ink is completely dry.

Apéritif et ses Amuse-bouches

Salade Gourmande

Duo de Saumon et Loup de Mer aux Deux Sauces

Sorbet Normand

Noix de Veau aux Pleurotes et ses Petits Légumes

Salade de Saison

Assiette de Fromages

Nougat Glacé

Café

Materials

Penholder
Speedball size C5 nib
Ink reservoir
Black ink
Soft 2B pencil
Eraser
Ruler
White cartridge paper
Green vegetable parchment
 paper

CHAPTER 6: COPPERPLATE

Copperplate writing became popular in the 17th century, but is more commonly associated with the 19th century. A fine flamboyant style, it can been seen on old documents from the era.

The name "Copperplate" derives from the sheets of metal that engravers often used in the manufacture of printed matter. They were sometimes etched with very fine thin and thick lines to resemble the writing of that time.

When Copperplate first appeared, most lettering was done with goose quill pens, but by the middle of the 18th century growing literacy rates increased demand for steel pens, and steel nibs were manufactured specifically for Copperplate writing. Soon there were many different types of pointed nibs. Many countries, including the United States, Britain, France, and Holland, all claim to have first invented the steel pen.

A fine-pointed tip is known as a Copperplate nib. It is narrow with a split down the middle and so was quite different than the cut goose or swan quill pens of before.

Copperplate writing was an important subject at school. Known as "handwriting," it was taught to British school-children of the Victorian era (19th century). A child would practice with white chalk on small slate boards by copying from the examples written on the blackboard. The children then progressed to using a wooden penholder and a steel-pointed nib to copy letters from a copybook.

Unlike other forms of Roman script, the different line thicknesses are mainly achieved through pressure, not just nib angle. Thick lines are made by putting more pressure on the nib, allowing more ink to flow. Thin lines are produced by easing up on the pressure of the nib and letting it glide.

The upstrokes are thin, while downstrokes are thick. The writing is characterized by its right-slanted angle with large loops and swashes going above and below the guideline.

COPPERPLATE MAJUSCULE

Use the stroke sequence arrows to complete the alphabet.

Step-by-step direct-pen techniques

The Copperplate alphabet is made up of distinct thick and thin lines. It is a free-flowing form of writing and so it is important to keep the pen moving at all times.

All the lowercase letters start on the baseline, not at the top line, as with other Roman scripts, and the nib slides up the paper. Loops are characteristic of this style and should be made as even as possible. Try to get a feel for the writing and let the pen glide over the paper.

The capital letters start in different places. Some have either loops or simple spiral strokes. As you write try to make the letters nice and round, ensuring they have an even slant to the right. Look at the step-by-step stroke direction to help you form this beautiful alphabet.

As the alphabet is written with a fine-point pen nib, you do not mark nib-widths on the left side of your paper, so you do not need to mark writing staves, unlike the other Roman scripts. The usual method is to mark just one baseline. If you prefer to rule lines across the page to help you with the writing height, then using a measurement of $^3/_8$ in. (10 mm) for capital letters and $^1/_4$ in. (6 mm) for lowercase letters works well when starting to write Copperplate.

Start by using a soft 2B pencil to mark a line across the paper for the baseline. Measure $^3/_8$ in. (10 mm) up and draw a second line as a guide for capital letters and lowercase letter ascenders. Keep the pen at a constant angle of 45° to the paper.

Writing the letter "A"

1 Start with a swirl begining at the x-height, and then write a curved stroke in one movement. The angle may seem flat but practice until you discover the best shape.

2 Now write the right-hand downstroke, which is much steeper than the previous stroke.

3 The movement continues into the crossbar, which becomes a tear-shaped stroke that almost reaches the height of the letter before cutting back through the first stroke.

Writing the letter "R"

1 The first stroke of the "R" seems to reflect the first stroke of the "A" but is, in fact, more upright. It also drops below the baseline between the swirl and ascender.

2 The rest of the letter is written in one movement. Halfway through, a clean curve has risen above the previous stroke before crossing it above the top line of the stave.

3 Continue the curve to make the bowl of the "R" before making a looped change of direction to create the letter's prop, which sits on the baseline.

COPPERPLATE MINUSCULE

Like the Italic hand Copperplate lettering involves fancy flourishes and swashes.
But unlike the pronounced slant and exaggerated loops and flourishes at the beginning
and end of capitals, the looped lowercase letters are fairly simple and upright and formed
from open spirals and curves. The letters below are shown apart for clarity, but when
writing join each one to the next in a word without lifting the nib from the paper.

Use the stroke sequence arrows to complete the alphabet.

Writing the letter "f"

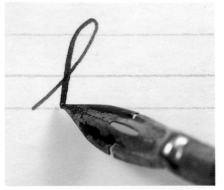

1 In contrast to the capitals, the lowercase letters are upright, so ensure that after the loop your first stroke is almost vertical.

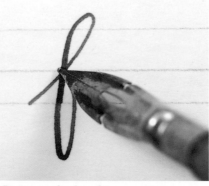

2 From the baseline, continue down before curving sharply up to finish at the first crossing.

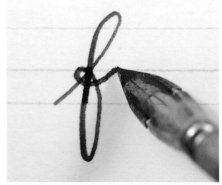

3 Complete the letter with a small, delicate twist that crosses the letter at the same position.

Writing the letter "z"

1 Starting at the baseline, curve up to the x-line before turning along it. Then come sharply down, mirroring the angle of the curve in a straight line to halfway between the lines.

2 Move the pen in a smooth clockwise turn, returning to the baseline and finishing just below it.

Use of colored inks

This script works well using waterproof colored ink and the Copperplate nib.

However, pointed nibs can get blocked easily so, to avoid this problem, when mixing gouache try to make the color a more watery consistency.

Apply the gouache with a brush in the usual way but keep washing the nib with water regularly as you write.

COMMON MISTAKES, TIPS, AND PROBLEM SOLVING

Making the strokes too wide: Copperplate letters are relatively narrow, so try to make even strokes at a flowing pace, and do not use too much pressure.

Pressing too hard when making your downstrokes: This can cause the ink to bleed into the paper.

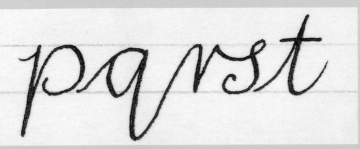

Leaving spaces: All the letters in a word should join up and the nib only rarely lifts off the paper. Let the pen glide across the surface and get a feel for holding the pen and forming the letters. Practice putting pressure on the nib and taking it off again. Upstrokes are light and thin, downstrokes are thicker.

Being too adventurous with flourishes at first: Start by doing practice flourishes to get the feel for the Copperplate alphabet before applying them to the letters.

BIRTH ANNOUNCEMENT

For special announcements, such as the birth of a baby, Copperplate writing adds an air of formality and authority that cannot be bettered. Practice writing the infant's name several times and, as an extra touch, be sure to add a flamboyant flourish drawn from the tail of one of the letters—it does not need to be the last one.

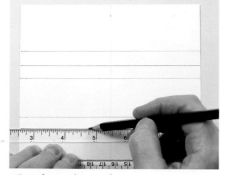

1 Take a sheet of practice cartridge paper and cut it in half. Use the ruler to find the center line and draw a pencil line down the paper. For the guidelines, measure 1³⁄₈ in. (3.5 cm) down from the top of the paper and draw a line across. Measure down from this line 2¹⁄₈ in. (5.4 cm) and draw another line across for the baby's name. For the birth weight measure down 1¹⁄₈ in. (3 cm) from the second line and draw a line across. Measure down another ³⁄₈ in. (10 mm) for the baseline. Finally measure up from the baseline ⁵⁄₁₆ in. (8 mm) and draw a line 1 in. (2.5 cm) long to the left of the center line. Measure up ¹⁄₄ in. (6 mm) and draw a line 1³⁄₈ in. (3.5 cm) long to the right of the center line.

2 Pencil in the wording, practicing the baby's name, weight, place of birth, and date of birth.

3 Fill your nib by dipping it into the red ink, and start writing. Cover the pencil wording with red ink, continuing through the flourish.

4 Move down to the next set of lines and do exactly the same, covering the pencil with black ink. Continue until you have written all the lines on the practice sheet.

5 Take the parchment paper and mark guidelines on it exactly as before. Start writing the baby's name on the top stave in red ink.

Materials

8¹⁄₂ x 11 in. cartridge paper
Pale pink parchment paper
Penholder
Copperplate nib
Black calligraphy ink
Red waterproof ink
Soft 2B pencil
Ruler
Eraser

6 Copy out the other lines in black ink, filling in the weight, place of birth, and date.

7 Rub out the pencil lines when the ink is completely dry.

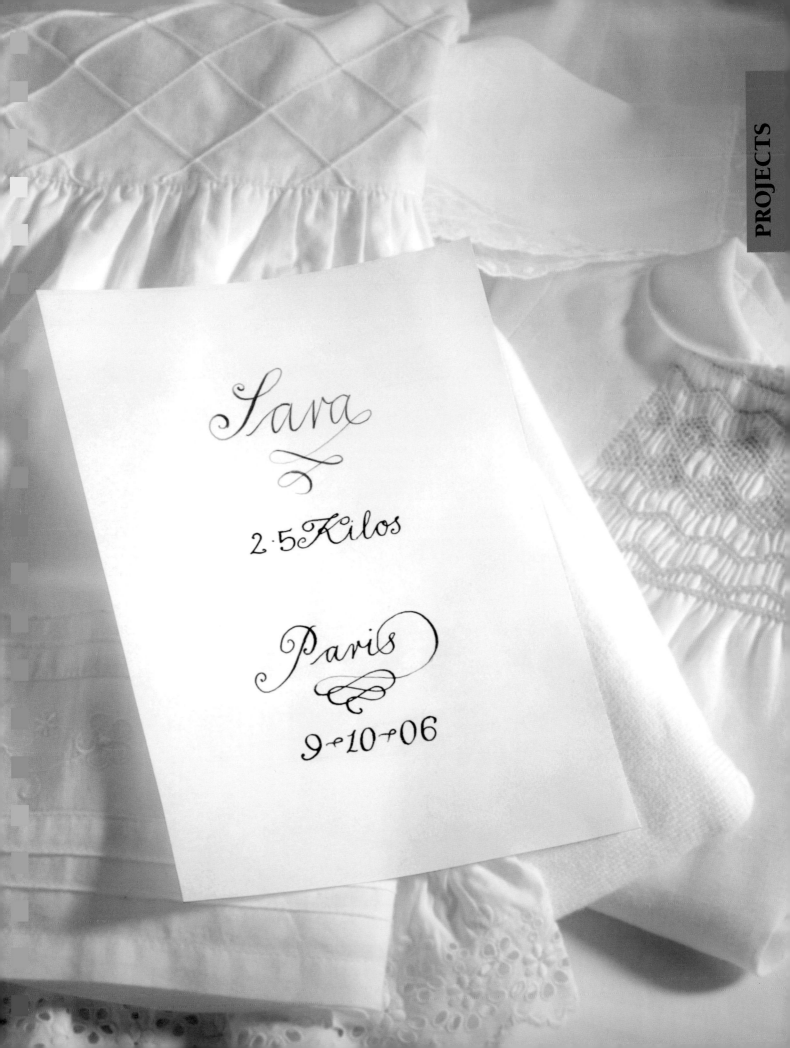

PLACE NAME CARDS

Beautiful handwritten place cards add elegance and originality to a dinner setting. Once you master this skill you will find you are in constant demand from friends to do the same for them! Another advantage—practicing all those names will help you to polish up your own handwriting.

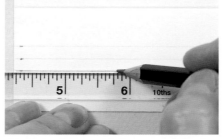

1 Take a piece of cartridge paper and rule three guidelines across it. Measure ³/₈ in. (10 mm) between base and top lines and add a line ¹/₄ in. (6 mm) up for the x-height. Practice writing on cartridge paper and then measure the length of each name and note it down.

2 Rule three guidelines on a blank place card, drawing the lines using the same measurements as before. Find the center of the card and transfer the length measurement ensuring it is centered. Put a pencil mark where the name starts and finishes.

3 Place the nib on the card either at the base or top line, depending on which letter the name starts with, and write the name.

4 Take care to give the capital letters a flourish, as with the "L" here.

5 When the ink has dried completely, rub out the pencil lines with an eraser.

Materials

Practice cartridge paper
Blank place cards
Violet waterproof ink
Pen holder
Copperplate nib
Soft 2B pencil
Ruler
Eraser

Elizabeth

NON-LATIN SCRIPTS

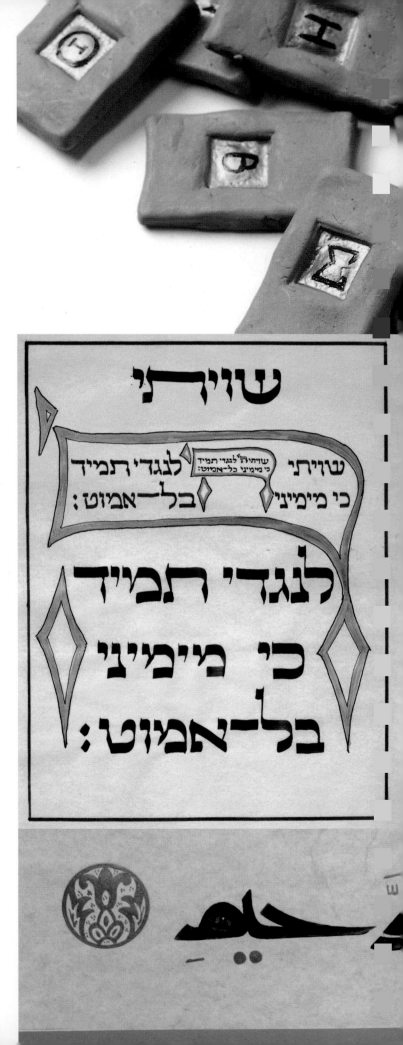

nglish-speakers often take it for granted that all European text is based on the Latin alphabet. But this is not so and there are many others in use, such as Greek, whose origins can be traced back to some of the oldest pieces of writing ever found in Europe. To the casual eye, Russian text looks similar to ancient Greek, as many of the letters are the same. The Russian alphabet is known as "Cyrillic" as it was thought for a long time—wrongly, as it happens—that the script was invented by Saint Cyril. The Middle East, too, boasts many stunning styles of writing, such as Hebrew and Arabic. These scripts are used here to decorate exotic projects, including beautiful plates and ceramic tiles covered with Arabic text, a quill used to write a Hebrew "shevti" or religious poster, ancient Greek clay "fortune-telling" tiles, an elegant manuscript book, and a Russian poem, illuminated in gold leaf.

Пословица

Погонишься

за двумя

зайцами,

ни одного

не поймаешь.

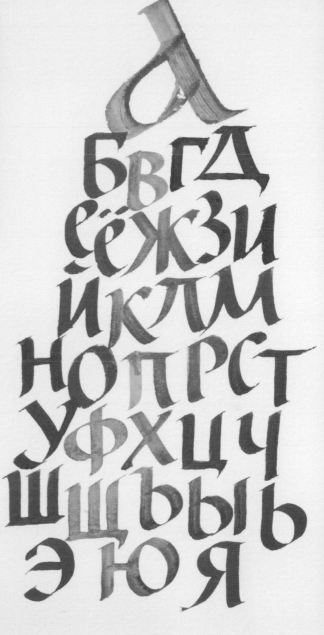

CHAPTER 7: ANCIENT GREEK

Ancient Greek calligraphy has its roots in some of the oldest writing systems. It can still be seen today in the surviving texts and inscriptions dating from the dawn of civilization. The techniques used are similar to those in modern calligraphy, and learning a little of the language and history of Ancient Greece, and using their preferred writing medium, papyrus, helps you to appreciate their historic scripts.

The people of Greece called themselves "Hellenes"— people of the mythical Hellen. The foundations of their culture, regarded by many as the world's first fledgling democracy (as most free men, but not women or slaves, had the vote), were laid in the islands and coastline around the western shores of Asia Minor (now Turkey) in the eighth century B.C.E. The Ancient Greece we think of today was not a single entity, but a group of separate city states.

Only a few of these states would now be regarded as democracies, in the modern sense of the word, but each one had its own government, currency, laws, and dialects. The binding force of their civilization was communication, by means of the spoken and written word.

Greek poetry dates back to the time of Homer, around 720 B.C.E., but during this period—and for a long time afterward—verse was handed down by word of mouth, known as "the oral tradition." Writing was reserved for financial records and religious works, such as incantations and prayers, the province of a special "class of scribes."

When the term "Ancient Greece" is used, it usually refers to the "golden age" of the Athenians, in the fifth and fourth centuries B.C.E. Despite Athens being quite a small city state, with a male population of around 50,000, the impact of the Athenian scholars, philosophers, politicians, and historians reaches out from their time to ours.

All their endeavors laid the principles for what we term "civilization," and even if you have never taken a really close look at Greek writing before, you will find that there is much that is familiar.

One of the enduring legacies left by the Ancient Greeks was the development of their alphabet—the word itself formed from the first two Greek letters: alpha and beta.

Above: Using ancient Greek you can recreate authentic-looking craft pieces, such as this temple frieze, made by the author.

Writing reached Greece in the Bronze Age (2200–1450 B.C.E.) and was first used in Crete by the Minoans. Pictures and symbols, possibly from hieroglyphics, were simplified into a script, now called Linear A (which remains undeciphered to this day). This may have evolved into the script now referred to as Linear B, which was used by the Myceneans (1600–1100 B.C.E.), but this is only a theory and scholars have never proved it beyond doubt. The Linear B script was lost during the later Barbarian invasions.

The Greeks then "borrowed" their alphabet from the Phoenicians, who lived in modern-day Lebanon around 1100 B.C.E., and by 500 B.C.E. the classical Greek alphabet had developed into its final form. By this time major changes had been made to it. The first line of Phoenician text runs from right to left. Boustrophedon (from the ancient Greek, meaning "following the ox furrow"), which is characteristic of early Greek, alternated the direction with the text snaking back and forth left to right and then right to left. By the fifth century B.C.E. the Greeks formalized the system to read left to right only—as we do in the West today. Separate signs were created for vowels, based on the Phoenician Aleph (Alpha), He (Epsilon), Yod (Iota), and Ain (Omicron).

These changes developed over a long time and each Greek state used different versions of the alphabet. By 370 B.C.E., it was the Ionian variant of the alphabet that had become standardized across Greece.

If you think our modern alphabet is taken from the Romans, take note! The Greeks took their writing to Italy—Old Roman is much like Greek, 16 letters are the same—the first step in ensuring the Greek alphabet spread to encompass Western civilization.

Above: The Greek world surrounded the Mediterranean, encompassing much of Africa and Asia.

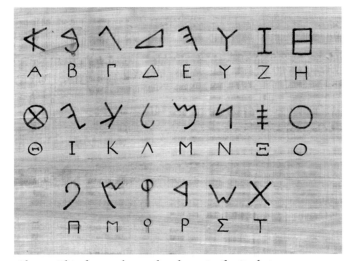

Above: This figure shows the close similarity between many Phoenician characters (shown in lines one, three and five) and Greek variants (lines two, four and six).

Below: Early Greek script used many of the letters that were to become familiar in the classical writings of a later age, such as this ode, recreated by the author.

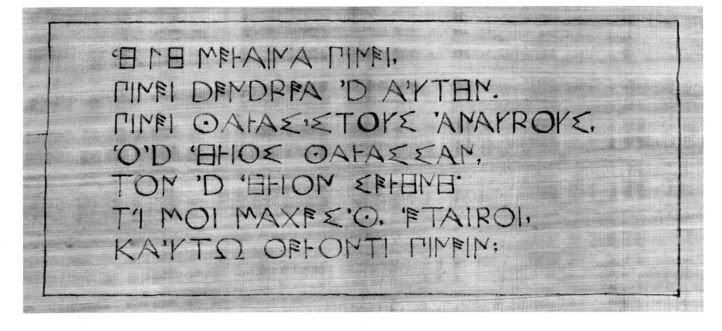

MATERIALS

Being an ancient text, Ancient Greek looks best when displayed on traditional materials such as papyrus—the earliest surviving example of which dates back to 3500 B.C.E. Buy plenty of sheets of papyrus so that you can try out different techniques, and use whatever paints you already have, rather than specially bought materials.

Which materials you use will depend on the effect you are trying to create. Don't try using ink straight onto papyrus as it is too watery. A form of solid ink was used in ancient times as the weather was so hot that a watery mix soon evaporated and it was a waste of time and water to keep diluting it. Think of calligraphy on papyrus as being a coating rather than an impression.

Many of the modern manufactured black pigments dry to a sheen, gloss, or hard metallic finish, so if you are trying to produce an "ancient" looking piece stick to dip pens and create your own color range.

Acrylic inks can give a good effect, but if the sheets you are using are very thick or translucent, avoid using too much water.

Fiber-tipped calligraphy pens are useful for drawing templates. Brown gives an aged look when used directly on papyrus. But avoid black, which can look hard and modern in the small sizes, and watery in larger sizes.

Avoid imitation papyrus made with banana strips. The difference is not obvious at first but the aroma soon gives it away!

Acrylic effect paints look good as long as you don't apply too many coats.

Varnishes will take some color—try adding a little crimson red and burnt sienna to antique gold.

Interesting effects can be created on papyrus using **gouache, pastels, crayons, charcoal,** and **water-based pencils.**

Watercolor brushes are easy to use, but be warned that papyrus soon wears them down.

A strong paint mix is needed on papyrus. If working with dip pens, use thickened **watercolor** rather than thinned acrylic.

Dip pens write well on papyrus, but take care to avoid snagging the fibers. If you are left-handed, place the sheet at an acute angle and take your time so the nib doesn't catch on the surface.

Early writing materials

Some of the earliest writing materials used in the Ancient Greek world were wood, the most commonly used writing medium, and clay and wax tablets. Clay tablets were simply molded pieces of clay with one surface smoothed over with a stick. Wax tablets were made by pouring wax into a depression carved into wood. The text was then inscribed into the clay or wax using a wooden stylus.

However, papyrus was the writing medium of choice for much of the ancient world, and is still made the traditional way, with strips of reed placed in the sun by the banks of the Nile and left to dry. The text was usually written with reed pens, or sometimes with wooden or quill pens, using ink made from soot, water, and plant gum.

With the wide range of modern paints, brushes, quills, and styles in current use, papyrus is still as versatile a medium as it ever was. Being "traditional" it is not as uniform as manufactured papers, or handmade papers that contain modern fibers, which makes it a very interesting surface to work with. You should look at each sheet of papyrus as an individual in its own right. It is made of plant strips that run in different directions on each side. Within each sheet, the strips may be from different plants, sometimes the strips don't meet, or the color can vary from translucent honey to reddish brown. You could even find the odd bug that has been "entombed" during manufacture. Sometimes one strip, or just a few fibers, may take on paint their entire length within seconds, ruining your artwork. So it pays to take care when choosing a sheet to make sure it is suitable for your subject. But all these aspects are just part of the charm of working with papyrus; they should be embraced, rather than viewed as "imperfections."

Papyrus is sensitive to water—buckling can be a serious problem—so avoid using washes. To get a wash effect, use a stronger shade and then lift off some of the color with paper towel. The paint that remains will have stained the sheet, giving it an "aged" look. Beware of too many layers of this effect, however, as watercolor can become very "muddy" looking on papyrus. You can probably repeat this technique twice, but three times may be too much, especially when using white or bright colors.

Translucent papyrus is quite resinous and looks good on matte black mountboard so that you can see the natural edges. Darker pieces are like rough canvas, and painted stone effects work well on these.

Avoid strong sunlight, and inks or paints containing vinegar or other acids, which can eat into the fibers.

Templates

Drawing a design onto papyrus can be the hardest part of the project. Try to keep the graphite layer to a minimum. The resin on the surface is quite tough but it will erode if you are over-enthusiastic with an eraser, and this can lead to problems when you start to paint or write.

It is probably best to make a template. This can be a little time-consuming, but mistakes are less likely. Use graph paper to make an initial sketch. If you are intending to write out an inscription this will also help you to keep your lines straight and your letters in proportion.

Creating a stave

It will make your work easier if you draw a writing stave for every line of text. Start by drawing a baseline. Measure up 5 nib-widths and use a ruler to mark a line for the x-height.

Next draw a line 5 nib-widths below the baseline for descenders, and another line 5 nib-widths above the x-line for ascenders. Use this as a guide for your letters.

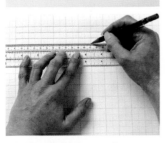

1 Draw four evenly spaced pencil lines across your practice paper.

2 Center lines are for the x-height; top and bottom are for ascenders/descenders.

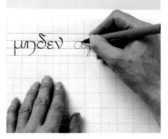

3 Keep within the stave when you are writing in ink over the practice pencil lines.

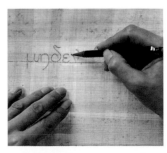

4 Draw the stave on the papyrus to keep the lettering even.

UPPERCASE ALPHABET

Ancient Greek calligraphy looks best when it has a "natural" appearance, and this is best achieved by writing at your normal speed. To Ancient Greeks content was much more important than having neat writing, so "scruffy" calligraphy looks good on papyrus! By formalizing your capital letters, text can be made to look like an old carving.

Classical Greece is famous for its great mathematicians, such as Euclid and Pythagoras, who laid down the basic rules and theorems of geometry in use today. So it is not surprising that many of the letters of the Ancient Greek alphabet are also found in mathematics and science.

Ancient Greek has been a dead language for more than 2,000 years, and so no one alive today can know for sure how it was spoken. The pronunciation guide at the bottom of the page is a reconstruction of what it might have sounded like, and is quite different from modern Greek pronunciation.

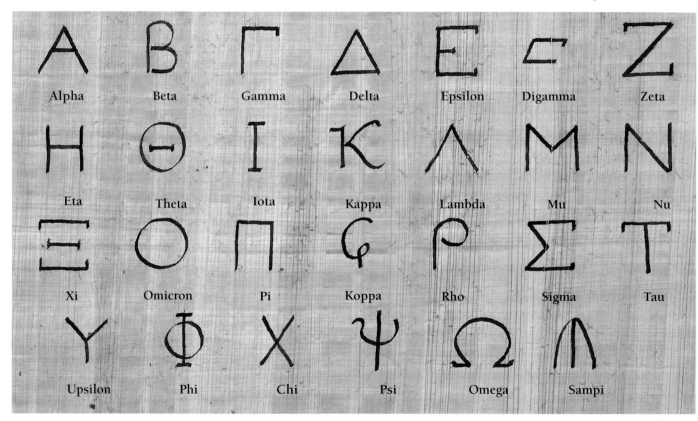

Alpha · Beta · Gamma · Delta · Epsilon · Digamma · Zeta

Eta · Theta · Iota · Kappa · Lambda · Mu · Nu

Xi · Omicron · Pi · Koppa · Rho · Sigma · Tau

Upsilon · Phi · Chi · Psi · Omega · Sampi

Name	English	Pronunciation
Alpha	a	as in "puppy" or "farm"
Beta	b	*as English*
Gamma	g	hard, as in "golf"
Delta	d	*as English*
Epsilon	e	short, as in "wet"
Zeta	z	as in "zoo" (from the first century C.E. but earlier dz as in "lads" or zd as in "wisdom")

Name	English	Pronunciation
Eta	ê	long, as in "stair"
Theta	th	as "thigh" or "ant-hill"
Iota	i	short, as in "pin"
Kappa	k	*as English*
Lambda	l	*as English*
Mu	m	*as English*
Nu	n	*as English*
Xi	x	*as English*
Omicron	o	short, as in "pot"
Pi	p	*as English*

Name	English	Pronunciation
Rho	r	*as English*, trilled
Sigma	s	soft, as in "sigh"
Tau	t	*as English*
Upsilon	u	as in "fuller"
Phi	ph	*as English*, or as in "drop here"
Chi	x or k-h	as in "exit" or "back-hand"
Psi	ps	as in "corpse"
Omega	ô	as in "ford"

Writing the uppercase "Sigma"

1 Start by writing the horizontal line along the top line.

2 Make the diagonal marks in two strokes, starting on the left.

3 Add a horizontal along the baseline to finish the letter's structure.

4 Complete the letter by adding small serifs inside the writing stave.

Writing the uppercase "Phi"

1 Draw half the circle of the letter centrally within the stave.

2 Enclose the letter bowl to create a circle.

3 Draw a straight line through the center of the bowl.

4 Add serifs to the ends of the straight line to complete the letter.

Writing the uppercase "Psi"

 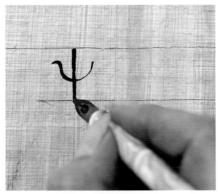

1 Within the stave, draw a semi-circular bowl, starting with a small horizontal line.

2 Finish with a vertical line through the center of the bowl from top line to baseline.

LOWERCASE ALPHABET

The chart below shows how to form the lowercase alphabet. To draw them simply follow the number sequence and the direction of the arrows. If you're copying out an ancient piece of text, seen in a book or a museum, for example, be sure to include the dots and dashes, as they influence the meaning.

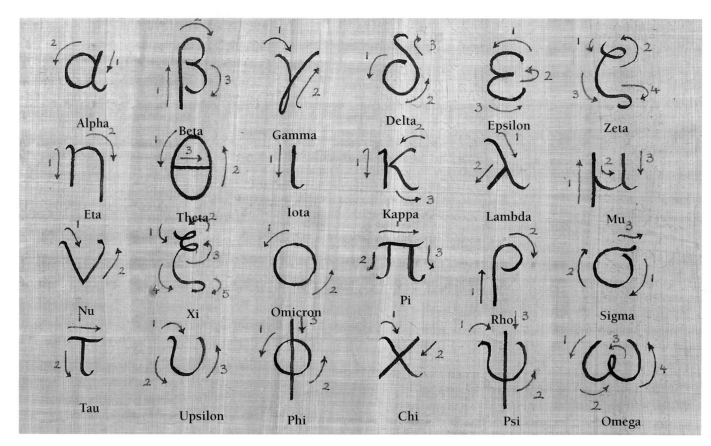

Use the stroke sequence arrows to complete the alphabet.

Anomalies and exceptions

Like all languages, Greek has its own unique set of rules, some dating from ancient days, whose logic has got lost in the mists of time. In particular some lowercase letters must be amended depending on where they appear in a sentence.

Words starting with a vowel must include a breathing to show which pronunciation is used. Finally, as in English, certain vowel sounds are created by using specific letter combinations (see facing page, top).

In modern Greek the letter "rho" gains a breathing (see facing page, bottom) if it occurs at the beginning of a word, although its pronunciation is unaffected.

The letter "sigma" is written differently when it occurs at the end of a word.

Diphthongs and double consonants

Diphthongs are special sounds created by combining two vowels, and are pronounced by running the two vowel sounds together, as in the words "fewer" or "toil."

Double consonants are pronounced by holding the sound of the consonant, as in "stop-per" and "black-coat," although there are a few exceptions.

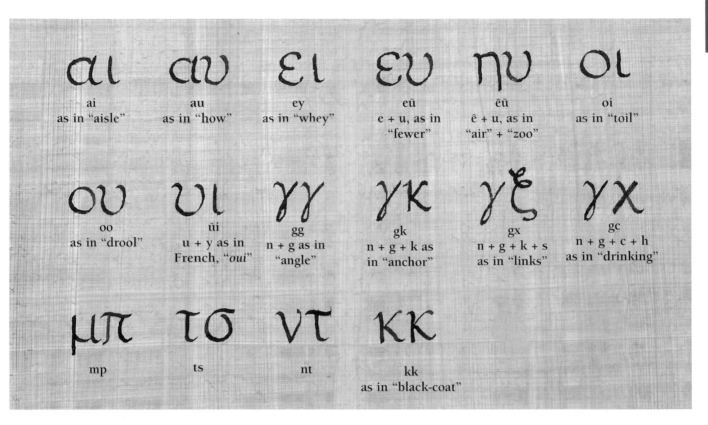

αι	αυ	ει	ευ	ηυ	οι
ai as in "aisle"	au as in "how"	ey as in "whey"	eü e + u, as in "fewer"	êü ê + u, as in "air" + "zoo"	oi as in "toil"

ου	υι	γγ	γκ	γξ	γχ
oo as in "drool"	üi u + y as in French, "oui"	gg n + g as in "angle"	gk n + g + k as in "anchor"	gx n + g + k + s as in "links"	gc n + g + c + h as in "drinking"

μπ	τσ	ντ	κκ
mp	ts	nt	kk as in "black-coat"

Punctuation and breathings

Greeks capitals are the most ancient form of Greek writing, and lowercase and punctuation came later. Spaces didn't come to be used until much later, but they have been included here for clarity, to avoid producing a confusing stream of letters. The period and comma were used just as they are in English. A dot placed above the line is the mark of a semicolon or colon. The symbol we use today for a semicolon was the ancient Greek question mark. There was no letter "H" in the Greek alphabet, but the sound was often used at the beginning of words, and indicated by a special mark, called a "rough breathing":

ἑ pronounced "he"

When the "H" sound is not meant to be pronounced at the beginning of a word that starts with a vowel or a diphthong it is indicated by:

ἐ pronounced "e"

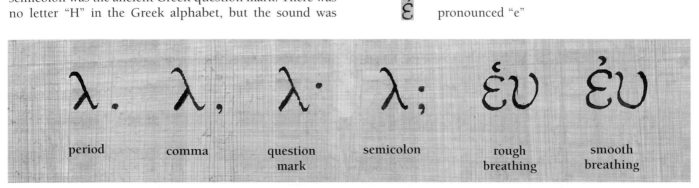

λ.	λ,	λ·	λ;	ἑυ	ἐυ
period	comma	question mark	semicolon	rough breathing	smooth breathing

CREATING AN AUTHENTIC TOUCH

You can produce a realistic-looking piece of art by taking a little trouble to recreate the color used in olden times, decorating your work with a border drawn in the style of the period, and learning the basics of the Greek numbering and dating systems.

1 Start by placing small amounts of burnt sienna, umber, indigo, and black inks into a mixing bowl using different brushes.

2 Add water to create a mix that replicates the color of ink used by the Ancient Greeks. Test it on the papyrus, adding more ink or water where necessary.

Using borders from vases and architecture

When creating your artworks, you can decorate them with borders that reflect the ancient origins of the language. Copy them from Ancient Greek vases and architecture and then combine them with the Greek lettering to give more interest and authenticity to your calligraphy work.

Converting English to Ancient Greek

One of the most enjoyable aspects of writing Greek calligraphy is to translate modern words and names into the equivalent Greek alphabet. A modern name or phrase gets extra resonance by being written in ancient lettering and can be especially enjoyed by both you and the recipient of the calligraphy.

1. Begin by breaking down the English words and write down how the syllables sound e.g., Matthew = Math + yew

2. Check if any sounds are diphthongs, combinations, or require breathing marks.

3. Write out the name in upper- and lowercase.

4. Decide on the writing style, and begin designing!

Numbers

The Ancient Greeks used two types of number systems for cardinals (1, 2, 3, and so on) and ordinals (1st, 2nd, 3rd, and so on). Acrophonic numbers—where the symbol comes from the first letter of the number's name—were used from c. 1500 B.C.E.–1000 B.C.E. This system was for only cardinal numbers, weights, measures, and units of value, and was mainly used for business transactions.

The Milesian system was used for both cardinals and ordinals, including the day of the month, lengths of time, money, distances, and so on. It is this system that is included here, as it was largely standardized by classical times. The system works by each letter in the alphabet having a value, nine letters for the units, nine for tens, and nine for hundreds (as shown below).

Milesian number system

1	2	3	4	5	6	7	8	9
10	20	30	40	50	60	70	80	90
100	200	300	400	500	600	700	800	900
1000	2000	3000						

Calendars and time

The Ancient Greek calendar, and its corresponding modern months, is shown below. The Greeks' calendar was much like their civilization: it was similar from region to region, but each city-state followed its own slightly different version.

All the calendars were "lunisolar"—each month was supposed to begin with a New Moon, the financial month being one lunar cycle—and so had 12 months. But as this system didn't make up a full "solar" year the months alternated between 29 and 30 days, corrected by observation when necessary, with the odd 13th month added as necessary to balance things.

The calendar below is the Athenian, chosen as it is the best known. The Athenian calendar was also called the "Festival Calendar," as the Ancient Greeks kept a separate

one for the political year. It is as confusing now as it probably was then. For example, ancient writers speak of the Olympics being every fifth year, rather than give a date, because they counted inclusively. The Athenian New Year began with Hekatombion, in summer. The New Year in other states varied widely, celebrated in the Fall in Sparta and Macedonia, and the winter in Delos.

The Athenians were relaxed about time-keeping. It was accurate in the long term, but a little vague from day to day. This was not from a lack of astronomical expertise, but because accuracy was left to those who cared about such things. Each "day" began at sunset, so "Tuesday" began at sundown on Monday. There was no concept of zero—no need to mark "nothing"—a space says it all.

The Athenian Festival Calendar

Βοηδρομιων	Boedromion	August 20–September 18
Πυανεψιων	Pyanepsion	September 19–October 17
Μαιμακτηριων	Maimacterion	October 18–November 16
Ποσειδεων	Poseideon	November 17–December 26
Γαμηλιων	Gamelion	December 27–January 25
Ανθεστηριων	Anthesterion	January 26–February 23
Ελαφηβολιων	Elaphebolion	February 24–March 25
Μουνυχιων	Munychion	March 26–April 23
Θαργηλιων	Thargelion	April 24–May 23
Σκιροφοριων	Skirophorion	May 24–June 21
Εκατομβαιων	Hekatombaion	June 22–July 21
Μεταγειτνιων	Metageitnion	July 22–August 19

DOLPHIN CARD

Make a beautiful card that reflects the art of Ancient Greece and its lovely alphabet.
You can use paper or, to make it more authentic, papyrus, and add lots of color
and geometric patterns to add interest to the basic designs.

1 Rule up the paper in pencil with two boxes, the top one 2½ in. (6.4 cm) deep.

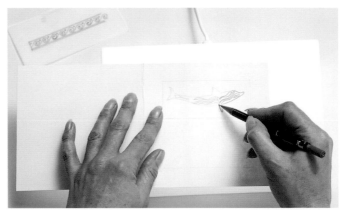

2 Use a small lightbox (or similar, see "Materials," below) and a pencil to transfer the designs onto the card.

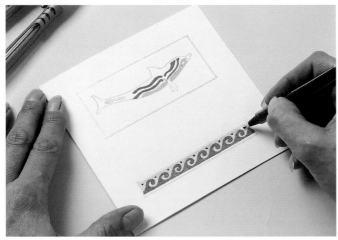

3 Color in and accent the design with gel pens.

4 Add the black lines and blocks with a fine-line pen.

Materials

Cartridge paper
Small card
Ruler
Lightbox (a window or glass-
 topped table with a lamp
 underneath work just as well)
Soft 2B pencil
Black and colored gel pens
Fine-line pen

5 Open out the card, and draw a writing stave and message in pencil. Overwrite in pen before rubbing out any visible pencil lines.

ALTERNATIVE: USING PAPYRUS

Materials
Papyrus
Watercolor paints
 – crimson
 – burnt sienna
 – burnt umber
 – black
Ruler
Pens

1 Make a brown mix from crimson, burnt sienna, and burnt umber watercolors, with a touch of black. Draw your chosen design on the front of the papyrus using a ruler as a guard.

2 Write on the inside in pencil as before. Overwrite in pen before rubbing out any visible pencil lines.

THE ALPHABET ORACLE

Citizens of Ancient Greece often used an "Alphabet Oracle" to reveal their future. This one is based on an inscription found in the ancient city of Olympus. It features 24 clay fragments painted with letters of the alphabet. Each letter has a matching oracle (see box, opposite). Put the pieces of clay in a bag and pick out three for a consultation!

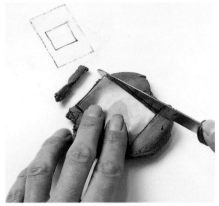

1 Cut out acetate rectangles and stick them onto a chunk of clay, wetting it with water. Cut around the acetate with a blunt knife.

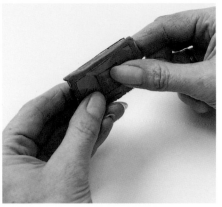

2 Place another acetate on the front and knead the two together to the desired thickness.

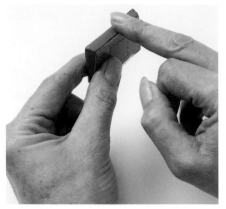

3 Use your finger to dampen and smooth down the edges.

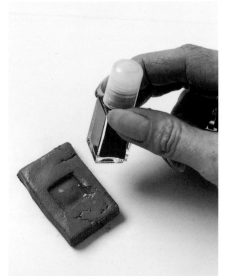

4 Make a small indentation on the top of the counter with a small square-bottomed bottle (e.g. for nail polish or similar).

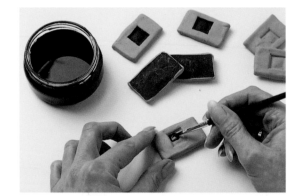

5 When the counters have dried out in the air, cover the backs and indentations with black paint.

Materials

Air-dry clay
Acetate sheet (available from art and craft stores)
Knife
Square-bottomed bottle
Paint: black and gold, any type
2 brushes

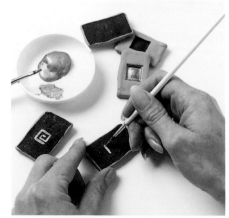

6 Cover the indentations with gold paint and add a key symbol on the reverse.

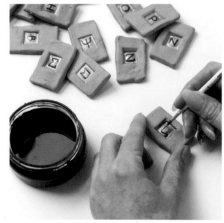

7 Paint one Greek letter into each indentation in black.

LETTER		MEANING	ACTION
Α	alpha	Everything	Achievement; Good luck; Good fortune.
Β	beta	Assistant	At a critical point, but Apollo will help you.
Γ	gamma	Gaia (the Earth)	A successful harvest; Reap profits; Results.
Δ	delta	Strength	Act with timing; Precision is everything.
Ε	epsilon	Desire (Eros)	Alliance; Union; Marriage; Children.
Ζ	zeta	Storm	Avoid raging storms; Take flight, don't fight.
Η	eta	Helios (the Sun)	Who watches everything, is watching you.
Θ	theta	Gods	You have the gods' help on your path.
Ι	iota	Sweat	Hard work is the surest means of success.
Κ	kappa	Waves	Don't fight waves; Endure with courage.
Λ	lambda	Left	A bad event may be a blessing in disguise.
Μ	mu	Labor	Hard work brings a change for the better.
Ν	nu	Strife/bearing	A gift given will bring strife with it.
Ξ	xi	Withered	Harshness and stinginess bring nothing.
Ο	omicron	There is not	What we send out comes back to us.
Π	pi	Many	Perseverance through adversity.
Ρ	rho	Easiness	Things will go easier if you wait awhile.
Σ	sigma	Simplicity	The best action is inaction, wait.
Τ	tau	From the companions	A separation; Parting.
Υ	upsilon	Undertaking	The affair holds a noble undertaking.
Φ	phi	Carelessness	Take responsibility for your actions.
Χ	chi	Gold	A rich ending; A golden event.
Ψ	psi	Judgment	The gods agree with your judgment.
Ω	omega	Difficulty (Omos)	A difficult time; A poor return.

One ancient method of divination was to put the pieces in a bowl or drum and shake them till one jumped out. Divination was so important to the Greeks that the rules of the Oracle and the meaning of the signs were carved into walls— hence the expression we still use today: "Set in stone."

KNIGHTS BY ARISTOPHANES

This is a small excerpt from the play *Knights*, by Aristophanes, first performed in Athens in 424 B.C.E. The paper is handmade with gold flecks and the calligraphy is written with a dual-tipped fiber pen. The writing was traced straight onto the handmade paper, as it will not tolerate the graphite in pencils.

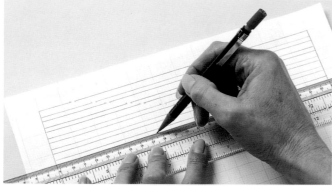

1 Decide how large your lettering is going to be and the number of lines required and mark a sheet of graph paper with the writing staves.

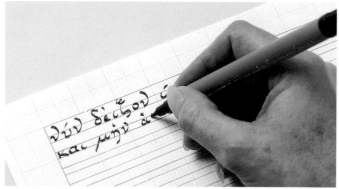

2 Roughly work out the spacings between letters, and write the words in pencil. When you are satisfied with your lettering, go over it with a black calligraphy pen.

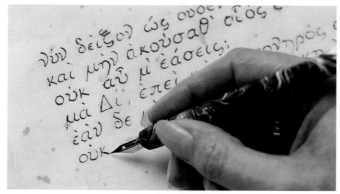

3 Put the graph paper on a lightbox. Place handmade paper over it and attach with masking tape. Trace through gently, taking care not to carve into the surface.

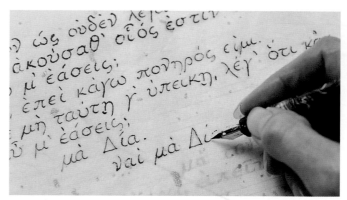

4 Where you require indents, move the handmade paper across the graph paper before continuing to trace.

Materials

Graph paper
Soft 2B pencil and ruler
Calligraphy pen and fiber pen
Handmade, gold-flecked paper
Lightbox (or window, or glass-
 topped table with lamp under)
Wooden scroll spindle (available
 from art and craft stores)
Ribbon
Masking tape

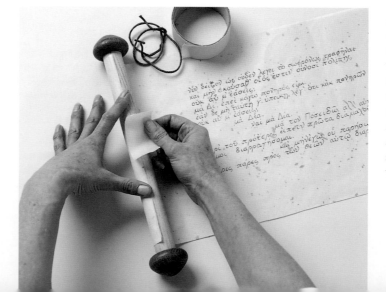

5 Attach the finished sheet to a wooden spindle (using masking tape or similar) and wrap it around as a scroll, tying it with a ribbon.

νῦν δεῖξον ὡς οὐδὲν λέγει τὸ σωφρόνως τραφῆναι
καὶ μὴν ἀκούσαθ' οἷός ἐστιν οὑτοσὶ πολίτης
οὐκ αὖ μ' ἐάσεις;
μὰ Δί', ἐπεὶ κἀγὼ πονηρός εἰμι.
ἐὰν δὲ μὴ ταύτῃ γ' ὑπείκῃ, λέγ' ὅτι κἀκ πονηρῶν
οὐκ αὖ μ' ἐάσεις;
μὰ Δία.
ναὶ μὰ Δία.
μὰ τὸν Ποσειδῶ, ἀλλ' αὐτὸ
περὶ τοῦ πρότερος εἰπεῖν πρῶτα διαμαχοῦμαι
οἴμοι διαρραγήσομαι.
καὶ μὴν ἐγὼ οὐ παρήσω
πάρες πάρες πρὸς τῶν θεῶν αὐτῷ διαρραγῆναι

TRANSLATION

Chorus: Now show us of how little worth is liberal education.
Sausage-seller: The sort of citizen he is, I'll first disclose my view.
Paphlagon: Give me precedence.
Sausage-seller: No, by Zeus, for I am a blackguard too.
Chorus: And if he doesn't give way, you can add to that,
"as all my fathers were."
Paphlagon: Give me precedence.
Sausage-seller: No, by Zeus.
Paphlagon: Oh yes, by Zeus.
Sausage-seller: I swear, I'll fight you on that very point. You will
never be first.
Paphlagon: Oh! I will burst.
Sausage-seller: You never will.
Chorus: Oh let him, let him burst!

Aristophanes' play recounts the war between the Athenians and the Spartans—when the fate of the city was hanging in the balance—and the political bickering and accusations of cowardice that resulted from it. This short excerpt features a confrontation between the hero, Paphlagon, and a sausage-seller, plus the chorus, representing the thousand cavalrymen caught up in the fighting.

CHAPTER 8: RUSSIAN CYRILLIC

The Cyrillic alphabet was devised in the ninth century specifically for writing Slavonic. The forms of the letters are based on Greek, but their order and value follow those of the Glagolitic alphabet, introduced earlier in the century by two Byzantine missionaries, St. Cyril and St. Methodius. Reforms carried out over the centuries have created the style in use today.

The origin of the Cyrillic alphabet is cloaked in mystery. Cyrillic has no direct connection with St. Cyril, the Thessalonian scholar, diplomat, and missionary whose name it bears. He, instead, was the inventor of the Glagolitic alphabet, devised in 862 C.E. in preparation for his mission to Great Moravia with his brother, St. Methodius, and used for the first Slavonic translation of the Scriptures and liturgy. Glagolitic survived into the 20th century in parts of Croatia, where a Slavonic Roman Catholic rite is used. Elsewhere it was largely forgotten, and since it was known that St. Cyril had devised an alphabet for the Slavs, his name became attached to the one actually in use.

Cyrillic probably originated in eastern Bulgaria. When Khan Boris was baptized in 864, Bulgaria was officially converted to Christianity, and a Greek liturgy was introduced. Surviving inscriptions provide evidence of fairly unsuccessful attempts to use Greek letters to write Old Bulgarian, so when Bulgaria adopted the Slavonic liturgy in the late 880s there seems to have been some resistance to the unfamiliar alphabet in which it was written: to this period belongs the famous treatise *On the Letters* by the monk Khrabr, which demonstrates that St. Cyril's writing system is the only one adequate for representing the sounds of Slavonic. Eventually a compromise was reached in the Cyrillic alphabet: its repertory of characters follows that of Glagolitic, but its letterforms are unrelated to it, and instead are based on the Greek uncial script in use at the time.

Other Slavonic nations that adopted the Eastern form of Christianity also adopted the Slavonic liturgy and Cyrillic alphabet, so that it is now used to write the languages of all the Orthodox Slavs. It was used by the Rumanians until it was superseded by the Latin alphabet in the 18th century. In more recent times, Cyrillic came to be used for a wide variety of non-Slavonic languages in the Russian Empire and Soviet Union, and Mongolian.

The monk Khrabr states that St. Cyril's alphabet had 38 letters, but the earliest surviving examples (both Cyrillic and Glagolitic) are not consistent, reflecting the fact that the language in those days was not standardized and already had considerable regional variations. With the passage of time and the evolution of the modern languages, some letters fell into disuse and others were added to meet local needs so that, for example, the alphabet used for modern Serbian has 30 letters, as does that for Bulgarian, but only 25 of them are common to both. The alphabet shown here is the modern Russian one, which has existed in this form since the language reforms of 1918.

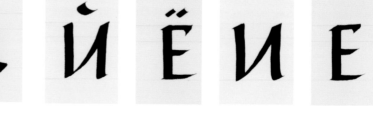

When writing the more unfamiliar Cyrillic letters, make sure that uppercase letters (above left) clearly differ from their lowercase versions (above right).

Two Cyrillic letters, "I kratkoe" and "I" (above left), are identical to their neighbors in the alphabet, "Ye" and "Yo" (above right), except for the addition of an accent.

MATERIALS

Cyrillic is an eye-catching alphabet that is ideal for projects involving color and gilding. When using color the essential skill is to mix gouache with water to a consistency where it will flow evenly through the pen. Gilding may appear over-ambitious for the beginner, but like all craft skills it becomes easier with practice.

Tracing paper allows you to work out your Cyrillic letter or design in rough and then reproduce it accurately. It also allows you to use one design for several projects.

Gold leaf is available in books of 25 transfers. When the glue has dried on the illuminated letter, simply press the gold side down onto the glue.

Bone folder is used to score and flatten paper, particularly in book-making. It can also be used with a bootknife to cut sheets to size.

Dog-tooth burnisher really brings out the sheen of gold leaf. Rub lightly over the gold at first and then increase the pressure until you see the gold gleam.

Ruler—choose clear plastic for drawing lines; this ensures your letters are all a uniform size.

Pointed nibs create thick or thin strokes according to the pressure applied.

Palette—mix gouache or watercolor paints for writing and painting.

Diluted PVA (white) glue is a good base for gold leaf. Paint the letter evenly and leave for 15 minutes to dry.

Paintbrushes are used for mixing paints, applying color to nibs, and painting backgrounds and borders. For most purposes a size 4 is ideal, but for intricate work you may need a size 00.

Pencils—choose hard types for drawing lines, and soft ones for sketching illuminated letters.

Bottled ink is best kept for fountain pens as it flows more easily through the nib.

Automatic pens (also called steel or poster pens) are for bold poster-size pieces of calligraphy.

Broad-edged nibs produce a thick or thin stroke depending on the angle of the nib.

UPPERCASE LETTERS

If you have practiced some of the script styles shown earlier in the book you should be well prepared for Cyrillic. The capitals are written in a formal, solid style with less variation in the thick and thin strokes than seen in most Roman scripts. A few letters also contain subtle serifs, used to distinguish two otherwise identical letters.

In printed Cyrillic many of the lowercase letters are simply smaller versions of the capitals. Reference to the section on writing Roman Capitals (pages 58–59) and Carolingian (pages 34–37 and 44) will help you in forming the shapes. The broad-edged pen is held at an angle varying between 20° and 30° with a few letters requiring flatter or steeper angles.

The cursive, or handwritten, Russian script may vary considerably in its letterforms, but the intention in this section is to help you to write a formal Russian script. The development of handwritten Cyrillic over the past two centuries has been broadly similar to that of handwritten Latin scripts. The cursive script shown on pages 146 and 147 is a version of Russian handwriting based on the Western Copperplate style. The most obvious difference is that the Cursive alphabet is written at a slope of about 10°—in contrast to the 45° slope usual with Copperplate.

You will need a pointed nib similar to the kind used for Copperplate writing and the same techniques of applying some pressure to downward strokes are applicable (see pages 114–117). So try to keep the point of your nib in the direction of your strokes. This may require changing the angle of your nib for some strokes.

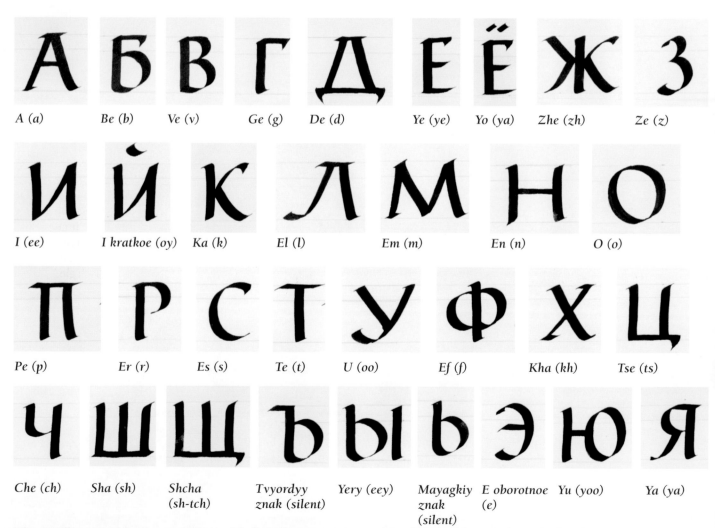

| A (a) | Be (b) | Ve (v) | Ge (g) | De (d) | Ye (ye) | Yo (ya) | Zhe (zh) | Ze (z) |

| I (ee) | I kratkoe (oy) | Ka (k) | El (l) | Em (m) | En (n) | O (o) |

| Pe (p) | Er (r) | Es (s) | Te (t) | U (oo) | Ef (f) | Kha (kh) | Tse (ts) |

| Che (ch) | Sha (sh) | Shcha (sh-tch) | Tvyordyy znak (silent) | Yery (eey) | Mayagkiy znak (silent) | E oborotnoe (e) | Yu (yoo) | Ya (ya) |

The Cyrillic capital letters are shown with their Russian names and English sound equivalents (in brackets) underneath.

Writing the letter "De"

1 At an angle of 20–25° draw the first stroke from top to baseline, curving a little to the left at the baseline.

2 Return to the top and, at the same angle, draw an overlapping stroke along the top line.

3 From the top, draw a diagonal line at the same pen angle to the right to touch the baseline.

4 Complete the stroke moving from left to right. At the end of the stroke, twist the nib to an angle of approximately 45° to create the serif. You will need this stroke on letters such as "Be" (b), "Ge" (g), "Tse" (ts) and "Shcha" (sh-tch).

Writing the letter "E oborotnoe"

1 At an angle of approximately 30°, make an arc to the right from top to baseline.

2 From the left, draw an arc on the baseline at the same pen angle to meet up with the first stroke.

3 Go back to the top and pull the stroke down to complete the arc.

4 Complete the stroke with an upward movement from the left and with a slight curve as you reach the stem. It is important that you don't overdo the "wiggle."

Writing the letter "Ef"

1 At an angle of approximately 25° draw a vertical stroke from the top to the baseline.

2 Placing the pen in the upper part of stroke one, draw an arc to the left, re-entering the lower part of stroke one.

3 Placing the pen at the same place as stroke two, draw another arc to the right, ending at the same spot on the lower part of stroke one.

LOWERCASE LETTERS

As with Roman-based languages, Cyrillic text mainly involves lowercase letterforms. Many of the letter shapes are unfamiliar to English speakers, but most have English sound equivalents. Therefore Cyrillic is not only an interesting and attractive script to learn, but can also help you to master the Russian language.

Modern printed Cyrillic originated with the type produced for Tsar Peter the Great, and was designed in deliberate imitation of Western European typefaces. Known as "civil script," it has been used ever since for printing secular texts; the service books of the Orthodox Church still use an older style of type resembing black letter.

The alphabet shown here is a handwritten variant of the civil script of the sort widely used for posters, notices, and, in the Soviet period, the "wall newspapers" that disseminated information and propaganda into almost every workplace. Print was not used because the Soviet government's anxiety to control the flow of information led it to impose severe restrictions on printing and copying facilities. This, however, had the benign side-effect that many people were able to write a hand suitable for public display.

Medieval Russian legal and business documents were written in a type of cursive that is as alien to modern Russians (and as difficult to read) as the secretary hand used in medieval Europe is to us. In the 18th century, however, a form of cursive strongly influenced by Latin Copperplate made its appearance, and became the basis of modern Russian handwriting.

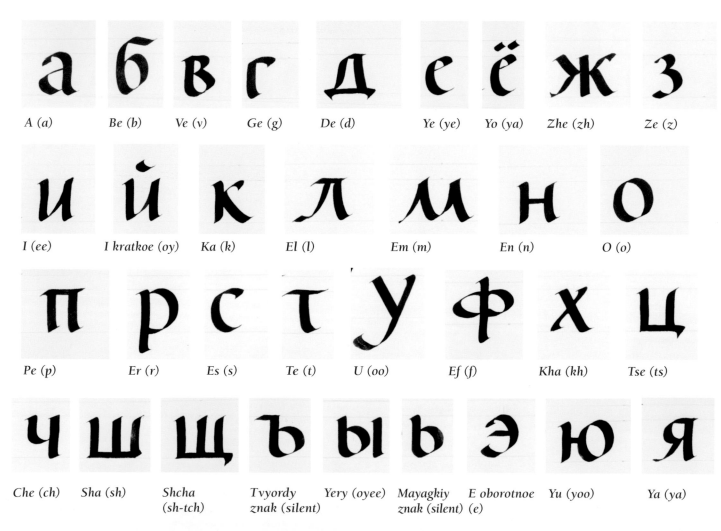

A (a)	*Be (b)*	*Ve (v)*	*Ge (g)*	*De (d)*	*Ye (ye)*	*Yo (ya)*	*Zhe (zh)*	*Ze (z)*
I (ee)	*I kratkoe (oy)*	*Ka (k)*	*El (l)*	*Em (m)*	*En (n)*	*O (o)*		
Pe (p)	*Er (r)*	*Es (s)*	*Te (t)*	*U (oo)*	*Ef (f)*	*Kha (kh)*	*Tse (ts)*	
Che (ch)	*Sha (sh)*	*Shcha (sh-tch)*	*Tvyordy znak (silent)*	*Yery (oyee)*	*Mayagkiy znak (silent)*	*E oborotnoe (e)*	*Yu (yoo)*	*Ya (ya)*

The Cyrillic lower-case letters are shown with their Russian names and English sound equivalents (in brackets) underneath.

Writing the letter "Be"

1 At an angle of about 25° draw the pen in a shallow arc to the left, starting at the top line and curving at the baseline.

2 Place the pen at the start of stroke one, and draw a slightly curved line to the right along the top line. Then, placing the pen in the center of stroke one, draw a flattened arc to the right, terminating at the end of stroke one.

Writing the letter "Zhe"

1 Starting at the x-line at an angle of approximately 30°, draw a gentle curve to about halfway down the x-height.

2 Flatten the pen angle to about 10° and draw a diagonal out to the baseline.

3 Moving to the right, draw a vertical line at about 20° from top to baseline.

4 At an angle of about 25°, draw a diagonal line leftward from the top to the stem, and then back out again to the right in a single movement.

5 Complete at the top with a twist of the nib to about 45°.

Writing the letter "Yery"

1 At an angle of 25°, draw a vertical line from x-line to baseline with a slight curve at the base.

2 Place the pen in the stem just above halfway and draw out a curve to the right and down to the baseline.

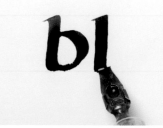

3 Complete the letter with a detached vertical stroke at the same angle.

CURSIVE ALPHABET

Working with a pointed nib produces a cursive style of Cyrillic—like English Copperplate but with a less distinct slope of 10°. Keep the point of the nib in line with the slope and direction of the letter-stroke, apply moderate pressure on "down" strokes, release pressure on "up" strokes, and make curved shapes oval—not round.

А а
A (a)

Б б
Be (b)

В в
Ve (v)

Г г
Ge (g)

Д д
De (d)

Е е
Ye (ye)

Ё ё
Yo (ya)

Ж ж
Zhe (zh)

З з
Ze (z)

И и
I (ee)

Й й
I kratkoe (oy)

К к
Ka (k)

Л л
El (l)

М м
Em (m)

Н н
En (n)

О о
O (o)

П п
Pe (p)

Р р
Er (r)

С с
Es (s)

Т т
Te (t)

У у
U (oo)

Ф ф
Ef (f)

Х х
Kha (kh)

Ц ц
Tse (ts)

Ч ч
Che (ch)

Ш ш
Sha (sh)

Щ щ
Shcha (sh-tch)

Ъ ъ
Tvyordy znak (silent)

Ы ы
Yery (oyee)

Ь ь
Mayagkiy znak (silent)

Э э
E oborotnoe (e)

Ю ю
Yu (yoo)

Я я
Ya (ya)

The uppercase "Te"

1 Draw a line at slight pressure from top to baseline, curve to the left and release pressure just before the baseline. Add a little ball at the end.

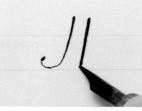

2 Draw a second line parallel to the first at a distance of about half the x-height.

3 Draw a third line at the same distance, allowing pressure to release just before turning right at the baseline.

4 With the nib at right angles, sweep around and up to a horizontal above the upright strokes; apply pressure and release at the end of the stroke.

The uppercase "De"

1 Pointing the pen in the direction of the stroke, move down, gradually increasing pressure to the baseline, then curve the stroke left and loop it back on itself.

2 With little pressure, continue right, curving up and around. Add pressure from the top curve, and release pressure for the final upward curve. Finish with a little ball.

The lowercase "Be"

1 From the x-line, use moderate pressure to curve left. As you curve right, release pressure. Swing the opposite curve upward without pressure to reach the top line.

2 Turn the nib at right angles and draw out a curved horizontal line to the right with pressure.

The lowercase "A"

1 From just below the x-line, draw a line up without pressure, curve left at the line and descend with pressure to curve to the right and up without pressure.

2 With the nib on the x-line, draw down vertically with pressure and curve to the right without pressure at the baseline.

COMMON MISTAKES, TIPS, AND PROBLEM SOLVING

The most common error found in broad-pen calligraphy is the failure to maintain a consistent pen angle. In the case of formal Russian, the pen angle is generally 20–25°. There are a few deliberate changes of angle, for example in the top serif on the letter "Ge," or the bottom serif on "De," which need to be twisted to about 45°, or some strokes of "Zhe" or "Ya," which require a flat pen angle. Poor assimilation of the letterforms is also common; you should learn to observe the underlying shapes that make up letters—circular or straight lines in the case of the formal alphabet, elliptical and curving in the case of the cursive alphabet.

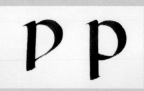

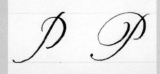

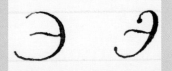

Try not to confuse the capital letter "Sha" with its close neighbor "Shcha," which ends with a twisted serif. Shcha's baseline needs a serif—ensure that you start the stroke to the left and bring it well over to the right. Also check that the verticals are evenly spaced.

The formal lowercase "Er" is like the lowercase "p" in Roundhand and should be written the same way. Do not write the bowl in one move but in two, starting from the stem—from top down, and then left to right. Drop the descender far below the baseline to give better balance.

The cursive capital "Er," resembles the Copperplate capital "P" and should be written the same way. Balance between left and right is vital. In the first example, the left-hand curve is narrow so the right looks too large. A better balance gives more finesse to the central stem (called "line of beauty").

The cursive capital "E oborotnoe" should resemble a reversed uncial "e." In the first example, the letter is too round and static. The correct example lifts easily to the top, drops in an ellipse with little pressure, and curves back to the left. Ensure the central bar balances the ends and is not short.

POEM ILLUMINATED IN GOLD LEAF

Nothing illuminates a work, such as this Russian poem, *Echo* by Pushkin, as gloriously as gold leaf, used here in transfer form. Apply as many layers you like as gold sticks well to gold. Paint the initial after applying the gold or the gold leaf might stick to the pigment. Red, blue, or green colors all contrast well with the gold.

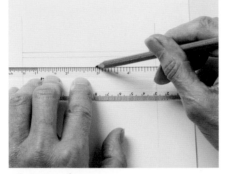

1 Write the text on practice paper so you can estimate the size of the text block. Fold a sheet of cartridge paper in half carefully and work out your margins so the gutter margin (the inside fold) is about half the outer margin on both sides. Top and base margins depend on the length of the text. Draw in the letter stave on both pages.

2 With a pencil trace or draw the initial letter as a dropped capital, sitting on the baseline of line two. Lightly draw a box around the capital that just touches its sides.

3 Write the text in black gouache mixed with water, painted onto the nib with a paintbrush.

4 Dilute the glue to the consistency of gouache. With a small brush, try to apply the PVA evenly across the drawn letter so there are no bumps. Leave to dry for at least 15 minutes. Breathe lightly on the PVA and press the transfer gold hard onto the letter.

5 Gently lift the transfer away. If the gold has not stuck completely, repeat the procedure. Apply more layers, if you wish. Burnish the gold to bring up the shine.

Materials

Cartridge paper
Soft 2B pencil
Speedball size C5 nib
Pointed nib
Gouache paint
PVA (white) glue
Sheet of transfer gold leaf
Burnisher
Ruler
Size 0 or 1 paintbrush

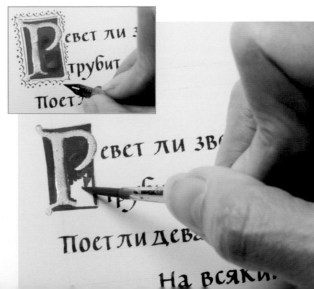

6 Mix a gouache color and paint the box around the gilded initial with a small brush. If you wish you can add decorative piping with white or a contrasting color in and around the initial.

ЭХО

Ревет ли зверь в лесу глух
Трубит ли рог, гремит ли гро
Поет ли дева за холмом —
На всякий звук
Свой отклик в воздухе пустом
Родишь ты вдруг.

ЭХО

Ревет ли зверь в лесу глухом,
Трубит ли рог, гремит ли гром,
Поет ли дева за холмом —
На всякий звук
Свой отклик в воздухе пустом
Родишь ты вдруг.

Ты внемлешь грохоту громов,
И гласу бури и валов,
И крику сельских пастухов —
И шлешь ответ;
Тебе ж нет отзыва ... Таков
И ты, поэт!

Александр П

7 Finally, mix a red gouache to write the title, possibly with a slightly larger nib than the text at the head of the piece. At the end of the text, use the same gouache to write the author's name in a cursive style with a pointed pen.

A SIMPLE MANUSCRIPT BOOK

This small single-section book can be used for a Russian poem or a piece of folk wisdom.
Find contrasting papers for the endpapers, openings, and cover. The book is fastened
using a simple sewing technique. Stiff card holds the book firm. The cover
can be as light as tissue paper; avoid heavy paper, which is too bulky.

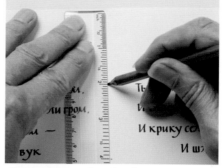

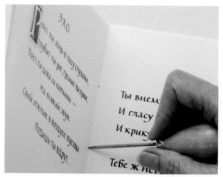

1 Trim the cartridge paper, card, and one sheet of decorative paper to the size of the sheet with text. Arrange with the text page on top, followed by a sheet of cartridge paper, the decorative paper, the other sheet of cartridge paper, finishing with the card. Fold carefully, ensuring they fit neatly inside each other.

2 With pencil and ruler mark a spot on the inside fold that is slightly above the center of the spine. Above and below this mark draw two equidistant spots.

3 Push the bradawl through each mark so that it goes through all the sheets and card from the inside.

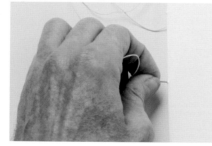

4 Thread the needle and begin sewing at the center hole from the outside in, leaving a tail of thread outside for tying later.

5 Move up to the top hole and push the needle through to the outside. Then take the needle all the way down to the bottom hole and push into the inside of the book again.

6 Bring the needle back out through the center hole and take the thread to the outside, where you then tie the two ends tightly together.

Materials

Illuminated text on cartridge paper
2 sheets of blank cartridge paper
2 sheets of decorative paper (try using different papers)
Sheet of light card
Soft 2B pencil
Ruler
Bradawl
Needle
Sewing thread
Bone folder

ЭХО

Ревет ли зверь в лесу глухом,

Трубит ли рог, гремит ли гром,

Поет ли дева за холмом —

На всякий звук

Свой отклик в воздухе пустом

Родишь ты вдруг.

Ты внемлешь грохоту громов,

И гласу бури и валов,

И крику сельским пастухов —

И шлешь ответ ;

Тебе ж нет отзыва … Таков

И ты , поэт !

Александр Пушкин

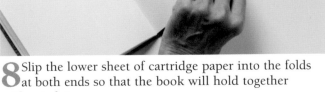

7 Take a piece of decorative paper about 1¼ in. (3.2 cm) larger all around and place the completed book open on the paper. Fold from the top between the stiff card and the cartridge paper. Use a bone folder to make a crisp fold. Do the same along the base and then at the sides.

8 Slip the lower sheet of cartridge paper into the folds at both ends so that the book will hold together without gluing.

CURSIVE WITH DECORATIVE BORDER

This project embellishes a quotation with a decorative border. Choose a border that matches the Russian cursive style. Work out the design on a sheet of paper and trace it. Here we have drawn only a small motif, and this has then been reversed and repeated to create the whole border.

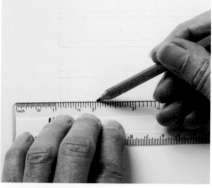

1 Draw the guidelines on your handmade paper.

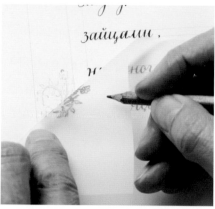

2 Write the text on layout paper so that you can work out how many lines you will need on the final sheet, leaving enough space for the decorative border on the side.

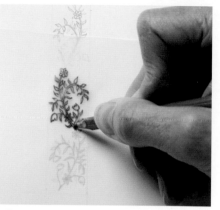

3 Draw a simple leaf-pattern border on tracing paper or copy the template on page 218. Trace the pattern to avoid unsightly erasing on your chosen paper.

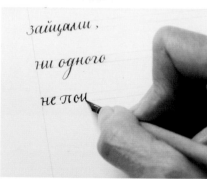

4 Using the pointed pen, write out your chosen text in black gouache.

Materials

Handmade paper
Pointed nib
Broad-edged nib
Pencil
Tracing paper
Ruler
Various gouache colors
Brush

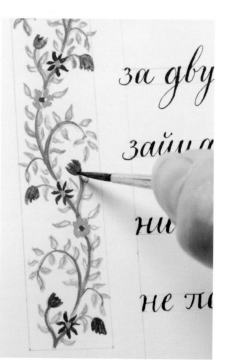

5 Place the tracing of the border design on the left-hand side of the handmade paper. Carefully draw over the design with a sharp pencil and, with a small brush, use gouache to paint in the design.

6 As a finishing touch, write the title in red gouache in a more formal script with a broad-edged pen. If you want to put the author's name as well, write it in a smaller size in a contrasting color.

Пословица

Погонишься

за двумя

зайцами,

ни одного

не поймаешь .

This proverb translates to: "If you run after two hares, you will catch neither."

COLORED ALPHABET

Here's a chance to really use your calligraphy skills. Make the changes subtle to avoid swamping one color with the next. Keep your palette within a limited color range and apply sparingly. There are no lines marked on the paper so you have a free hand. Take time to practice and experiment and you'll be astonished at the results.

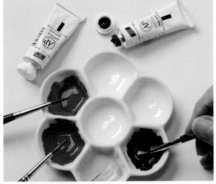

1 In this project you work directly on the paper without preliminary "roughs." Mix colors with water separately on a palette with their own brushes.

2 Load each color onto a large pen for the first letter, using the brush to place the ink in the reservoir. Start with yellow on one side and Venetian red on the other.

3 Write the first letter, letting the two colors mix in the pen.

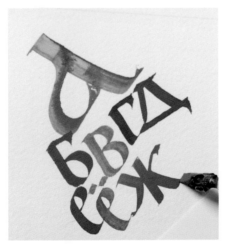

4 Take a smaller nib and continue writing the alphabet, experimenting all the time by loading a little more of a different color into the nib with each stroke.

5 Test the stroke on a spare sheet of paper, if required. Remember to use water to dilute strong colors and allow each paint to flow evenly and blend into another.

Materials

Automatic, steel, or poster pen
Heavyweight watercolor paper
Speedball size C1 or C2 nib
Palette
4 gouache colors:
 Venetian red, brown,
 cadmium yellow, &
 scarlet red
4 size 3 paintbrushes

6 Change the height and position of the letters as you work through the alphabet. Finally, finish off with the larger pen and a similar mix of colors to those you began with.

Never be tempted to rule lines. If colors start to get "muddy," try to lighten them by mixing in another (lighter) color. When you have succeeded with your first combination of colors, try others and see what happens!

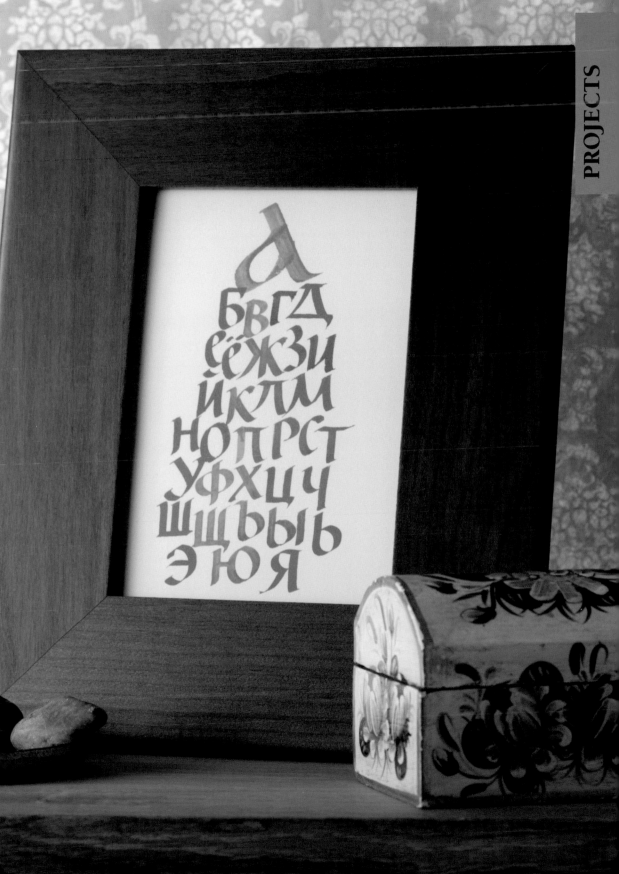

CHAPTER 9: HEBREW

The overriding requirement of Hebrew calligraphy has always been unambiguous clarity. For more than 2,000 years, from the first written texts to the introduction of printing, the primary role of the scribe was to transmit sacred texts uncorrupted from excessive copying. The letterforms evolved in response to this function.

The Aramaic script had been fully adopted by the Hebrews by the second century B.C.E., completely replacing the earlier Cuneiform script that had been used on clay tablets made permanent through firing. Time ensured that the Aramaic soon split into two distinct forms: the western Ashkenazic script, which used quill and parchment; and the eastern Sephardic script, which used a reed pen on papyrus.

To this day the Scrolls of the Law are written out by hand on parchment by specially trained scribes using materials and letterforms designed to ensure that the text is an exact replica of the original.

Holding the Pen

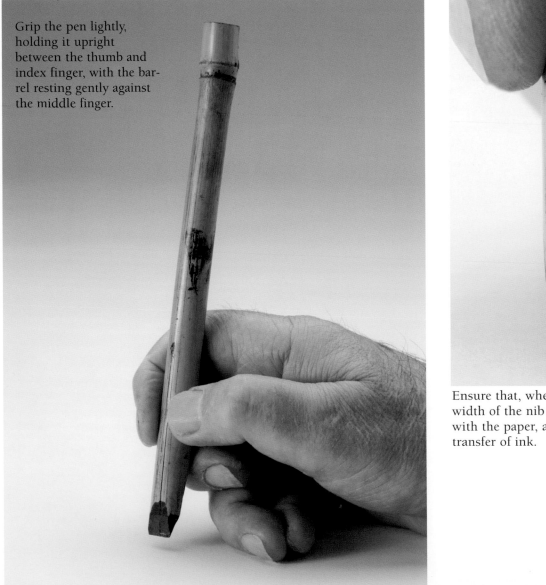

Grip the pen lightly, holding it upright between the thumb and index finger, with the barrel resting gently against the middle finger.

Ensure that, when writing, the full width of the nib is always in contact with the paper, allowing for a smooth transfer of ink.

Making a quill

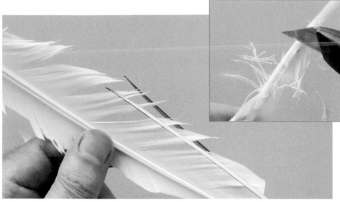

1 Holding the quill in one hand, cut away most of the feathers and then scrape away the wax and fronds nearest the tip.

2 Use a sharp knife to carefully slice away the underside in one swift movement, then use the hooked end of a bent wire to scrape all the material from the center of the feather.

3 Cut away the bottom of the nib, then turn it over and cut the end square.

4 Slice off the sides and scrape the top before turning the quill over and using the knife to make a $\frac{1}{4}$-in. (6 mm) split along the nib.

Making a reed pen

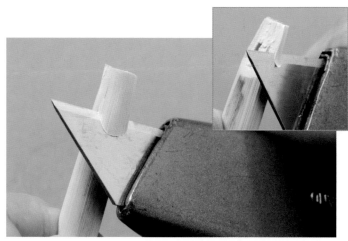

1 Take a length of reed and pull off the outer husk and soft flesh around the central core.

2 Use a sharp knife to cut away the bottom of the nib at an angle and fashion the edges to make a smooth writing surface.

ASHKENAZI ALPHABET

This medieval Ashkenazi script originates from northern Italy. It differs slightly from the Sephardi hand of the Middle East but is typical of the script used in Europe in the Middle Ages.

The chart that follows contains the 27 letters of the Hebrew Aleph Bet and shows how each letter is composed. The height of the letter should be 3½ times the width of the nib, and although the text runs from right to left each letter is built up from left to right. One other major difference from the Western alphabet is that all the letters hang from a top line, rather than using a baseline.

Aleph silent

Bet as in "big"

Gimel as in "get"

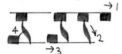

Dalet as in "dog"

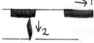

Hey as in "hat"

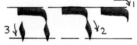

Vav as in "vet"

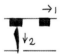

Zayin as in "zip"

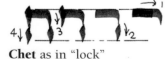

Chet as in "lock"

Tet as in "tap"

Tet alternative form

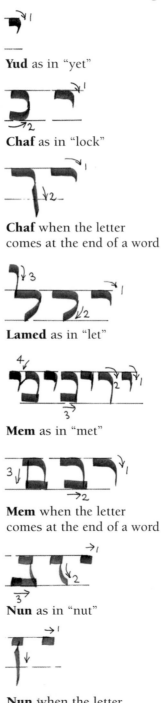

Yud as in "yet"

Chaf as in "lock"

Chaf when the letter comes at the end of a word

Lamed as in "let"

Mem as in "met"

Mem when the letter comes at the end of a word

Nun as in "nut"

Nun when the letter comes at the end of a word

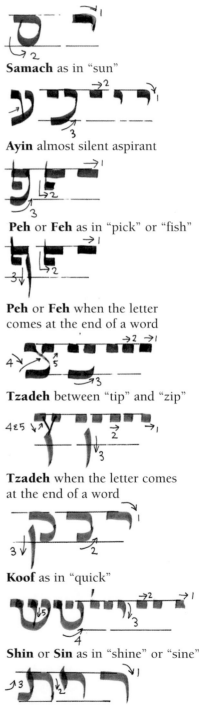

Samach as in "sun"

Ayin almost silent aspirant

Peh or **Feh** as in "pick" or "fish"

Peh or **Feh** when the letter comes at the end of a word

Tzadeh between "tip" and "zip"

Tzadeh when the letter comes at the end of a word

Koof as in "quick"

Shin or **Sin** as in "shine" or "sine"

Tav as in "take"

BASIC ASHKENAZI LETTERS

Writing the letter "Aleph"

1 With the nib at an angle of 90° to the page, draw a diagonal from top left to bottom right.

2 Return to the top line and make a mark before twisting the pen and bringing it down to the diagonal.

3 Using the edge of the nib make a vertical mark from the top left corner of the letter and finish by making a short horizontal mark along the baseline.

Writing the letter "Shin"

1 Mark a faint ligature at the left-hand end of the letter and make three equal marks along the top line, finishing the right-hand mark with a tick.

2 Make a similar mark on the left-hand mark and draw a curved bowl between the two.

3 Finish by making a vertical ligature from the central mark down to the base of the bowl.

COMMON MISTAKES, TIPS, AND PROBLEM SOLVING

The two most common mistakes are simple, but can ruin a piece of calligraphy.
- Do not overfill the nib with ink: this loses any differentiation between the thick and thin strokes, causing the ligatures to be indistinguishable from the thick strokes.
- Never push the quill: this instantly causes the ink to spray and will quickly shatter the nib.

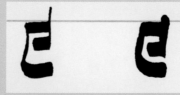

An overfull nib makes "Peh's" ligatures too thick (above left).

Sprayed ink can be clearly seen on a pushed stroke (above left).

LOVE QUOTATION

Use the famous passage from Solomon's *Song of Songs*—"I am my Beloved's, and my Beloved is mine"—to write a note of love that will be treasured. The piece of calligraphy, decorated with both colored motifs and gold lettering, can then be hung on a wall as a permanent reminder of the original love.

1 Make a rough practice sketch of the design, incorporating space for both text and decoration, ensuring the two forms balance each other.

2 Establish the framework of your design on the card, marking out the areas for text and decoration using a ruler and a soft 2B pencil.

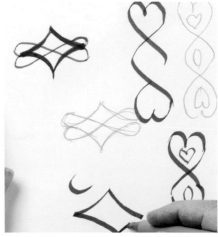

3 On another sheet practice the decorative motifs until you are confident you can draw all of them freehand with a felt-tip pen.

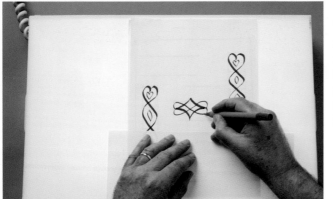

4 Draw the more difficult blue decoration onto the card using a lightbox. If you are more confident you can draw them freehand.

5 Take a thick bamboo pen and write the text in black ink. Take care to keep the nib at a constant angle and do not overfill it with ink.

Materials

Card
Practice paper
Soft 2B pencil
Ruler
Felt-tip pen
Bamboo pen and black ink
Gold pen
Lightbox (optional)

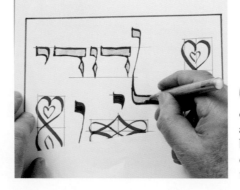

6 When the ink is completely dry, go over the lettering with a gold pen, leaving a black outline, and rub out any pencil lines that are still visible.

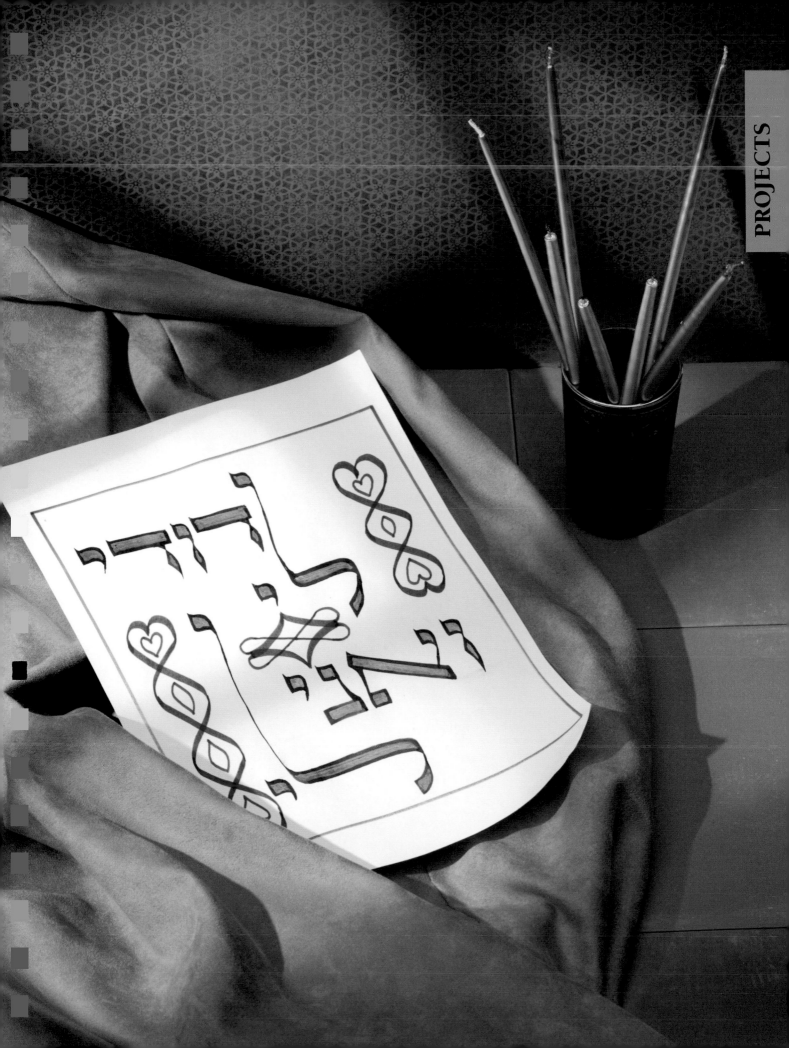

SHEVITI

A sheviti is a written page positioned as a poster to arouse people's awareness of God.
If you want to make your own, be as beautiful and intricate as you want,
making a celebratory piece of calligraphy and decoration.

1 Sketch out the design on a practice sheet, using enlarged letters as motifs with which to frame the text.

2 Transfer the design onto the card, checking the line heights for the various text styles.

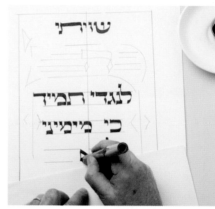

3 Use a bamboo pen and black ink to write in the main text, remembering to write from right to left and taking care not to smudge the letters as you write them.

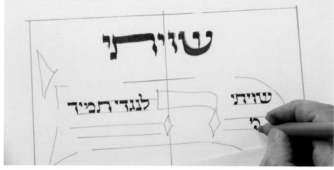

4 Write the smaller wording with a blue felt-tip pen, keeping the lettering formal and filling the full height of the guidelines. Frame the sheviti with the same pen.

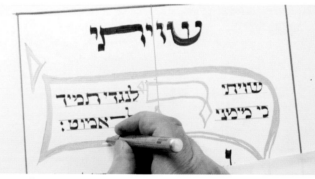

5 Fill in the decoration with a gold pen.

Materials

Large card
Practice paper
Soft 2B pencil
Ruler
Bamboo pen
Black ink
Blue felt-tip pen
Gold pen
Black fine-line felt-tip pen

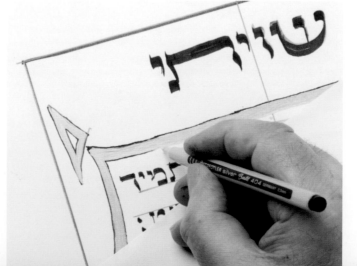

6 Finish by outlining the gold with a fine black pen.

שויתי

שויתי לנגדי תמיד
כי מימיני בל-אמוט:

לנגדי תמיד

כי מימיני

בל-אמוט:

CHAPTER 10: ARABIC

Arabic script is thought to have evolved from a form of Nabataean which was itself derived from Aramaic. As the religion of Islam spread throughout Asia, Arabic text spread with it, evolving into two main forms: cursive script, mainly used for everyday writings, and Kufic script, reserved for copying the Koran.

"Nun. By the Pen and what they inscribe" Holy Koran 68:1

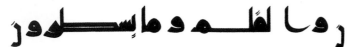

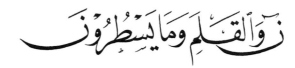

Kufic, named after the city of Kufa in Iraq, is one of the most powerful scripts used in Arabic calligraphy because of its profound visual impact. It has a clear simplicity, combined with a dramatic contrast between the elongated horizontal strokes and the short verticals. This gives a dynamic effect, especially for sacred texts.

Naskh, which means "transcription," is normally executed using a fine-point nib. It was initially employed for inscribing *Hadith* (the Prophetic tradition) and other manuscripts. *Naskh* replaced *Muhaqqaq* for copying the Koran from the 16th century onward.

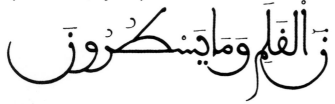

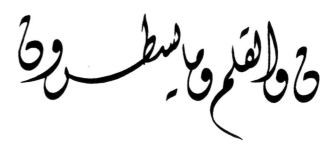

This script, called *Maghrebi Kufic*, developed in North Africa (*al-Maghrib al-Arabi*) and Spain in the 10th century C.E. The characters are based on straight lines, semicircular shapes, and curved strokes, giving a light, graceful, free-flowing style. It is still in use in North Africa, but is otherwise reserved for copies of the Holy Koran (Qur'an).

Nast'aliq, or "hanging script," is described as "the bride of Islamic styles of writing." Most likely derived from *Naskh* (see below), it was developed by the Persian calligraphers who used it mostly for copying works of poetry.

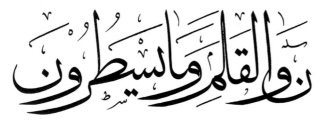

Muhaqqaq* means "realized" or "consummated" and is one of the two original styles of Arabic writing. Until the 16th century it was widely used for transcribing the Koran because of its majestic and clear-cut style.

Diwani is a very rounded style. It was developed by the Ottoman calligraphers in the 16th century and reached its peak during the 19th century. It is used particularly for chancellery documents such as *Firmans*.

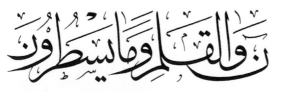

Thuluth means "one third" and is the Arabic script *par excellence*, gaining enormous popularity among master calligraphers. It is the favored style for monumental inscriptions.

Squared *Kufic* is a monumental script that was developed in the 13th century. It was the most popular style used in the architecture of Central Asia, Iran, and Afghanistan. The character designs were made in square forms with black lines interspersed with white, using the same system as found on a chessboard.

MATERIALS

Good Arabic calligraphy depends primarily on having good-quality writing instruments. The skill of good writing has long been highly revered in the Islamic world, and this is reflected in the meticulous preparation of the pens and ink, and the superb detail and ornate decoration applied to inkwells and pen rests.

Paper (*al-Waraq*) was introduced into the Arab world from China in the eighth century C.E. Before then, Arabs used vellum and papyrus. Papermaking reached its height in the 11th century when paper of superb quality was produced. Paper was made from rags or textile waste. It was coated with *Aahar*, a mixture of rice powder, starch, and egg white, to make a glossy, smooth writing surface on which the pen could move easily.

Ink (*al-Hebr*) was traditionally made from lamp soot collected in mosques. This was mixed with gum Arabic, water, and salt, and placed in elaborate inkwells (*dawat*) of glass, pottery, and even precious metals and jade. A wad of raw silk or cotton placed inside absorbs the ink and prevents the pen from overfilling.

Reed pens (*al-Qalam*) are brown, fine, and light and have a hard outer skin and soft fiber inside. The best reeds are gathered on the marshy banks of Waset in Iraq, and from the shores of the Caspian Sea.

The **pen rest** (*al-Maqatt* or *Maqta'*, second from right), made of ivory, tortoiseshell, or mother-of-pearl, holds the reed pen while its nib is cut.

The **penknife** (*as-Sekkin*) has a razor-sharp tempered steel blade to cut the pen nib.

Making the reed pen (*al-Qalam*)

The reed pen is an essential tool if you want to write authentic Arabic calligraphy. It must be firm enough to cope with frequent cutting, and the nib should be able to last intact through the writing of a long piece of text. Making the pen is one of the most important skills the calligrapher must learn. This process involves six stages:

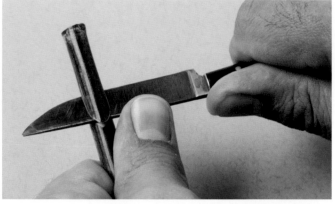

1 Open one end of the pen with a smooth diagonal cut to give the nib the basic shape.

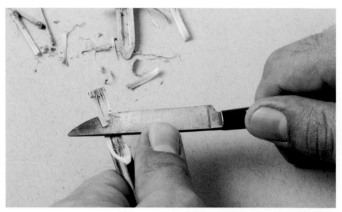

2 Trim the underside of the nib into a smooth, concave shape, discarding the inner core of the reed.

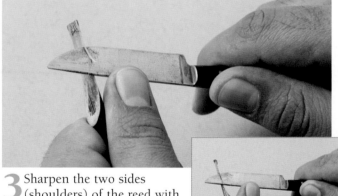

3 Sharpen the two sides (shoulders) of the reed with straight strokes. This determines the width of the nib.

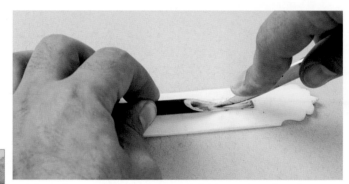

4 Lay the reed on a pen rest (*al-Maqatt*) and make a split in the center of the reed at the end of the two shoulders by pressing down with the point of a sharp knife.

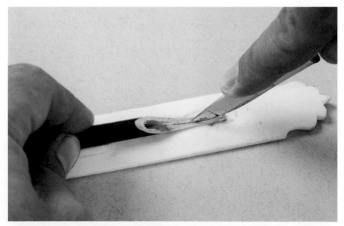

5 Slide the knife toward the end of the reed in a straight line down the center of the reed.

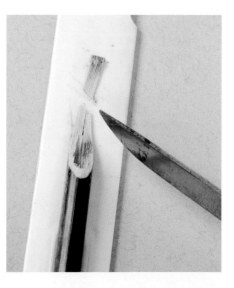

6 Finally, trim the nib-end to any angle, depending on the desired style.

Holding the pen

Hold the pen at an angle of about 50°, so that the face of the nib sits evenly on the paper. Hold the pen lightly between the thumb and first finger, resting the barrel of the pen on the second finger. Keep the hand relaxed: rest the third and pinky fingers on the writing surface so that the muscles of the wrist and hand do not get tired.

Drawing up a stave

The stave is as important in Arabic calligraphy as in any other form of writing. The only difference is that all the measurements are taken from the top line, rather than the baseline, but the result is the same.

1 Draw the top line in pencil, then draw five diamond shapes downward using the pen.

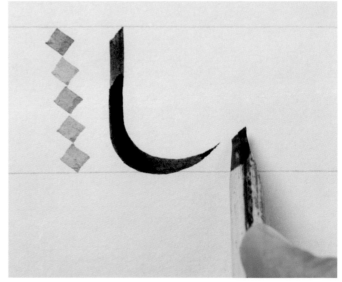

2 Draw in the baseline and write an "alif" to confirm that the proportions of the stave match the width of the pen nib.

THE KUFIC ALPHABET

The Kufic alphabet is elegant, bold, and angular with horizontally stretched strokes. From the seventh century, Arabic calligraphy developed through its central role in the spread of Islam. The Kufic alphabet gained wide acceptance as the most suitable and popular script for copying the Holy Koran up to the ninth century.

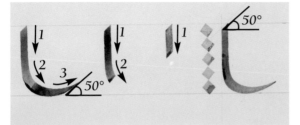

Alif

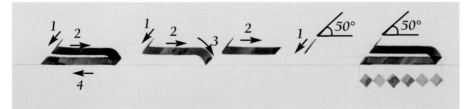

Ba, ta, and tha

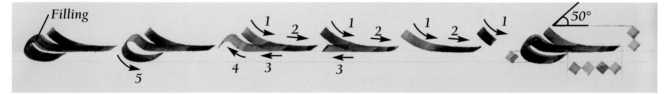

Jim, ha, and kha

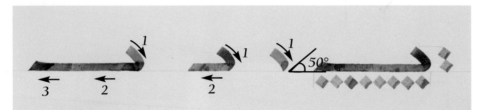

Dal and dhal

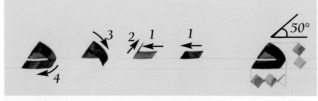

Ra and zay

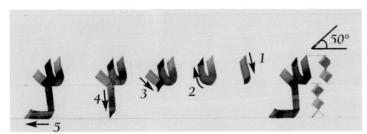

Sin and shin

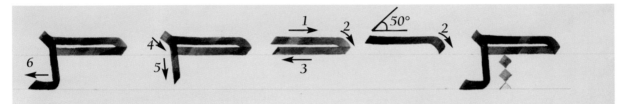

Ssad and ddad

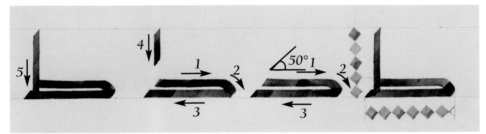

Tta and za

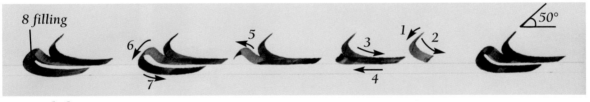

'Ayn and ghayn

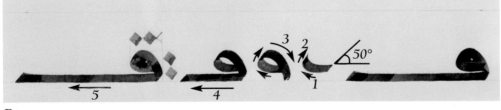

Fa

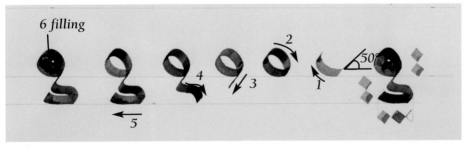

Qaf

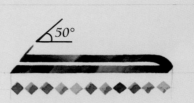

Kaf

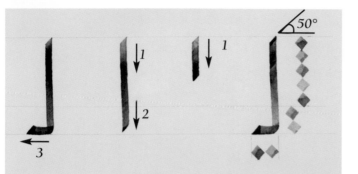

Lam

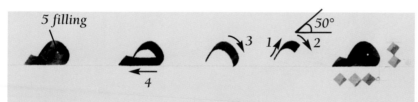

Mim

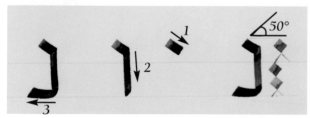

Nun

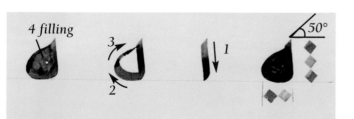

Ha

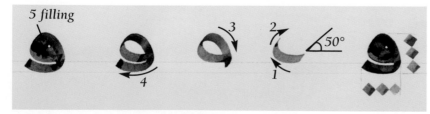

Waw

Letterform variations

	Stand-alone form	Initial form	Medial form	Final form
Alif				
Ba				
Ta				
Tha				
Jim				
Ha				
Kha				
Dal				
Dhal				
Ra				
Zay				
Sin				
Shin				
Ssad				
Ddad				
Tta				
Za				
'Ayn				
Ghayn				
Fa				
Qaf				
Kaf				
Lam				
Mim				
Nun				
Ha				
Waw				
Ya				
Lam-alif				

The shape of each letter can change subtly, depending on its position within a word.

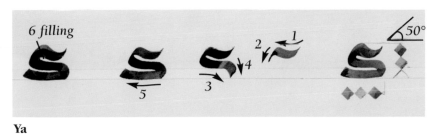

Ya

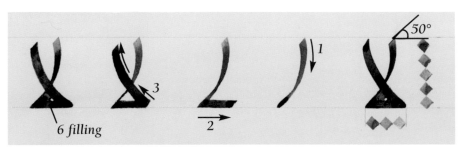

Returning ya

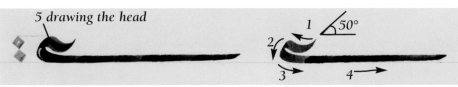

Lam-alif

COMMON MISTAKES, TIPS, AND PROBLEM SOLVING

• To produce the correct form of letters it is necessary to keep to a writing angle of around 50°. A shallower angle results in fat verticals and thin horizontals. Conversely, a steeper angle gives thin verticals and fat horizontals.
• The space left between the double horizontal strokes in letters such as "dal," "ssad," "tta," and "kaf" should be as narrow as possible. The Persian poets of the 13th century spoke about a person's intellect as being "as narrow as a Kufic *kaf*."
• The upright letters, such as "alif," "ta," "za," and "lam," must be straight, with no slope to right or left.
• The tailed letters, such as "alif," "jim," and "ayn," must end with a pointed stroke. It is incorrect to finish it with the full pen-width.

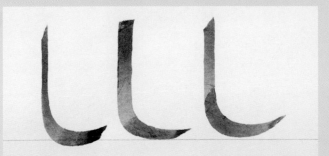

Keep the nib at a 50° writing angle.

Ensure the verticals are straight.

Keep a tight space between double horizontals.

Give tailed letters a sharp-pointed end.

PANEL

This beautiful panel offers a simple introduction to the techniques required for writing Arabic script. It features a phrase commonly found inscribed on the wall in a Muslim home, and placed in order to grant God's blessing on the property and all who live there. In English it reads as: "In the name of God, the Compassionate, the Merciful."

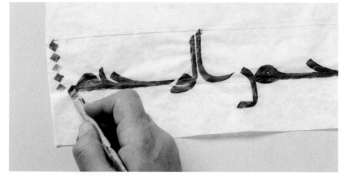

1 Draw a writing stave on a sheet of tracing paper in the size and shape of the finished panel and write the text from right to left. Alternatively, photocopy the template on page 219 and trace it through.

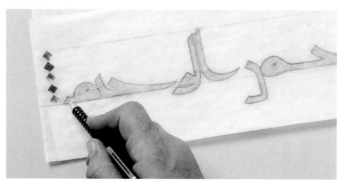

2 Draw the stave on a second sheet of tracing paper and make an outline of the text with the hard pencil.

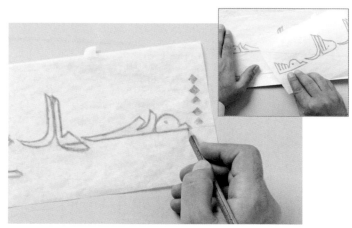

3 Carbonize the reverse of the second sheet before placing it the correct way up on the sheet of card and transfer the text using a soft pencil.

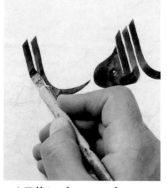

4 Fill in the traced lettering with a reed pen and ink.

5 Trace the circular motif from page 219 and transfer it to the end of the text, at the left-hand side of the lettering.

6 Add dots and vocalization marks to the letters and fill in the motif with gold paint using a fine brush.

Materials

Tracing paper and pen
Reed pen
Brown ink
2 pencils: Soft (2B) & hard (H)
Card
Fine brush
Gold paint
Ruler

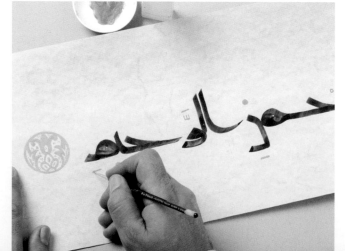

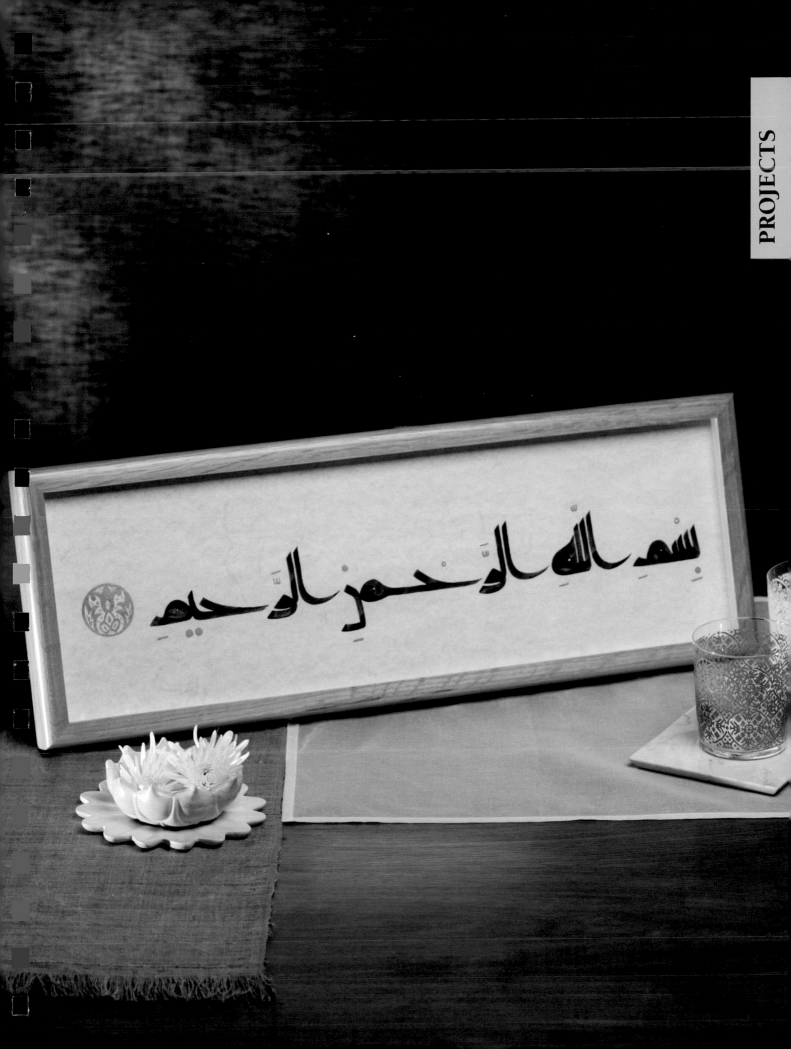

DECORATIVE PLATE

Surprise and enthrall your dinner party guests by serving their meals on these delightfully decorated plates. If this project fires your imagination, you can use the same technique to create an entire dinner service embellished with Arabic sayings or verses. The text shown here translates as "The best manners are those that urge the noble deeds."

1 Start by placing your plate upside down on a sheet of tracing paper and drawing around it with a pencil.

2 To write evenly in a circle you need to find the center. You can do this by folding the sheet in half, then fold a second time, and gently press the folds at the center.

3 Strengthen the center with masking tape and draw circles for the baseline and inner ring using a compass, in this case with radiuses of 4³/₄ in. (12 cm) and 2 in. (5 cm).

4 Ink in the lettering, or photocopy the template on page 219, to the exact size and then trace.

5 Transfer the outline of the lettering to another sheet of tracing paper and lay it over the plate, marking the center on the plate through the paper.

Materials

Plain white dinner plate
Tracing paper and pen
2 pencils: soft (2B) & hard (H)
Masking tape
Compass
Reed pen
Brown ink
Size 00 or 0 paintbrush
Gold paint

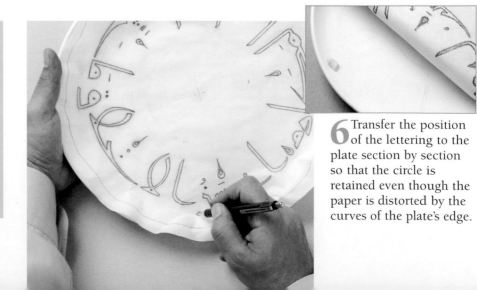

6 Transfer the position of the lettering to the plate section by section so that the circle is retained even though the paper is distorted by the curves of the plate's edge.

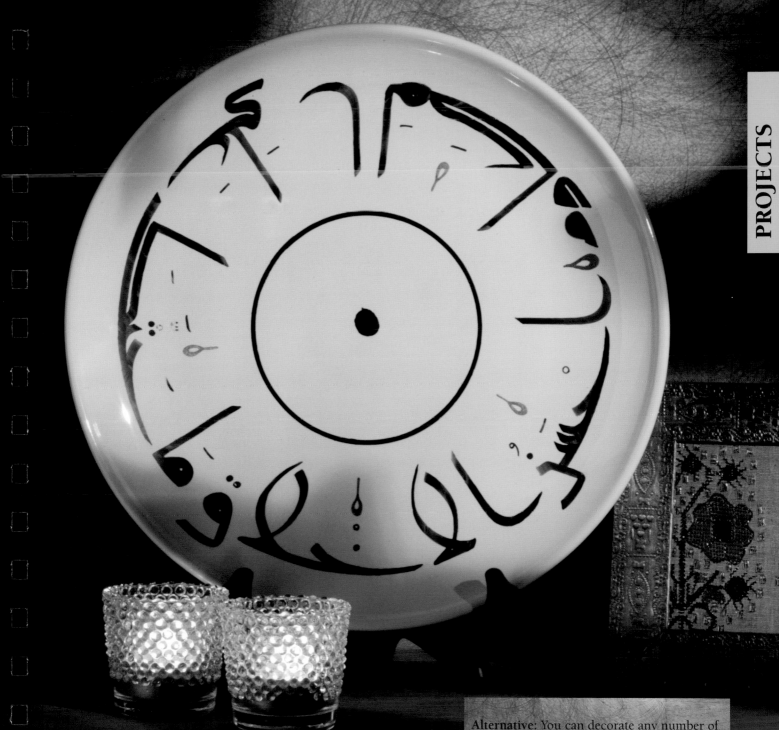

7 Paint in the lettering with a narrow brush using brown ink.

8 Add the center mark and the inner circle. Finish with the gold decoration, using a teardrop motif to mark the start of the text.

Alternative: You can decorate any number of plates using different motifs. This single line of text reads, "Praise be to the Praiseworthy."

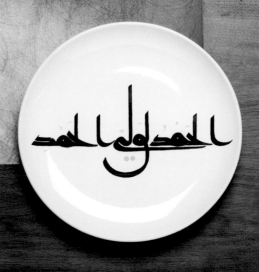

CERAMIC TILE

The elegant flowing strokes of Arabic script set off ceramic tiles perfectly, creating an eye-catching design for hanging in the entrance hall, or any room that you choose. The sentiment expressed here—"Peace upon you"—bestows calm and serenity on your home, which is particularly welcome in today's troubled world.

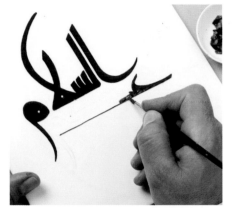

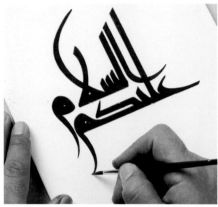

1 Transfer the design onto a sheet of tracing paper from the template on page 219. Carbonize the reverse and transfer a hint of the lettering to the ceramic tile by tracing the pattern with a 2B pencil.

2 Use a fine brush to fill in the letters with blue pigment. Work from right to left and top to bottom, taking special care to keep all the horizontal and vertical lines even.

3 Finish the lettering with smooth curves to the left.

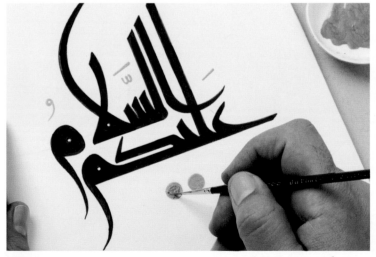

4 Use a second brush to add the gold decoration.

Materials

Tracing paper
Pencils: soft (2B) and hard (H)
2 size 0 paintbrushes
Blue pigment and gold paint
Blank ceramic tile

Alternative: Paint a tile in normal calligraphy ink. This has a natural fixative that does not require firing. Use a large reed pen and take care to ensure that the text—"The name of God," or *Allah*—is even.

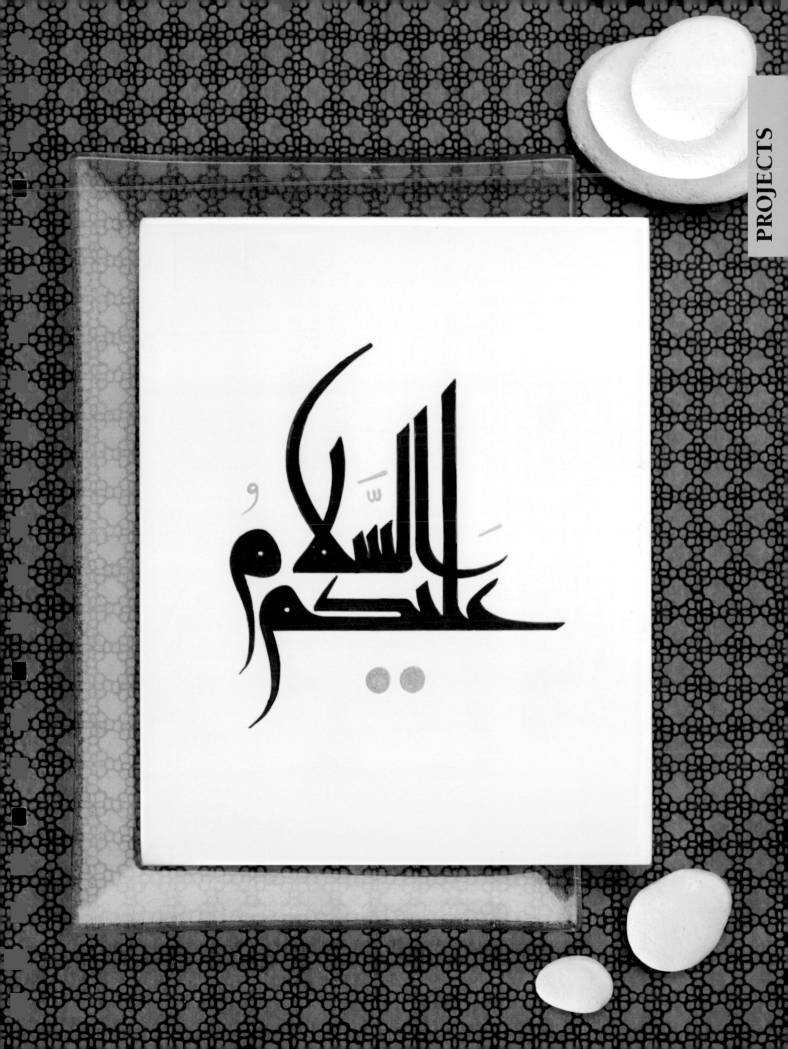

CARDS

Greeting cards decorated with Arabic script not only look attractive, but can also provide an appropriate message for festive occasions. The greetings shown here are especially associated with the two major Muslim festivals, *Eid al-Fitr*, which ends the fasting month of Ramadan, and *Eid ul-Adha*, marking the culmination of the annual pilgrimage (*Hajj*) to Mecca.

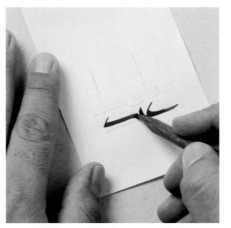

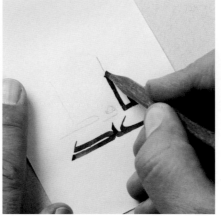

1 Take the small piece of card and sketch out the lettering with a hard H pencil.

2 When you are happy with the design, begin to cover the pencil with ink, starting with the horizontal strokes of the lower line of letters.

3 If a letter is joined to the previous one (to the right) you should write the vertical strokes in an upward direction.

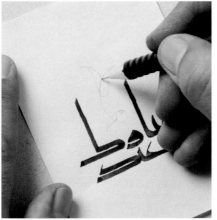

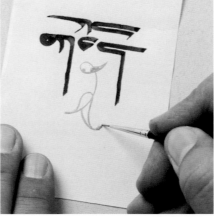

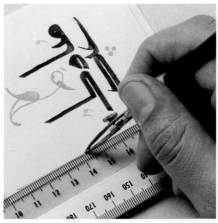

4 Draw the decorative design in rough using a soft 2B pencil.

5 Use a small brush and gold paint to complete the design.

6 Using a ruler draw an outline around the lettering in gold ink with a fine-line pen.

Materials
2 sheets of card (small & large)
2 pencils: soft (2B) & hard (H)
Reed pen and ink
Size 00 or 0 paintbrush
Gold paint
Fine-line gold pen
Ruler

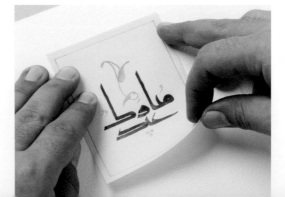

7 Prepare a larger piece of card and stick the calligraphy to the left of the fold on the outside.

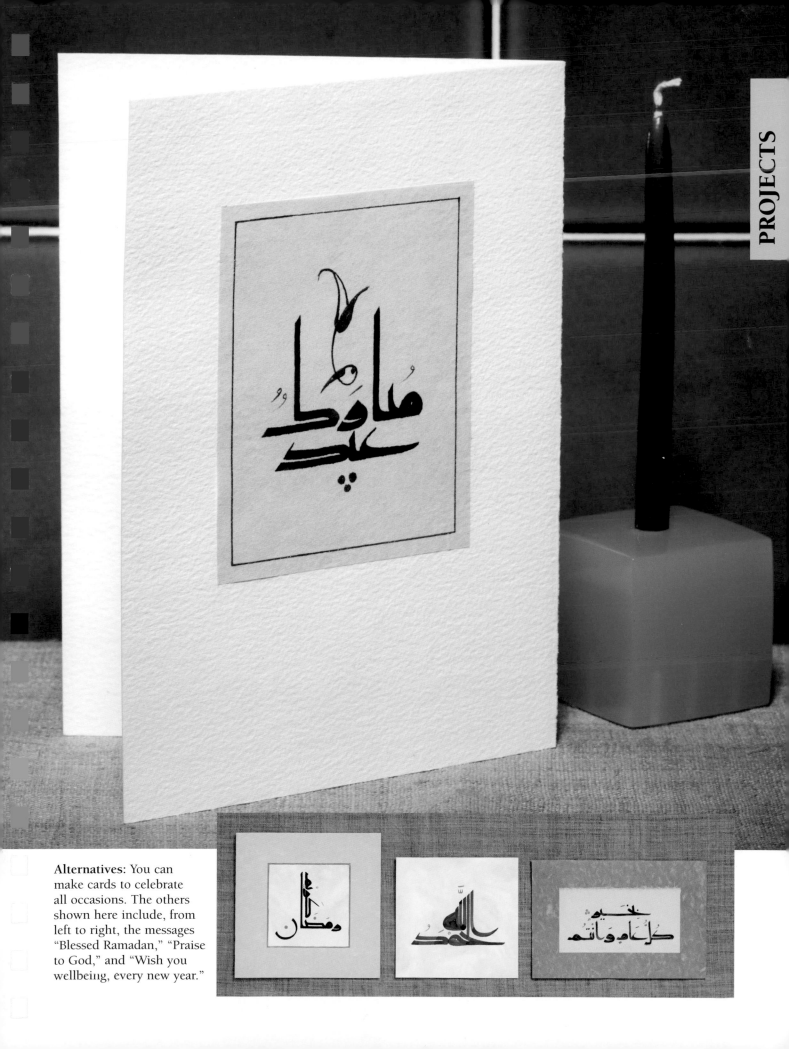

Alternatives: You can make cards to celebrate all occasions. The others shown here include, from left to right, the messages "Blessed Ramadan," "Praise to God," and "Wish you wellbeing, every new year."

PICTO-GRAPHIC SCRIPTS

The advantage of pictographic scripts—which use simple images to express concepts, rather than phonetic letter groups to indicate how the word is spoken—is that people of different races can communicate with each other, even when they do not have a common verbal language. This is important for a country that is as huge and culturally diverse as China, and also means non-Chinese people can recognize the characters. In this section you'll learn how to draw beautiful Chinese characters so that you can decorate lovely craft projects such as a lampshade. Japanese calligraphy evolved from Chinese characters, but developed along its own unique lines, reflecting the art and culture of Japan. The projects chosen to display this beautiful script, such as the fan and the placemat, are just as elegant and delightful as Japanese calligraphy itself.

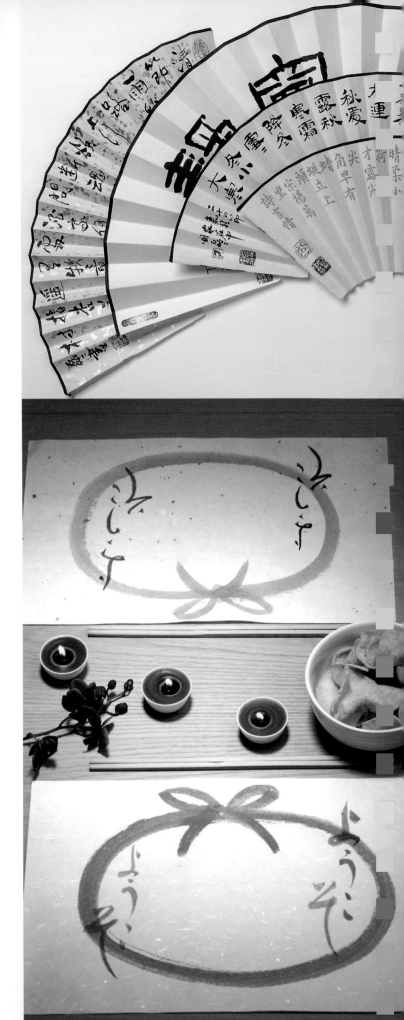

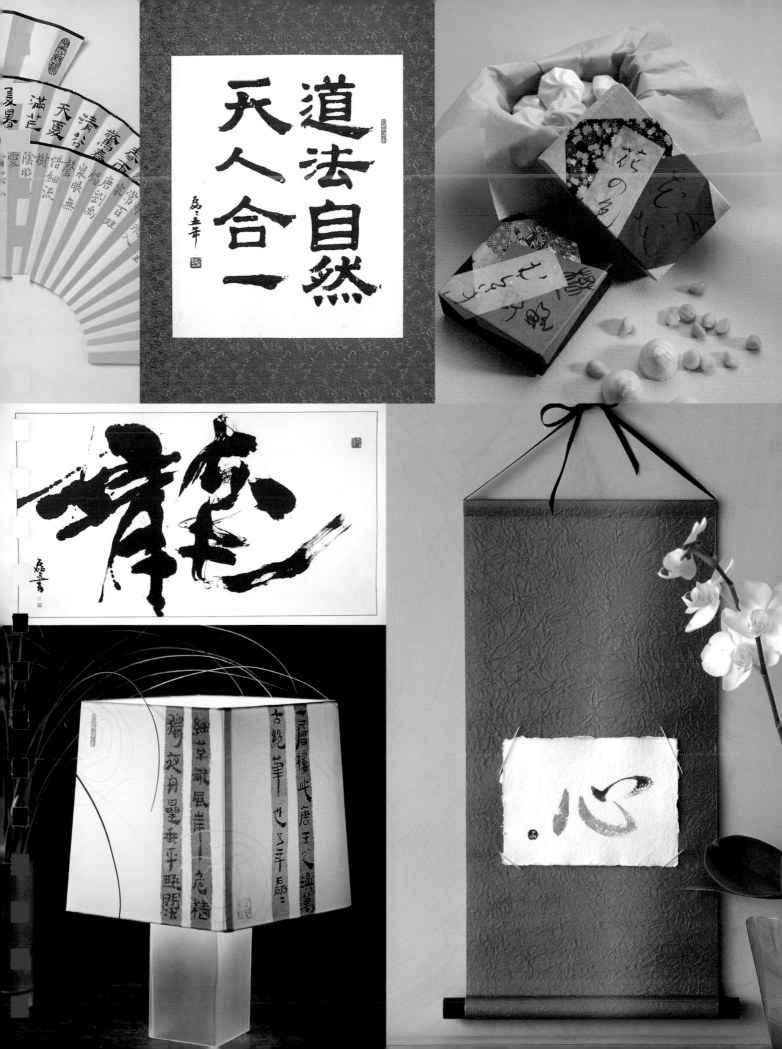

CHAPTER 11: CHINESE

Chinese calligraphy is a writing system and an art form, written on all types of surfaces, including bamboo, silk, wood, and paper. Using soft-haired brushes allows each stroke to be infinitely varied. Calligraphers are said to put their own spirit into their writing, creating a prized personal style. Over thousands of years there have been many great Chinese calligraphers—whose spirit lives on in their work.

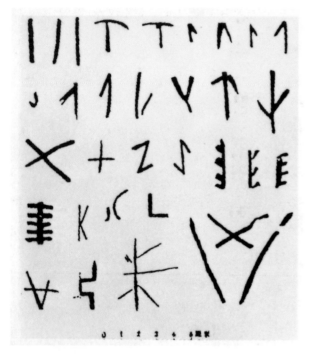

Above: *An early manuscript from c. 4000 B.C.E. showing one of the world's oldest pieces of script. The earliest writings (from about 6,000 years ago) were pictographic. But over time most world writing systems became phonetic. Chinese is one of the few to have retained a mainly pictographic writing form into modern times.*

The earliest forms of Chinese calligraphy discovered so far date from the Shang dynasty (18th–12th century B.C.E.). The characters were carved on natural materials, such as cattle bones and tortoise shells. These character forms were simple pictograms created using mainly straight lines and were meant to depict actual objects, such as plants and animals. The character for "man," for example, showed a "stick man" standing upright. By around 2,000 years ago, scribes were using brushes and ink, which allowed far greater artistic expression and made possible the creation of more subtle forms of writing.

Unlike the phonetic writing systems—based on the sounds of the spoken words—that developed in the West, in Chinese calligraphy the characters represent complete units of language, known as logograms. So two words that sound the same when spoken may be depicted by entirely different characters.

Chinese writing is not entirely pictographic. Over the centuries the characters have subtly altered to include a phonetic element, indicating how the word should be pronounced. This was particularly important when conveying abstract concepts such as "beauty" or "sincerity" that we cannot depict easily in pictorial form. This development gave rise to wide variation in characters written by different speakers. During the Ch'in dynasty (221–206 B.C.E.), calligraphy started to become standardized, and today a piece of writing can be equally well understood by all literate Chinese, even if they speak mutually unintelligible dialects.

Right: *A bronze ding—a pot on legs—from the Shang dynasty (1600–1100 B.C.E.) shows advanced writing— the characters here are particularly clear. Chinese text from this period was often cast on bronze objects. These pots were used mainly for religious purposes and on important state occasions.*

Far right: *Chinese calligraphers often wrote or carved on natural materials, such as animal bone or tortoise shell, as shown here.*

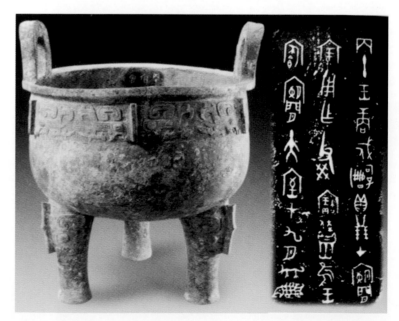

Above: *Before the invention of paper, calligraphy was often written on "books" of wooden strips. The Han dynasty (206 B.C.E.–220 C.E.) marked an important transitional phase during which the Han Official, or Clerical, script evolved from the Zhuan. The many different variations of writing—the way to hold, move, and stop the brush, and the speed, pressure, or rotation to use—can be seen in the differences between these two scripts.*

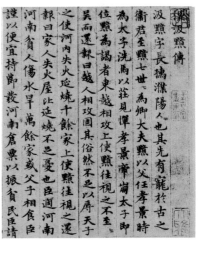

Left: *At the end of the Han dynasty, Chinese characters had finally settled into the standard script still in use today. In the Six Dynasty period (265–581 C.E.), which followed, the writing of Standard script reached its peak of beauty. It remains the best model from which to learn today. Wang Xizhi's (303–61) description of Yue Yi is a fine example.*

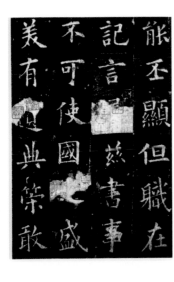

Ouyang Xun (557–641 C.E.) was the earliest of the four great calligraphers from the golden period of Chinese calligraphy.

Yan Zhenqing (709–785 C.E.) followed in the Tang dynasty (618–907 C.E.).

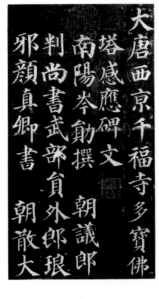

Liu Gongquan (778–865 C.E.) lived in the same period as Yan Zhenqing, but gave calligraphy new life in his use of the Standard script.

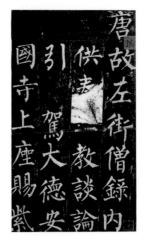

During the Yuan dynasty (1271–1368 C.E.), Zhao Mengfu (1254–1322 C.E.), the last of the four great calligraphers, took the script an important stage further by using a looser hand than his predecessors.

MATERIALS

For Chinese calligraphy, the basic instruments are brush, ink, paper, and ink stone, which are collectively known as the "Four Treasures."

Brush

Chinese brushes can be made from soft, stiff, or mixed hairs. When starting out, choose one of each with the hairs about 1 in. (2.5 cm) long. To judge the quality of the brush, check the sharpness, evenness, and roundness of the clump of hairs, and the resilience of the bristles. Avoid buying a set; purchase brushes separately to ensure their quality.

Ink

Pine-soot ink has a subtle color, while oil-soot ink is darker and brighter. Either one is fine to use. If you prefer, you can use ready-made liquid ink. However, you should throw away any excess liquid ink—never pour it back into the bottle. So you will need to take care that you do not pour out too much ink to start with.

Paper

There are many different kinds of paper. But most Chinese calligraphers recommend *yuanshu* or *mao bian* paper. These types are often known in the West as "grass paper" or "rice paper," but the major fiber in them is actually bamboo. This gives a soft color, allows good brush control, and has the additional advantage of being cheap. However, to practice you can use sheets of old newspaper.

Ink stone

The ink stone is used to grind an ink stick with water. The stone needs to be solid and smooth so that ink is produced cleanly, using a fast action. The quality and price of ink stones varies hugely. But when starting out, it is best to choose a basic type, or use one side of a piece of smoothly sanded slate. You do not need an ink stone if using liquid ink. To hold the ink a simple dish is perfectly adequate.

It is a good idea to place a sheet of felt or an old blanket on the table as backing—the fine hairs lift the paper up and protect the artwork from the surface, as well as preventing it from sticking to the table. Other useful items include a brush washer, brush stand, brush pot, paperweight, and a bamboo rolling mat to protect your brush tips when traveling. Finally, you will need some paper towel to absorb excess ink from the brush.

HOLDING THE BRUSH

1 When writing characters of about 1 in. (2.5 cm) square, hold the brush in the standard way most of the time.

a. First, grip the brush using the thumb, first, and second fingers. Now place the third and pinky fingers against the brush stem opposite the second finger to provide a firm grip. These last two fingers are very important as they give control and help create the movement.

b. Keep the brush handle perfectly upright at all times—never write at an angle to the paper. You should use the arm, wrist, and fingers to move the brush tip in any direction.

c. Ensure the handle can be freely rotated at all times, using thumb, first, and second fingers.

d. Never let the wrist press down on the table. Allow the forearm to move freely, and the elbow should be free to move when producing larger strokes.

2 To write characters smaller than ½ in. (15 mm) square:

a. Place your left hand under your right wrist to stabilize the paper and support your writing hand.

b. Use the bottom hand to slide the paper while you are writing, keeping the position of your body and writing hand comfortable.

3 For larger calligraphy:

a. Use the same method as above but hold the brush much higher up the handle. Keep the wrist and back of the hand level with the forearm.

b. Ideally, write while standing and adjust the angle of your wrist to enable the brush to remain straight.

c. You can use a big brush to write small characters, but never use a small brush to write large characters.

d. Ideally, ensure around one-third of the bristle length touches the paper (and never more than half). Never press the brush tip down to the base.

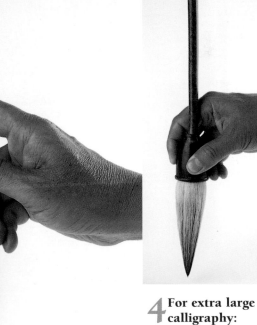

4 For extra large calligraphy:

Hold the handle close to the brush, keeping your wrist, arm, elbow, and shoulder relaxed and free to rotate.

EIGHT STROKES

Dot

Press the brush down, and move the tip away from you, then press down, rotating the brush clockwise before lifting it up to complete the dot.

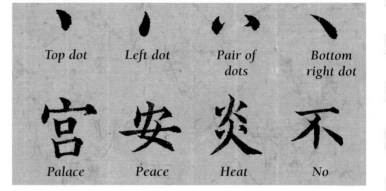

Top dot	Left dot	Pair of dots	Bottom right dot
宮	安	炎	不
Palace	Peace	Heat	No

Horizontal

As you press the brush down, swing it away slightly before pressing forward, rotating counter-clockwise, then move it across. Finish by pushing the brush away and back in one movement, rotating it clockwise, then lift it away.

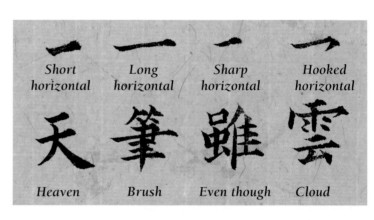

Short horizontal	Long horizontal	Sharp horizontal	Hooked horizontal
天	筆	雖	雲
Heaven	Brush	Even though	Cloud

Vertical

Press down, making a little clockwise twist. Move straight down before ending in a counterclockwise turn, lifting the brush.

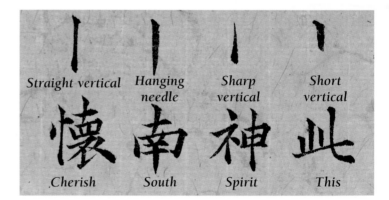

Straight vertical	Hanging needle	Sharp vertical	Short vertical
懷	南	神	此
Cherish	South	Spirit	This

Lift

Press down and immediately rotate counterclockwise to get the tip into the center of the line. Then flick the brush up and off the paper.

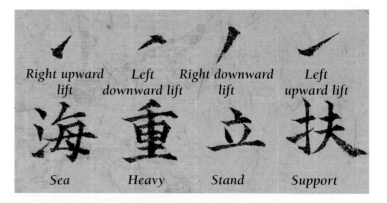

Right upward lift	Left downward lift	Right downward lift	Left upward lift
海	重	立	扶
Sea	Heavy	Stand	Support

Hook

Press down and rotate the brush clockwise slightly. Move the brush down and, at the bottom, lift the brush tip up, moving very slightly to the left. Press down again, turning counterclockwise slightly and flick up to the right.

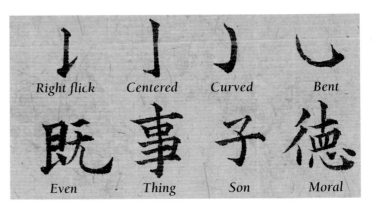

Right flick	Centered	Curved	Bent
既	事	子	德
Even	Thing	Son	Moral

Bend

Press down, rotating the tip counterclockwise until it is in the center of the stroke, and moving to the right. At the turn lift then press down, rotating the tip counterclockwise, and move straight down. Stop, resume rotating the tip, and flick up.

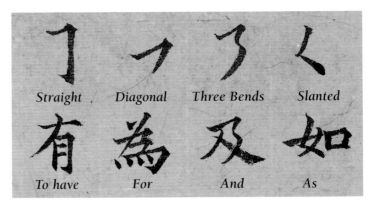

Straight	Diagonal	Three Bends	Slanted
有	為	及	如
To have	For	And	As

Aside

Press the brush down onto the paper, rotate clockwise and sweep the brush to the left.

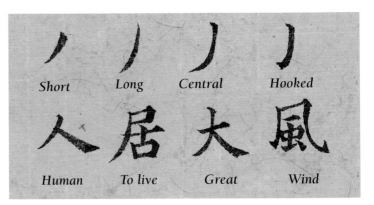

Short	Long	Central	Hooked
人	居	大	風
Human	To live	Great	Wind

Right falling

Sweep the brush to the right and gradually press down to the bottom. Now lift the brush while gently rotating it counterclockwise.

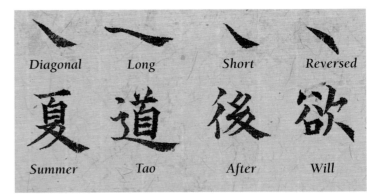

Diagonal	Long	Short	Reversed
夏	道	後	欲
Summer	Tao	After	Will

STRUCTURE OF THE CHARACTERS

Chinese characters can look very complicated, but they divide into eight basic forms.
It doesn't matter how many strokes make up each character, but when complete
they should all occupy the same amount of space on the page.

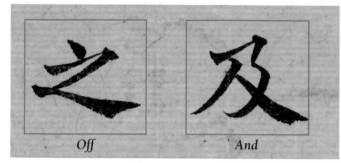

Off *And*

Individual type

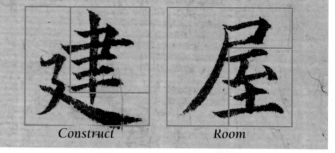

Construct *Room*

Half-enclosed combinations

Dragon *Thank*

Left-right combinations

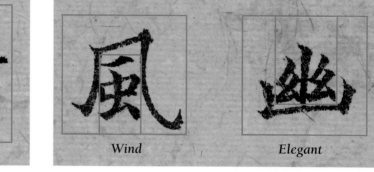

Wind *Elegant*

Three-quarters enclosed combinations

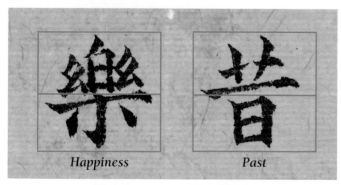

Happiness *Past*

Top-bottom combinations

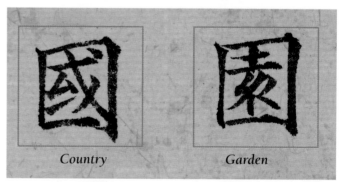

Country *Garden*

Fully enclosed combinations

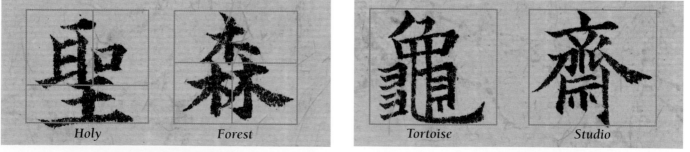

Holy *Forest*

Three-part combinations

Tortoise *Studio*

Complex combinations

SEQUENCE OF STROKES

The sequence of strokes used in Chinese writing can be quite confusing. Nine sequences cover most of the characters. Perform the strokes in the order shown and, with a little practice, you should soon begin to get a sense of the sequence naturally.

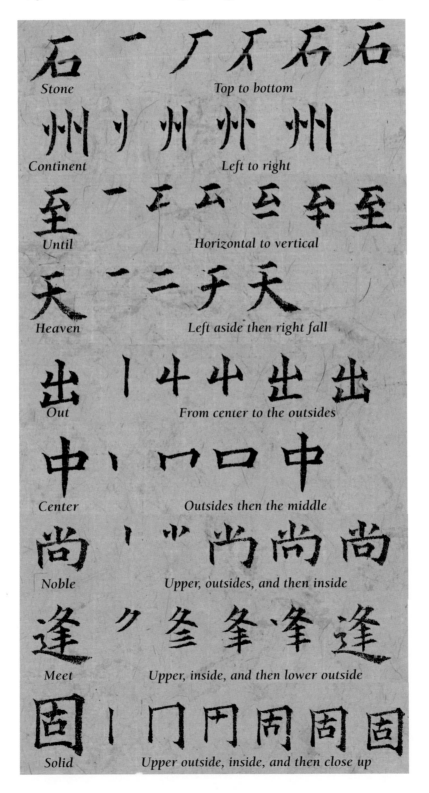

Stone — Top to bottom

Continent — Left to right

Until — Horizontal to vertical

Heaven — Left aside then right fall

Out — From center to the outsides

Center — Outsides then the middle

Noble — Upper, outsides, and then inside

Meet — Upper, inside, and then lower outside

Solid — Upper outside, inside, and then close up

THE *TAO*

This work of calligraphy describes the central concept of Taoist philosophy, as described by the great thinker Lao Zi: "Man follows the law of earth, the earth follows the law of sky, the sky follows the law of *Tao*, and the *Tao* follows the way of nature." If you prefer you can choose any saying by one of the great Chinese philosophers.

1 Work out the number of characters and the layout, then fold the *washi* (paper) to give creased boundaries for the characters. For this layout make 2-in. (5-cm) borders at the top and bottom. Fold the paper in half, then fold again, leaving 2 in. (5 cm) showing, and fold this edge over.

2 Now open the sheet and make vertical creases. Make a 3-in. (7.5-cm) margin on the left and a 2-in. (5-cm) margin on the right by folding the paper over to within 1 in. (2.5 cm) of the edge, before folding both sides in half.

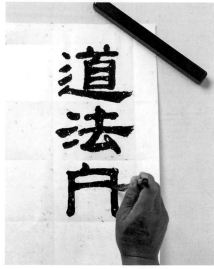

3 Begin writing each character, centering it within the creases.

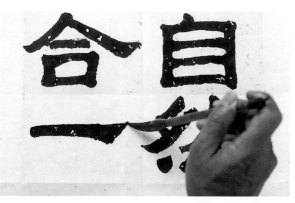

4 Write in columns working from top right to bottom left, taking care to make sure that each character occupies the same amount of space on the paper.

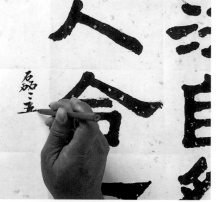

5 Using a small mixed-hair brush write your signature down the left margin, starting halfway down.

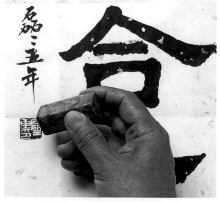

6 Press the seals, placing card underneath the *washi* to give a firm, flat surface on which to press.

Materials

Decorated, gold-flecked *washi*
Black ink
Medium-size soft paintbrush
Small mixed-hair paintbrush
Seals and seal ink

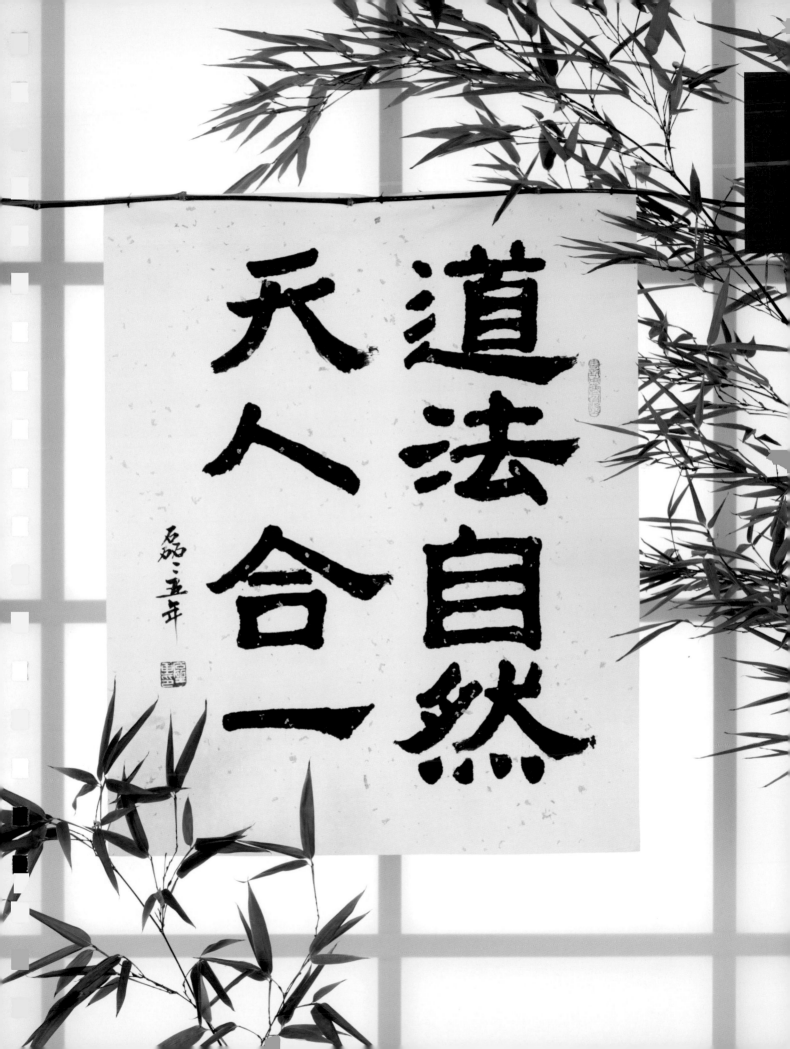

FAN

In Chinese culture fans are not just for keeping you cool. They also make very popular art forms featuring paintings and poetry. You can write any message you like on your fan. Before you start calculate the number of characters you are going to use and plan the layout accordingly. Finally, personalize your fan with a seal.

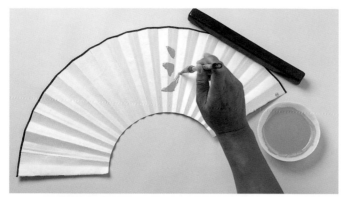

1 Flatten out the fan and start to write the right-hand character, marking the dots first.

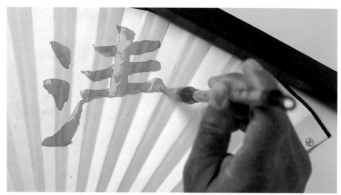

2 Continue with the horizontals and verticals, following the fan's creases. Don't worry if the paint flows back down into the grooves—this adds to the handmade effect.

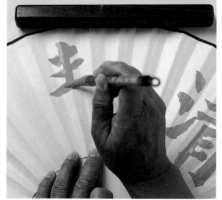

3 Turn the fan so that the right side is in front of you and start to write the character at the top left.

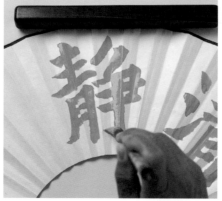

4 Finish with a vertical hook.

5 Press the fan down to keep it flat and use a small stiff brush to write your signature.

Materials

Paper fan
Black ink and Green Chinese ink
Medium-size soft paintbrush
Small mixed-hair paintbrush
Seals and seal ink

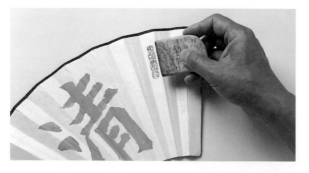

6 Add the signature seal on the left and balance it on the right with a second seal. Line it up with the grooves of the fan, rather than the other characters.

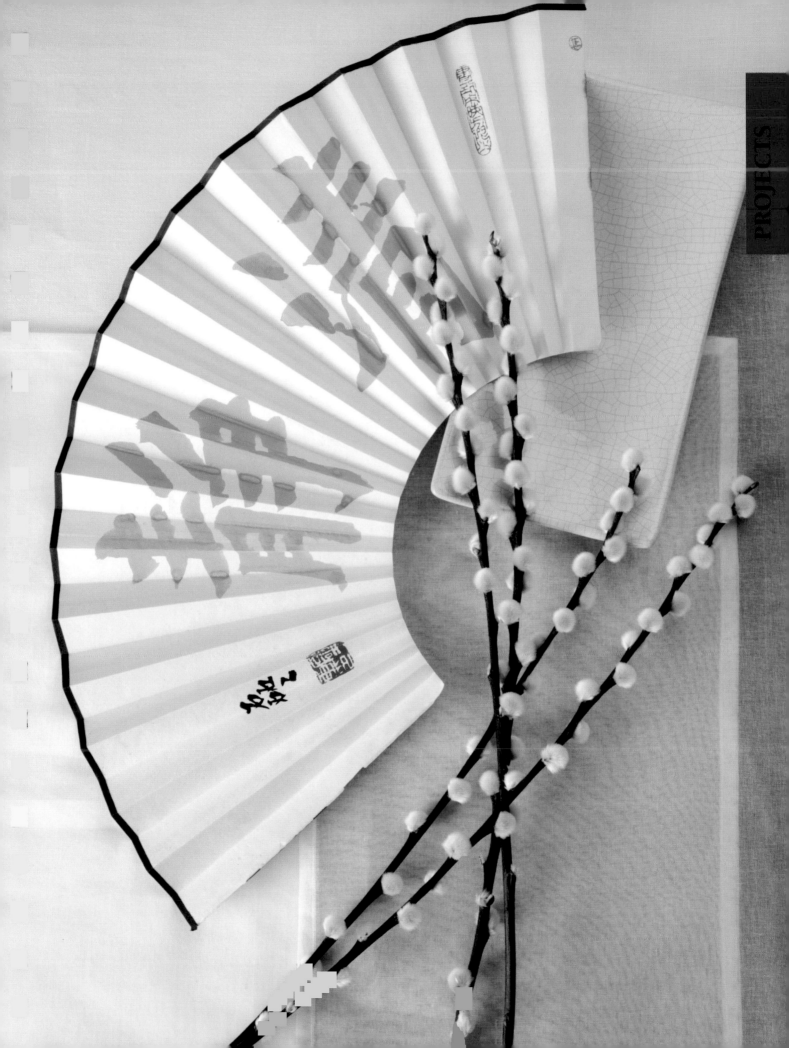

LAMPSHADE

You can use calligraphy to decorate your own lampshade—a plain white one works best for this. The lamp shown here is decorated with poetry inspired by the bamboo-strip books of the Han dynasty. To give the shade the authentic period feel, use the Han Official Script. This poem is by one of the most famous of all Chinese poets, Du Fu (701–762 C.E.).

1 Mix a tiny drop of indigo with burnt sienna to create the color of old bamboo, and paint stripes down the shade using a flat brush.

2 When the ink is thoroughly dry, use a small mixed-hair brush to write the poem you have chosen.

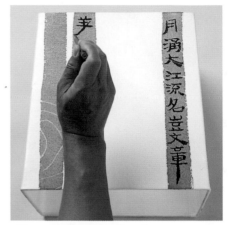

3 Work down each column in turn, and then move onto the next column.

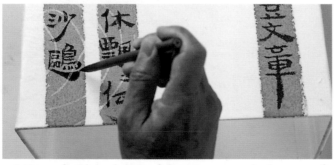

4 Try to finish each line of the poem near the bottom of the column.

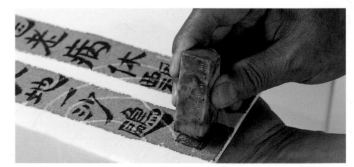

5 Place the seal at the end of a column, using your free hand as a solid base.

Materials

Plain square lampshade
Flat paintbrush
Small mixed-hair paintbrush
2 inks: burnt sienna & indigo
Seal and seal ink

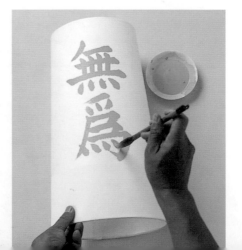

Alternative: Use yellow paint to write the saying, "Action without action," one of the central concepts of Taoist philosophy. Take care that the paint doesn't drip as you roll the shade round. You should always aim to work the brush down the uppermost side of the shade, so move the shade rather than the brush whenever possible.

This poem reads:

By bent grasses
　In a gentle wind
Under straight mast
　I'm alone tonight,
And the stars hang
　Above the broad plain
But the moon's afloat
　In this great river;
Oh, where's my name
　Among the poets?
Official rank?
　Retired for ill-health?
Drifting, drifting,
　What am I more than
A single gull
　Between sky and earth?

"SINCERITY" ARTWORK

Chinese people like to hang large calligraphy works on their wall, often comprising just two characters. This work proclaims "sincerity." You will need a big brush and lots of ink. Be clear about where you will be writing before your brush touches paper. Although this is a large work, the techniques are the same as for smaller calligraphy.

1 Lay the *washi* on a sheet of felt. Start with the top dot and the three short horizontals of the left-hand character.

2 Add in the square shape, keeping the composition compact.

3 Even though the scale is much larger than normal, ensure that the brush stays vertical and that your arm remains horizontal.

4 Use a smooth, even movement of the whole arm from the shoulder for the downward hook.

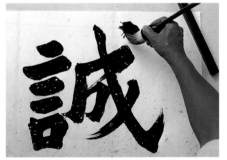

5 Finish the final side and dot in the top right corner.

6 As usual, complete the artwork with your signature and seals.

Materials

Large *washi*
Large soft paintbrush
Black ink
Backing felt
Seals and seal ink

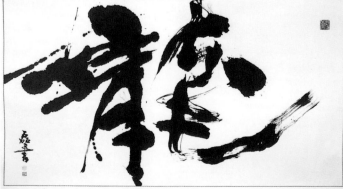

Alternative: Any of the characters shown on these pages are suitable for a wall artwork—choose ones that fit in with your personal outlook and philosophy.

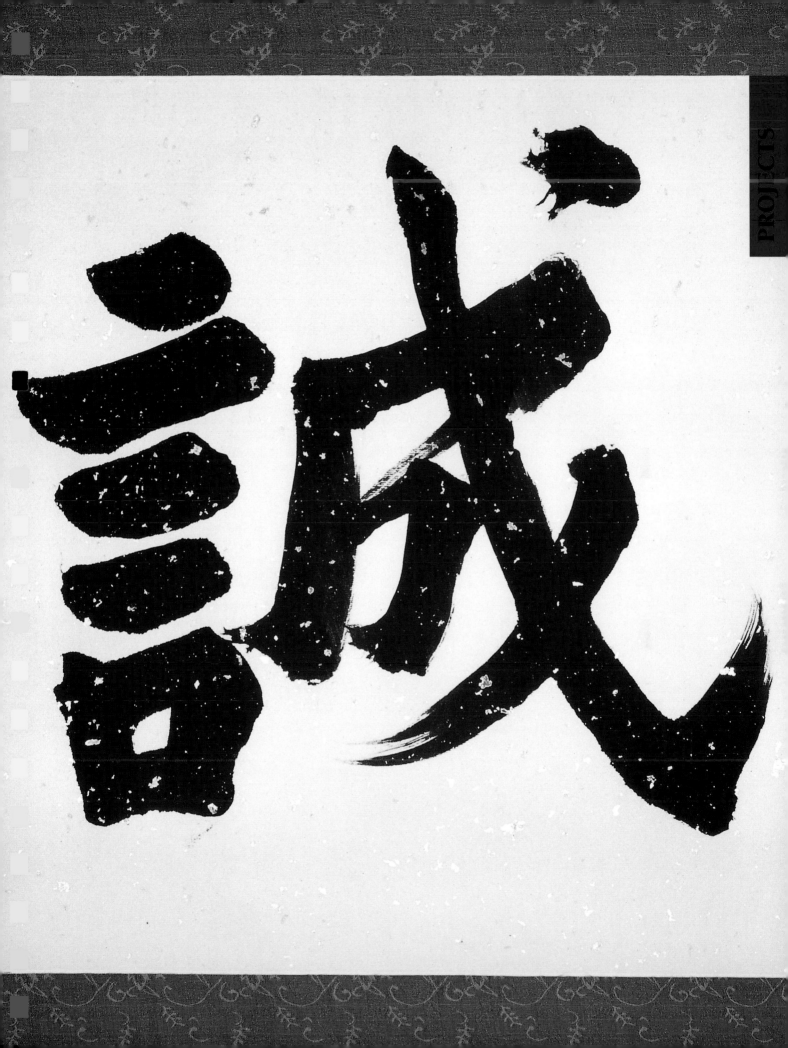

CHAPTER 12: JAPANESE

Japanese calligraphy was originally based on ancient Chinese pictograms known as *kanji*. Over the centuries these characters have subtly changed to reflect the language and culture of Japan. In particular, phonetic forms were added to convey the unique inflections of Japanese speech. This led to the creation of an elaborate writing system able to impart complex ideas and subtle nuances.

The first *kanji* are believed to have arrived in Japan as early as the first century C.E. The oldest forms of *kanji* were inscribed on solid materials such as bone and metal. In the sixth century C.E., examples of Chinese sutras and Buddhist commentaries entered Japan, mostly written on paper with brush and ink, using a variety of script styles. In 607 C.E. Japanese monks began to travel to China to study Buddhism and Chinese culture in a program that was to last until the late ninth century. The monks brought back with them the most fashionable aspects of the culture of the Sui (589–618) and Tang (618–906) dynasties, including their particular styles of calligraphy. This developed over the centuries into different styles including *tensho* (seal), *reisho* (script), *kaisho* (block/standard), *sosho* (cursive or "joined-up") and *gyosho* (semi-cursive) to become the characters in use today.

The transformation from the original Chinese form of writing to a uniquely Japanese style was greatly accelerated after 894 C.E. when the program to send Buddhist monks to China was finally brought to an end. By the 10th century, Japanese *kanji* script had developed an elegant rounded style that reflected Japanese esthetics, emphasizing flow and harmony.

Although the basic Japanese writing system was imported from China, the two languages are very different. In particular, Chinese words are mostly monosyllables, whereas the Japanese language is polysyllabic. So a separate phonetic writing system, called *kana*,

Above: *These two examples show the development of the five main* kanji *styles. The invention of paper helped the art to flourish. The top two examples are pictograms for "mountain" and "fish."*

Left: *These examples show how the phonetic* hiragana *form (on the bottom) developed from the original Chinese* kanji *characters (on the top) into a new flowing and cursive style of writing. The left-hand column shows the sound "aa" and on the right is "ee."*

Above: *Each single* hiragana *phonetic can be expressed by many different Chinese characters. This is another of the Chinese characters that represented the sound "ee."*

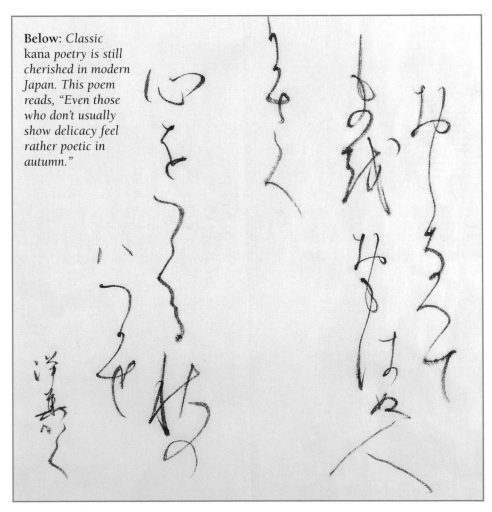

Above: *This is an example of* chowa-tai, *where* kanji, hiragana, *and* katakana *are used together. It reads, "Meeting people occurs by chance. We should all enjoy these occasions without shyness."*

began to be used in Japan. *Kana* exists in two principal forms, *hiragana* ("plain *kana*") and *katakana* (or "partial *kana*").

Hiragana slowly developed over the centuries into an elegant, flowing, and very feminine form of writing. At first this style was used mainly by women and was largely avoided by men.

As a consequence *hiragana* came to be associated with some of the great works of Japanese feminine literature, such as *The Tale of Genji* and *The Pillow Book of Sei Shonagon*, both works of literature now renowned throughout the world.

Katakana is a simpler non-cursive form. Its development was easier, because it was a process of simply picking out and then retaining parts of the original *kanji* characters.

Japanese calligraphy today uses a combination of systems, including *kana*, *kanji*, and now *chowa-tai*—a more harmonious style used in modern poetry that mixes together *kanji* and the two forms of *kana*.

Below: *Classic* kana *poetry is still cherished in modern Japan. This poem reads, "Even those who don't usually show delicacy feel rather poetic in autumn."*

KANJI: KAISHO—STANDARD STYLE

Kanji in the *kaisho* style is the most basic form of Japanese calligraphy. It is characterized by crisp strokes with a sharp beginning and ending, made by placing the brush on the paper at a 45° angle. Each character has a specific order of writing that should be followed.

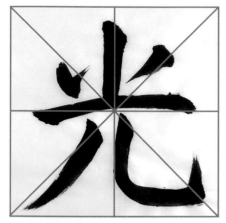

This character incorporates most of the basic strokes you need. Follow the order given to create the character for *hikari*, meaning "ray of light."

1 Start at the top. Make a 45° angle, with the brush tip on the left and the body of the brush on the right. Push down to make a solid head, then twist the brush slightly toward you to straighten it, and pull down.

2 For the dot place the brush on the paper at 45°. Push down so that the body of the brush touches the paper, and then pull up slightly, turning the brush to flick up and to the right toward the next stroke.

3 With the tip of the brush on the left and the body of the brush on the right, push down and gradually pull up to make a triangular blade shape, paying great attention to its position in relation to the second stroke.

4 Now begin on the left, starting at 45°, and push down, twisting only the body of the brush slightly upward to make a concave horizontal line. At the end push down with the body of the brush while twisting the tip of the brush slightly to make a solid ending.

5 Start with a 45° entry with the tip directly above the body of the brush. Push down to make a clear mark and gradually pull the brush up as the tip follows the upper edge of the blade stroke with the body of the brush following along the lower edge.

6 Starting at the top, come down making a 90° turn, pushing sideways to the end. Push down and lift up with the tip following the left edge and the body of the brush following the right edge of the triangular hook.

KANJI: GYOSHO—SEMI-CURSIVE STYLE

In the semi-cursive *gyosho* style, some strokes are joined together and more emphasis is put on the momentum and the rhythm of the brush movement. *Gyosho* is often used because it is easier to understand than the cursive style, and is quicker to write than Standard style.

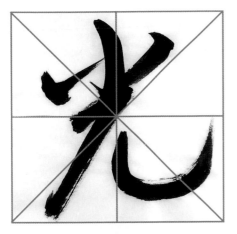

1 The vertical stroke is not as sharp as in the *kaisho* style.

Holding the brush

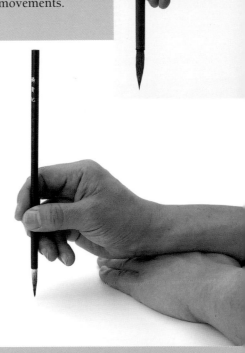

Always hold the brush in an upright position, with your arm straight, keeping the wrist loose to allow it to turn. Grip the brush with your thumb, first, and second fingers, placing your third and pinky finger behind to control the more delicate movements.

2 For the dot use a similar stroke to *kaisho*, but make the flick longer to emphasize its connection with the next stroke.

3 The third, fourth, and fifth *kaisho* strokes are made in one movement. The connection between the third and fourth strokes is stronger and the horizontal stroke is shorter than in *kaisho*.

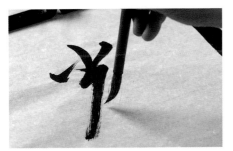

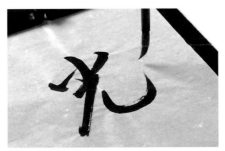

4 From the end of the horizontal line, start the left downward aside stroke without lifting the brush. Stop lightly at the end in order to change the direction of your brush for the final stroke.

5 The final hook is rounder than in *kaisho* style. Make sure you keep the character balanced.

When working on more detailed calligraphy, you can rest your wrist on the back of your other hand. Ensure that you grip the brush in the same way as before and keep your writing arm straight and the brush upright.

HIRAGANA

Hiragana developed from *kanji* cursive style in order to write uniquely Japanese phonetics. The characters highlighted below are pronounced "hi," "ka," and "ri"—altogether they spell *hikari*, a ray of light. The characters below them show the transformation from the original *kanji* forms. Note that in *hiragana* calligraphy, each stroke is rounded, with space between the strokes, and they never become too heavy or square.

Knowing the background to a character's development can help you to create well-shaped hiragana.

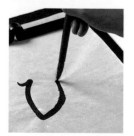

1 Make the uppermost part of the character with a short horizontal.

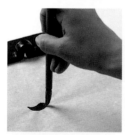

2 Write the main form of the character in a single movement.

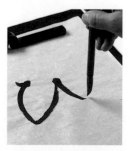

3 Finish with a short vertical.

1 Begin with a right-hand stroke that falls and then curves to the left.

2 Cross the left side of the stroke with a vertical.

3 Finish with the right-hand element, ending in a hook.

1 Begin with a vertical stroke and end by turning the brush as you lift it.

2 Lower the brush again, facing in the same direction and then move upward.

3 Without lifting the brush from the paper, twist the tip and sweep toward you, gently lifting as you end the stroke.

JOINING THE CHARACTERS

The *hiragana* on the left is written in *hanachi-gaki* style, with each character apart. The right-hand column is written in *renmen* style, which joins the characters together, emphasizing the flow of the lines. Note the flexibility of *renmen*—you can change the angles of some strokes or adjust the size and the shape of the characters to suit your calligraphy.

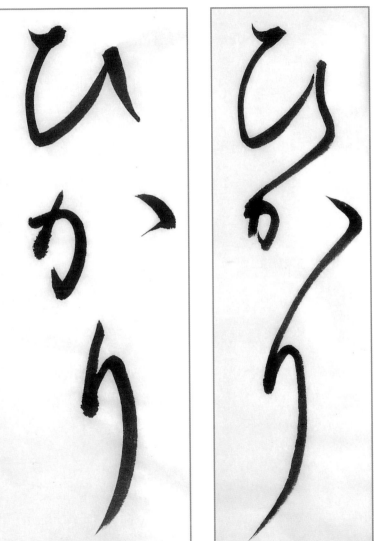

Flower exercise

This flower exercise shows you how to twist the tip of the brush—a skill that is especially useful when writing an elegant flow of *kana*. At the top of each petal, and in the center of the flower, your brush is being twisted or "tortured" to give the stroke a resilience and strength.

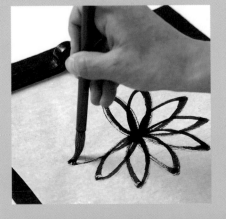

KATAKANA

Katakana is the second form of phonetic writing now in use in Japan. These characters were developed from *kaisho*-style *kanji*, so the strokes are crisp and sharp and there are fewer of them. Today, *katakana* is mostly used to write imported foreign words and names.

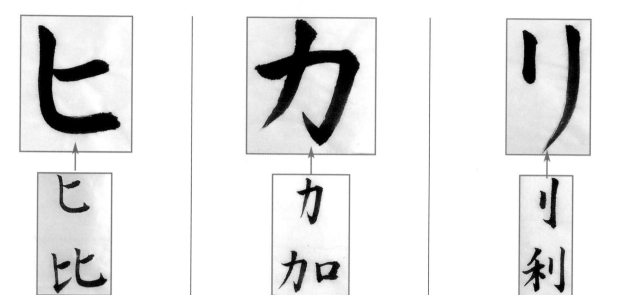

These characters also read "hi," "ka," and "ri" (hikari) and developed from kaisho-*style* kanji, *as shown.*

1 Start the *hi* character with a firm horizontal stroke.

1 Write the body of the *ka* in one move that incorporates horizontal, downward sweep, and hook.

1 The *ri* has been reduced to two vertical lines. Start with the shorter, straight element.

2 Finish the character with a single sweeping stroke downward and to the right.

2 Finish with a single, short crossing stroke.

2 Ensure that the second stroke is longer and curves slightly underneath the left-hand stroke.

WRITING NAMES

The names of foreign countries are usually written in *katakana*. Some of the Japanese names will not be familiar, so their phonetic translations are also included. You can also practice writing the names of other countries, people, or even pets.

Igirisu—
Great Britain

England

Wales

Scotland

France

America—
United States

Canada

Australia

Doitsu—
Germany

Suisu—
Switzerland

LUNCH MAT

Paper lunch mats with bright, cheery messages are ideal for entertaining guests, and as they're disposable you don't have to worry about food being spilled on them! The circle represents friendship, harmony, and tranquility of mind. Adding a little knot on top depicts joyous spirit. The writing says *yo-u-ko-so*—"Welcome!" The color shown, called *shu* in Japanese, is for happy occasions.

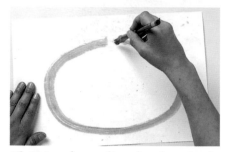

1 Using the medium brush and red watercolor ink, take a deep breath and, as you breathe out, make a big round oval on a sheet of decorative paper, large enough to fit a dinner plate inside.

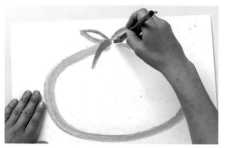

2 Paint a knot at the top of the circle, using the "flower petal" technique described on page 203. Let the ink dry.

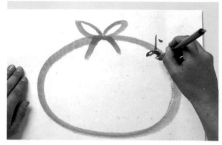

3 Using the black ink and small brush, start the first character so that the stroke crosses the top-right edge of the circle. Write *yo* in *hiragana*—a short horizontal followed by a long pretzel-like stroke.

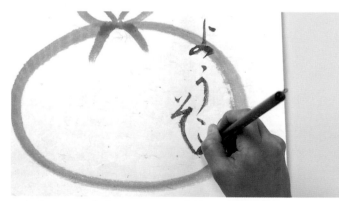

4 The second character, *u*, is followed by the third, *ko*. The final character, *so*, is written a little bit bigger as an accent.

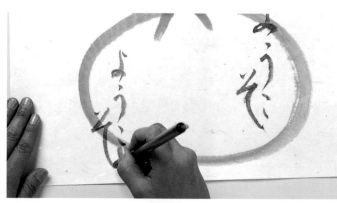

5 Repeat the same phrase in the lower left corner.

Materials

Thick decorative paper
Watercolor ink
Black ink
Medium-sized brush
Thin brush

Alternative:
You can use different colors and include any number of different messages. The phrase over this blue circle reads "Happy Birthday."

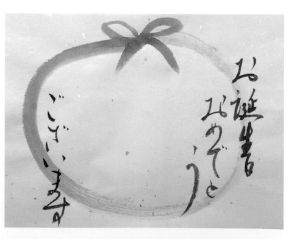

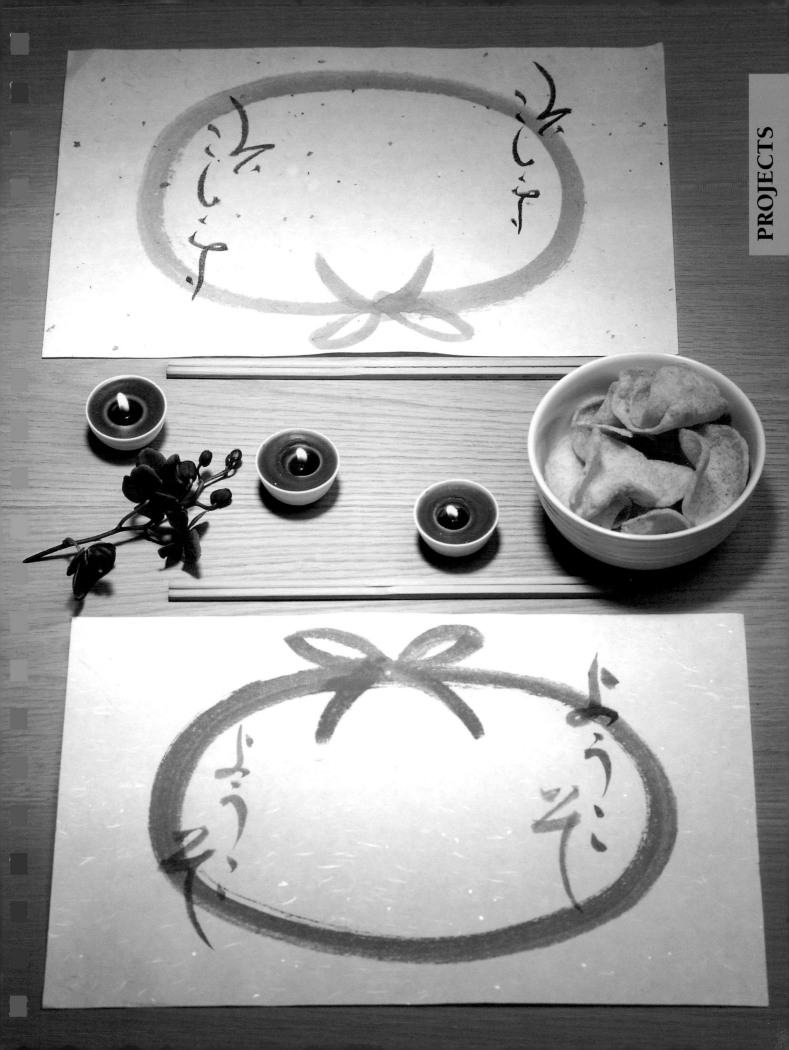

SIMPLE POSTCARD

What could be a nicer present than a simple handmade card decorated with the *kanji* character for "heart"? You can include a personal message on the reverse. The recipient can hang it up on a small scroll as a keepsake. The character derives from an original pictogram representing a biological heart. By using bright red ink you express the warmth of friendship.

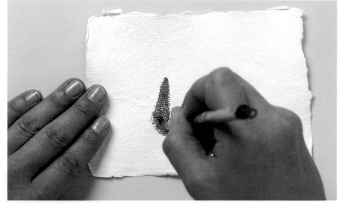

1 Take the postcard, black ink, and medium brush. Begin at the top of the first stroke of *kanji* "heart," increasing the pressure as you pull down.

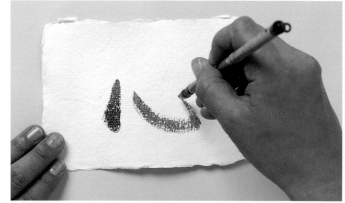

2 The second stroke starts lightly, curving diagonally down with a triangular hook at the end.

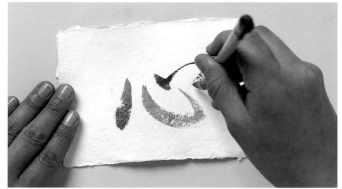

3 Change the color of the ink and make two dots.

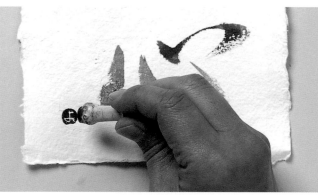

4 Using red seal ink, place a seal at the lower left-hand corner of the card.

Materials

Postcard made of paper with rough fibers
Black and red inks
Medium-sized brush
Seal and seal ink
Water-based PVA glue
Colored scroll

5 Glue the finished card onto a scroll to hang on the wall.

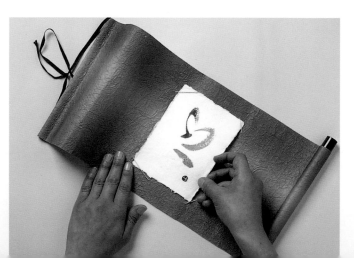

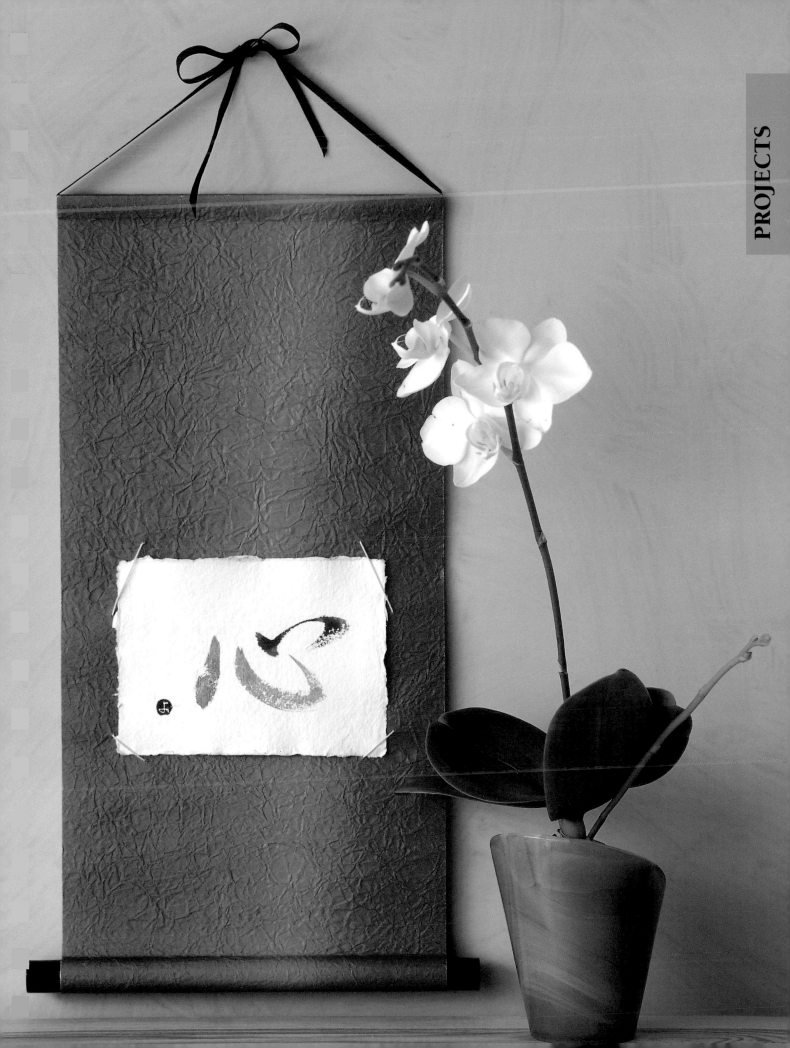

DECORATED BOX

You can make a lovely gift box or trinket holder using paper boxes decorated with calligraphy paper and plain and patterned origami paper. Calligraphy paper is slightly transparent and so gives a lacquered effect. The pink box is the color of cherry blossom and is ornamented with words and phrases such as "flower" and "color of flower." The purple box is decorated with words like "purple" and "field."

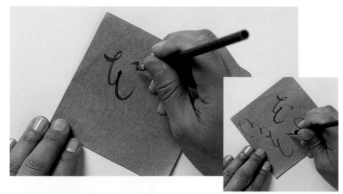

1 Use the small brush and black ink and, in the cursive style, write *hana*, meaning "flower" in *hiragana*, on origami paper. Write it a couple more times at different angles.

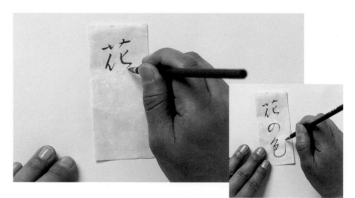

2 Now write the phrase "color of flower" on light calligraphy paper.

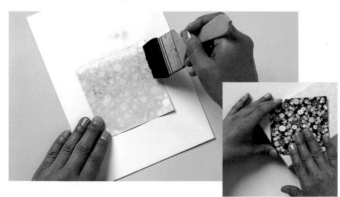

3 Apply a thin layer of glue, slightly diluted, onto the back of a piece of decorative *chiyogami* paper using a flat brush. Now stick it to the box lid.

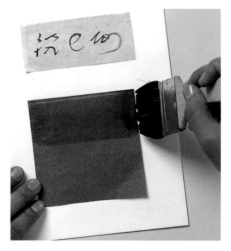

4 Apply glue to the origami and calligraphy papers. Arrange the pieces elegantly on the box.

Materials

Cardboard boxes
Origami paper
Chiyogami (traditionally patterned origami paper)
Calligraphy paper
Black ink
Small paintbrush
Water-based PVA glue
Flat paintbrush for gluing

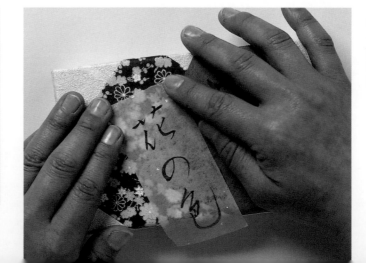

5 Make sure that the calligraphy paper is on top, as this is slightly transparent.

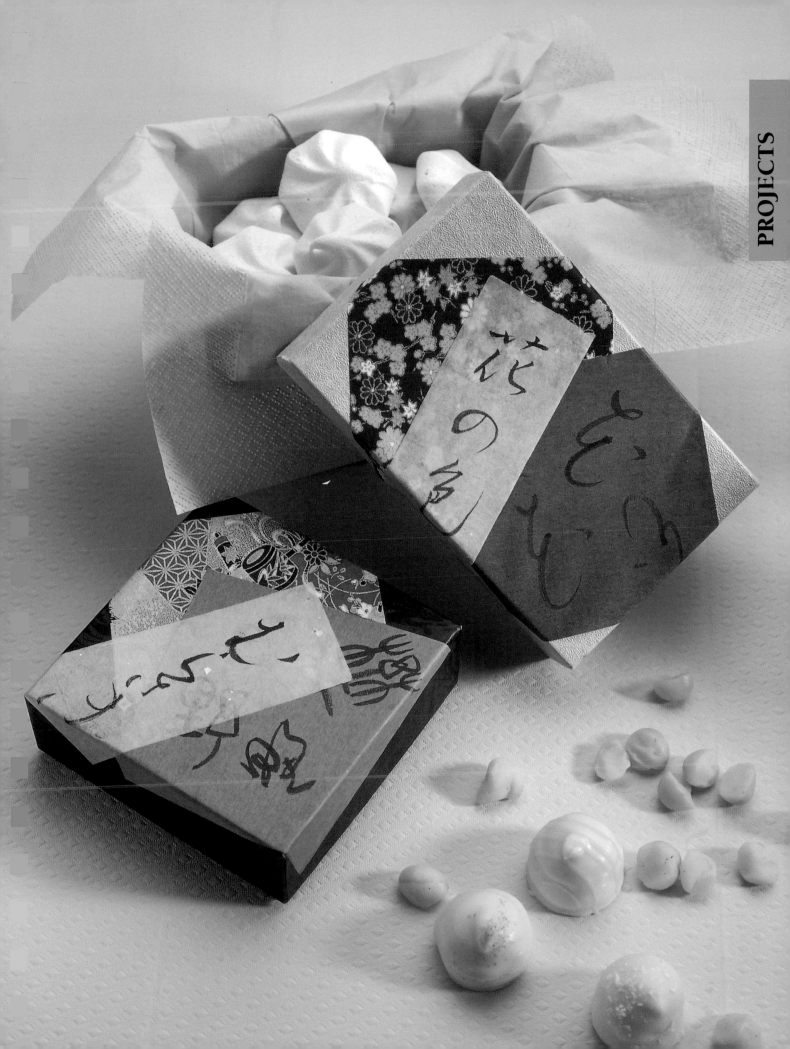

FAN

On this traditional fan is written the phrase, "I wish I could fly in the wind." The first *kanji* character, meaning "wind," is emphasized. All the other phonetics, written in *katakana*, are scattered around it—as though blown by a swirl of wind. To represent the transparent flow of air you can use a more diluted ink color.

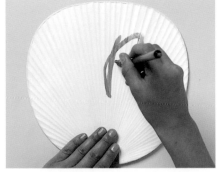

1 With the ink and medium brush, write the word "wind" in a semi-cursive *kanji* style. The first stroke sets the frame for the rest of the character.

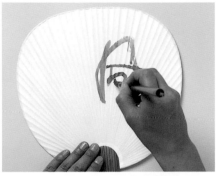

2 Continue your stroke after stopping briefly at the upper left corner. Make sure that you leave plenty of space on the right-hand side within the frame.

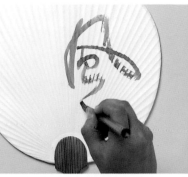

3 The last stroke should be made smoothly. Don't worry if part of your stroke is uneven because of the surface of the fan, as this is regarded as an attractive effect.

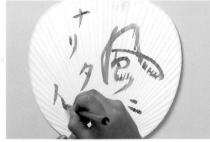

4 Write "I wish I could fly" using the *katakana* characters *ni, na, ri, ta,* and *i* placed at different angles around the *kanji*.

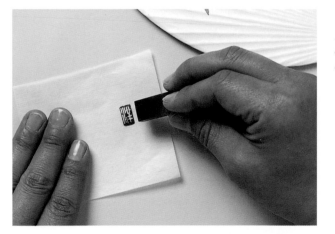

5 Mark your seal on a separate piece of calligraphy paper and carefully cut it out.

Materials

Fan
Colored ink
Medium-sized brush
Calligraphy paper
Seal and seal ink
Scissors
Glue

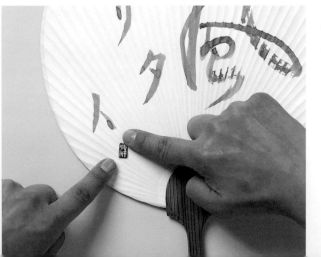

6 Use glue to paste it to the bottom corner of the fan.

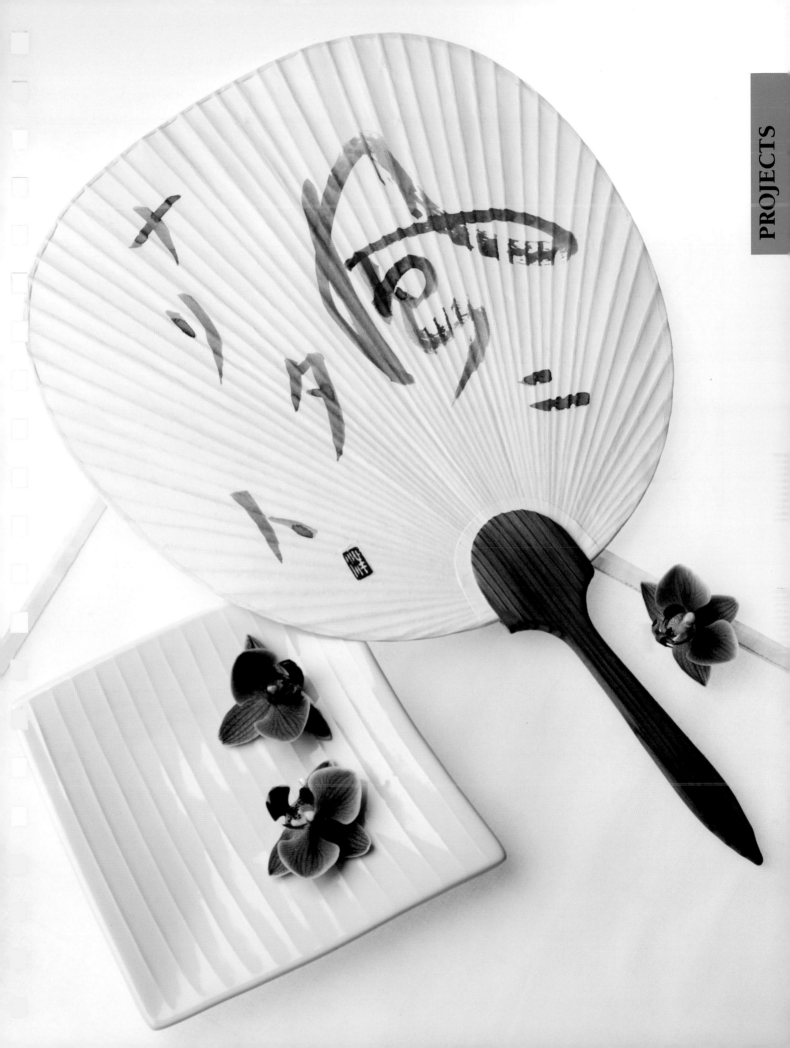

TEMPLATES

pp. 64–65 Petrarch border

Uncial zoomorphic motif

pp. 76–77 Illuminated letter

p. 77 Uncial zoomorphic motif

p. 77 Uncial zoomorphic motif

p. 77 Uncial zoomorphic motif

Uncial zoomorphic motif

p. 77 Uncial zoomorphic motif

Uncial design

p. 77 Uncial design

p. 77 Uncial design

Uncial design

p. 77 Uncial design

p. 77 Uncial design

pp. 80–81 Illuminated Letter — Uncial Capital

p. 77 Uncial design

pp. 84–85 Wooden box design motif

pp. 86–87 Animal on stone

pp. 94–95 Illuminated page motif

pp. 94–95 Illuminated page motif

pp. 152–153 Russian cursive project motif

pp. 172–173 *Panel project*

pp. 176–177 *Tile project*

p. 175 *Plate project — alternative*

pp. 174–175 *Plate project*

p. 176 *Tile — alternative*

CALLIGRAPHY SOCIETIES, SUPPLIERS, AND WEBSITES

Extend your interest in calligraphy by contacting one of the many societies that have been set up to widen the appeal of the the craft and distribute information and advice. There are many suppliers specializing in the calligrapher's mainstays: papers, pens, nibs, brushes, and inks. Alternatively, general art stores will be able to supply you with the majority of your materials, and all are available through an ever-growing number of internet-based distributors.

Calligraphy Societies

Association for the Calligraphic Arts
1223 Woodward Avenue
South Bend, IN 46616
Tel: (219) 233-6233
Fax: (219) 233-6229
http://www.calligraphicarts.org
Directory of local calligraphy groups in the U.S. and worldwide.

Atlanta Friends of the Alphabet
P.O. Box 682
Decatur, GA 30031
http://www.friendsofthealphabet.org
Classes, resources, and exhibits.

Calligraphy Centre
560 North Trade Street
Winston-Salem, NC 27101-2915
Tel: (336) 724-5475
Fax: (336) 924-5146
http://www.calligraphycentre.com
Classes, resources, and exhibits.

The Canadian Bookbinders and Book Artists Guild
60 Atlantic Avenue, Suite 112
Toronto, ON M6K 1X9
Tel: (416) 581-1071
Fax: (416) 581-1053
http://www.cbbag.ca
Web page "Other sites of book arts interest" has many useful links.

Chicago Calligraphy Collective
P.O. Box 11333
Chicago, IL 60611
http://www.chicagocallig.com
Classes, resources, and exhibits.

Friends of Calligraphy
P.O. Box 425194
San Francisco, CA 94142-5194
http://www.friendsofcalligraphy.org
Classes, resources, and exhibits.

The International Association of Master Penmen, Engrossers and Teachers of Handwriting
1818 Kennedy Road
Webster, NY 14580
http://www.iampeth.com
America's oldest penmanship society.

The Society for Calligraphy, Southern California
P.O. Box 64174
Los Angeles, CA 90064-0174
Tel: (323) 931-6146
http://www.societyforcalligraphy.com
Classes, resources, and exhibits.

Society of Scribes
P.O. Box 933
New York, NY 10150
Tel: (212) 452-0139
http://www.societyofscribes.org
Classes, resources, and exhibits.

Washington Calligraphers Guild
P.O. Box 3688
Merrifield, VA 22116
http://www.calligraphersguild.org
Classes, resources, and exhibits.

Calligraphy Suppliers

Acorn Planet, Inc.
1091 Route 25A
Stony Brook, NY 11790
Fax: (631) 675-0496
http://www.acornplanet.com
Oriental brushes, ink stones and sticks, watercolors, and rice papers.

Blick Art Materials
Galesburg, IL 61402-1267
Toll-free tel: 1-800-828-4548
Tel: (309) 343-6181
Toll-free fax: 1-800-1621-8293
Fax: (309) 343-5785
http://www.dickblick.com
Books and supplies. On-line shopping and store locator.

Brackendale Arts
1 Sparvell Way
Camberley, Surrey GY15 3SF
United Kingdom
Tel/Fax: +44 (0)1276 681344
http://www.brackendalearts.co.uk
Very good range of calligraphy equipment.

L. Cornelissens & Son
105 Great Russell Street
London WC1B 3RY
United Kingdom
Tel: +44 (0)20 7636 2045
http://www.cornelissen.com
A huge selection of calligraphy materials, brushes and pigment powder. Ships abroad.

Currys Artists Materials
2345 Stanfield Road, Suite 400
Mississauga, ON L4Y 3Y3
Toll-free tel: 1-800-268-2969
Tel: (416) 798-7983
Fax: (905) 272-0778
http://www.currys.com
General art and craft supplies.

DHP Papermill & Press
158 North Clinton Street
Poughkeepsie, NY 12601
Tel: (845) 454-8151
Fax: (845) 454-6429
http://www.dhproductions.net
Handmade paper and stationery.

Exaclair, Inc.
143 West 29th Street, Suite 1000
New York, NY 10001
Toll-free tel: 1-800-933-8595
Tel: (646) 473-1754
Fax: (646) 473-1422
http://www.exaclairinc.com/calligraphy.html
Brause nibs and holders, Schut mill papers, and calligraphy pads.

Falkiner Fine Papers
76 Southampton Row
London WC1B 4AR
United Kingdom
Tel: +44 (0)20 7831 1151
A wide range of specialist paper, calligraphy, and bookbinding supplies.

J. Herbin
143 West 29th Street, Suite 1000
New York, NY 10001
Toll-free tel: 1-800-933-8595
Tel: (646) 473-1754
Fax: (646) 473-1422
http://www.jherbin.com
Purveyor of handmade French and Italian inks, quills, and reed and glass pens.

Ichiyo Art Center
1224 Converse Drive N.E.
Atlanta, GA 30324
Toll-free tel: 1-800-535-2263
Tel: (404) 233-1846
http://www.ichiyoart.com
Japanese papers, brushes, pens, and ink sticks.

Japan Centre
212 Piccadilly
London W1J 9HG
United Kingdom
Tel: +44 (0)20 7255 8260
http://www.japancentre.com
Japanese paper specialists.

The Japanese Paper Place
887 Queen Street West
Toronto, ON M6J 1G5
Tel: (416) 703-0089
Fax: (416) 703-0163
http://www.japanesepaperplace.com
Japanese and other imported and handmade papers.

Letter Arts Book Club, Inc.
John Neal Books
833 Spring Garden Street
Greensboro, NC 27403
Tel: (336) 272 6139
Toll-free tel: 1-800-348-PENS
Fax: (336) 272 9015
http://www.johnnealbooks.com
Books and supplies, including nibs for left-handers.

Loomis Art Stores
Omer DeSerres
334 St-Catherine Street East
Montreal, QC H2X 1L7
Toll-free tel: 1-800-363-0318
Tel: (514) 842-6637
Toll-free fax: 1-800-565-1413
Fax: (514) 842-1413
http://www.loomisartstore.com
21 stores across Canada. Ships abroad.

Manuscript Pen Company Ltd.
Highley Nr Bridgnorth
Shropshire WV16 6NN
United Kingdom
Tel: +44 (0)1746 861236
Fax: +44 (0)1746 862737
http://www.calligraphy.co.uk
For supplies not widely available in U.S. Ships abroad.

New York Central Art Supply
62 Third Avenue
New York, NY 10003
Toll-free tel: 1-800-950-6111
Tel: (212) 473-7705
Fax: (212) 475-2513
http://www.nycentralart.com
Extensive selection of papers.

Opus Framing & Art Supplies
3445 Cornett Road
Vancouver, BC V5M 2H3
Toll-free tel: 1-800-663-6953
Tel: (604) 435-9991
Fax: (604) 435-9941
http://www.opusframing.com
Locations in Western Canada. Ships abroad.

Oriental Art Supply
21522 Surveyor Circle
Huntington Beach, CA 92646
Tel: (714) 969-4470
Fax: (714) 969-5897
http://www.orientalartsupply.com
Japanese and Chinese ink sticks and brushes.

Paper & Ink Arts
3 North 2nd Street
Woodsboro, MD 21798
Tel: (301) 898-7991
Fax: (301) 898-7994
http://www.paperinkarts.com
Vast selection of books and supplies.

Pendemonium
619 Avenue G
Fort Madison, IA 52627
Toll-free tel: 1-888-372-2050
Tel: (319) 372-0881
Fax: (319) 372-0882
http://www.pendemonium.com
Specialist in pens and inks.

Scribblers
12 Witney Road
Pakefield, Lowestoft
Suffolk, NR33 7AW
United Kingdom
Tel: +44 (0)1502 562392
http://www.scribblers.co.uk
Calligraphy supplies and the unique X-Height Calculator. Ships abroad.

Sepp Leaf Products, Inc.
381 Park Avenue South
New York, NY 10016
Toll-free tel: 1-800-971-SEPP
Tel: (212) 683-2840
Toll-free fax: 1-800-971-7377
Fax: (212) 725-0308
http://www.seppleaf.com
Traditional gold and metal leaf and gilding supplies.

Calligraphy Websites

A search on the Internet will yield a vast wealth of resources on calligraphy, from classes and workshops to suppliers and publications.

http://www.cynscribe.com
A good place to start your search is with this online directory of more than 1,000 calligraphy links.

http://www.winsornewton.com
One of the most comprehensive ranges of all types of calligraphy equipment, available worldwide.

http://www.tigon-crafts.co.uk
Information about Latin scripts including the Uncial and Half-uncial alphabets from author Fiona Graham-Flynn.

http://www.princesschooltraditionalarts.org/
http://islamicart.bau.edu.jo/
http://www.trmkt.com/overview.html
http://www.thebritishmuseum.ac.uk/asia/ashome.html
A selection of sites giving information about the history, development, and practice of Arabic calligraphy.

INDEX

acrylic effect paints 126
angles see writing angles
Arabic script 9, 10, 164–79
 history and forms of 164
 Kufic alphabet 168–71
 materials 165
 projects 172–9
 vocalization marks 172
Aramaic script 156, 164
Arrighi, Ludovico degli 10
Arts and Crafts movement 11
ascenders 20, 41, 224
automatic pens 141

bamboo see reed pens
baseline 25, 29, 224
birth announcement 118–19
birthday card 48–9
Black Letter Gothic 10, 88–99
 letter constructions 89, 91
 Majuscule 88–9
 Miniscule 90–1
 projects 94–9
 Rotunda 92–3
book, Russian manuscript 150–1
Book of Durrow 72
Book of Hours, Duc de Berry's 11, 94–5
Book of Kells 72
book-plate, "ex-libris" 108–9
borders 27
bottom line 25, 29, 224
bowl 20, 224
brush, holding 185, 201
brushes 8, 18, 141
 for Chinese calligraphy 184–5
 chisel-edged 18, 23
 practice strokes 23
 watercolor 126

calendars and time, Greek 133
calligraphy, origins of 9–10
cards
 ancient Greek dolphin 134–5
 Arabic 178–9
 birthday 48–9
 coming-of-age 62–3
 place name 120–1
Carolingian script
 foundation skills 28–39
 illumination 47
 letter combinations 46
 letter constructions 29, 30–3, 35–7
 Majuscule 34–7
 Miniscule 28–33
 projects 48–57
 using the pen 40–3, 44
cartridge paper 16

celebration menu in French 112–13
Celtic animal on stone 86–7
Celtic nameplate 78–9
Celtic scripts
 decorated 10, 11
 illuminated letters 76–7
 projects 78–87
 see also Uncial scripts
ceramic tile 176–7
Chinese calligraphy
 character structure 188
 history of 182–3
 materials 184
 projects 190–7
 strokes 186–7, 189
Chinese writing system 7, 8, 9
clay tablets 8, 127
colored alphabet 154–5
coming-of-age card 62–3
Copperplate 10–11, 114–21
 history of 114
 letter constructions 115, 116–17
 Majuscule 114–15
 Miniscule 116–17
 projects 118–21
Crete
 Linear A 125
 Linear B 7, 9, 125
cuneiform 8, 156
Cyrillic script 9, 10, 11, 140–55
 capital letters 142–3
 cursive 146–7, 152–3
 history and development 140
 letter constructions 143, 145, 147
 lowercase letters 144–5
 materials for 141
 projects 148–55

decorated box 210–11
decorative plate 174–5
descenders 20, 41, 224
dip-in pens 14, 126
dolphin card 134–5
double pencils
 Carolingian numerals 38–9
 for Majuscule 34–7
 for Miniscule 28–33
 practice strokes 23

Egypt, ancient 9

fan
 Chinese 192–3
 Japanese 212–13
felt-tip pens 15
fiber-tipped pens 15, 126
fountain pens 15

Gaelic prayer 82–3
gilding, for Cyrillic 141, 148–9
Gill, Eric 11
Glagolithic script 10, 140
Gothic see Black Letter Gothic
gouache colors 19, 22, 47, 126, 141
Greek 9, 10
Greek, ancient 124–39
 anomalies 130, 131
 calendars and time 133
 capital alphabet 128
 diphthongs 131
 history of 124–5
 letter constructions 129
 lowercase alphabet 131–2
 numbers 133
 projects 134–9

Half-uncial script 74–5
handmade paper 16
handwriting
 Russian Cyrillic 144, 146–7
 see also Copperplate
Hebrew script 10, 156–63
 Ashkenazi alphabet 158–9
 history of 156
 letter construction 159
 projects 160–3
hieroglyphs 8
hiragana Japanese characters 198–9,
 202–3

illuminated letter on vellum 80–1
illuminated page 94–5
illumination 10, 11
 Black Letter Gothic 93
 Carolingian 47
 Celtic letters 76–7, 80–1
 Russian poem 148-9
ink stone, for Chinese calligraphy 184
inks 15, 19, 22, 141
 for Arabic script 165
 for Chinese script 184
 mixing 132
invitations
 Black Letter Gothic 98–9
 Carolingian 56–7
Italic script 11, 100–13
 flourishes and swashes 105
 history of 100
 letter constructions 101, 103
 linking letters 103
 Majuscule 100–1
 Miniscule 102–3
 numerals 104
 projects 106–13

Japanese calligraphy
 hiragana 198–9, 202–3
 history of 198–9
 joining characters 203
 kanji in *gyosho* (semi-cursive) style 201
 kanji in *kaisho* (standard) style 198–9,
 200
 katakana 198–9, 204
 projects 206–13
 strokes 200–1
 writing names 205
Japanese writing systems 7, 8, 9,
 198–9
 kana phonetics 199

kana Japanese phonetics 199
kanji Japanese characters
 gyosho (semi-cursive) style 201
 kaisho (standard) style 198–9, 200
katakana Japanese characters 198–9, 204
Knights by Aristophanes 138–9
Kufa, Iraq 165

lampshade 194–5
Latin love card 110–11
Latin script 9
 foundation skills 20–7
layouts 26
letter box 96–7
letter staves *see* staves
Lindisfarne Gospels 72
logographic scripts 7–8
love quotation, Hebrew 160–1
love scrolls
 Carolingian 54–5
 Latin 66–7
lunch mat 206–7

manuscript book 150–1
menu 112–13
Morris, William 11

name plaque, Celtic 78–9
nibs 6, 14, 141, 224
 loading (with ink) 22
numerals
 ancient Greek 133
 Black Letter Gothic 92
 Carolingian 38–9, 45
 Half-uncial 75
 Italic script 104
 Latin 20
 Rotunda 92

Ogham 8
oracle, ancient Greek alphabet 136–7

paints 19, 126
panel, Arabic 172–3
paper 10, 16–17
 for Arabic script 165
 for Chinese script 184
papyrus 8, 9, 17, 126
parchment 17
party invitation 56–7
pencils 141
 see also double pencils
pens
 holding 21, 156, 167
 nibs, and 14–15
 practice strokes 24
pen-widths 22
personal letterhead 50–1
Petrarch plaque 64–5
Phoenician 8, 9, 125
pictographic writing systems 7, 182
 see also Chinese; Japanese
place name cards 120–1
plaques
 celtic 78–9
 Petrarch 64–5
plate, Arabic 174–5
poem, illuminated in gold leaf 148–9
postcard 208–9
practice strokes 23–4
printing 10
projects
 ancient Greek 134–9
 Arabic 172–9
 Black Letter Gothic 94–9
 Carolingian 48–57
 Chinese 190–7
 Copperplate 118–21
 Cyrillic 148–55
 Hebrew 160–3
 Italic 106–13
 Japanese 206–13
 Roman capitals 62–7
 Uncial 78–87

quill pens 14, 157

reed pens 15, 157
 for Arabic script 165, 166
relief carving on wood 68–9
Roman capitals 58–71
 incising 61
 letter constructions 59–61
 origins 58
 projects 62–7
Rome 9
 Trajan's Column 10
Rotunda, Black Letter Gothic 92–3
Runic script 8

Sanskrit 8
scribes, monastic 10, 72, 88
scrolls
 ancient Greek 138–9
 Carolingian 54–5
 Roman capitals 66–7
serifs 20, 224
Shakespeare sonnet 106–7
Sheviti 162–3
sign writing, Roman capitals 61
signs 7
"Sincerity" artwork 196–7
staves 25, 26–7, 29, 73, 127, 167, 224
stencilled T-shirt 70–1
stone 8, 61
 Celtic decoration on 86–7

Tang dynasty, China 183, 198
Tao project 190–1
top line 25, 29, 224
tracing, for borders 27
typefaces 10
typewriters 11

Uncial scripts 72–85
 Half-uncial script 74–5
 history of 72
 letter constructions 73
 see also Celtic scripts

vacation wrapping paper 52–3
varnishes 126
vellum 17
 Celtic illuminated letter on 80–1

watercolor brushes 126
watercolor paints 19
watercolor paper 17
wax tablets 127
wedding invitation 98–9
wood 8, 61
 relief carving 68–9
wooden box 84–5
wrapping paper, vacation 52–3
writing 7
 ancient materials 8
 circular and spiral 26
writing angles 22
writing masters 10–11, 100
writing slopes 21
writing systems 7–9
 syllabaries 7, 8

x-height 25, 224
x-line 25, 29, 224

Zapf, Hermann 11

NIB SIZE CHART

While William Mitchell roundhand nibs are pictured throughout this book, all instructions refer to Speedball nibs, which are the most widely available brand in North America. The table below provides specific nib widths in millimeters and corresponding sizes for Speedball, William Mitchell, and Brause brand nibs. If you are using a different make altogether, use the millimeter measurement to find the relevant alternative.

Width (mm)	Speedball Style C (flat pen points)	William Mitchell Roundhand (mm)	Brause
4	C1	0	4
3	C2	1	3
2.5	–	1.5	2.5
2	C3	2	2
1.5	C4	2.5	1.5
1.25	–	3	–
1	C5	3.5	1
0.75	–	4	0.5
0.6	–	5	–
0.5	C6	6	–

GLOSSARY

ascender The uppermost part of a letter such as "l." It runs above the *x-line*.

baseline The line on which the main body of the letter rests.

bottom line The bottommost guideline in a stave. Also called the descender line, it marks the line for lowercase letter *descenders*.

bowl The rounded part of letter such as "o."

Capital line *see top line*.

crossbar The horizontal line in a letter such as "t."

descender Bottommost part of a letter such as "j." The descender runs below the *baseline*.

guideline Generic term used here to describe the various pencil lines that guide calligraphy writing.

majuscule Uppercase, or capital, letter.

minuscule Lowercase letter.

serif Short decorative stroke at the end of a letter.

stave A series of guidelines, usually two to four, used to direct calligraphy writing.

top line The topmost line in a *stave*. Also called the capital line or descender line, it marks the line for the tops of uppercase letter and lowercase letter *ascenders*.

x-height The space between the *baseline* and the *x-line*. It is the height of a standard lowercase letter, such as "x."

x-line The *guideline* between the *baseline* and the *top line*. It marks the line for the tops of standard lowercase letters, such as "x."